FARM

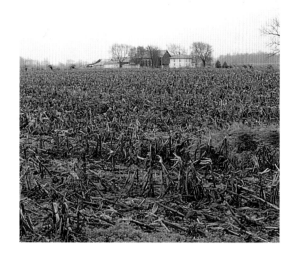

THE VERNACULAR
TRADITION OF
WORKING
BUILDINGS

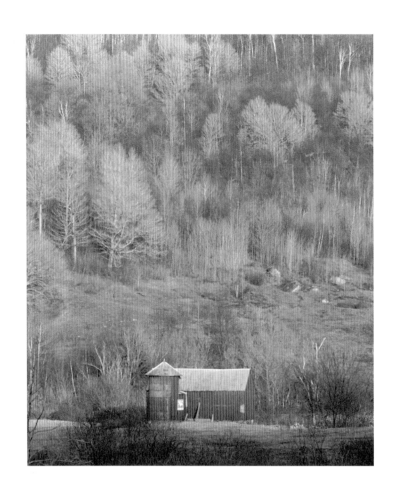

FARM

THE VERNACULAR TRADITION
OF WORKING BUILDINGS

DAVID LARKIN

PRINCIPAL PHOTOGRAPHY BY PAUL ROCHELEAU

THE MONACELLI PRESS

A DAVID LARKIN BOOK

First published in the United States of America in 1995 by
The Monacelli Press, Inc.,
10 East 92nd Street, New York, New York 10128.

Library of Congress Cataloging-in-Publication Data
Larkin, David, 1936– .
Farm : the vernacular tradition of working buildings / David Larkin ; principal photography by Paul Rocheleau.
p. cm.
Includes bibliographical references.
ISBN 1-58093-000-X
1. Farm buildings—United States. 2. Vernacular architecture—United States. I. Rocheleau, Paul. II. Title.
NA8201.L37 1995
728'.6'0973—dc20 95-24305

Printed and bound in Italy

Editor: David Brown
Design Coordinator: Meredith Miller

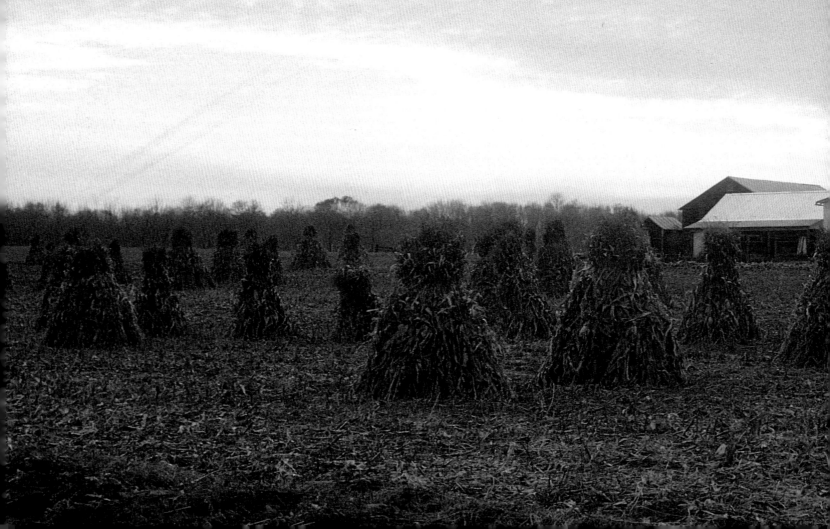

CONTENTS

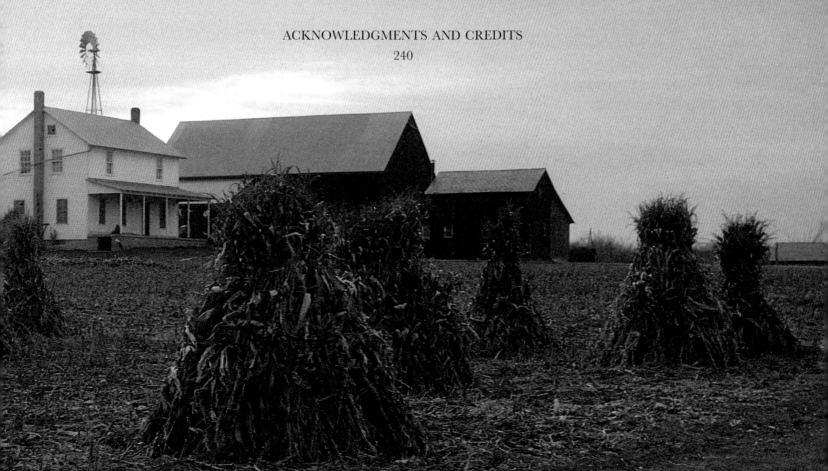

Introduction

THE NORTH AMERICAN FARM was created by Europeans who crossed the Atlantic looking to change their lives. Successful farmers had stayed behind, and for many of the immigrants, farming was a new way of life. But all the newcomers brought with them well-worn ideas and attitudes on how their farms should be run and how they should look.

The new Americans had to unlearn their past and learn about self-sufficiency. They had moved away from a communal culture, where they had always been close to a village's grain- and sawmills, blacksmith, church, and tavern; now the nearest neighbor was off on the horizon. The farms they built reflect this; in addition to a farmhouse and a barn, many outbuildings were built to accommodate the different activities of the isolated farmer. For more than two centuries, they were prosperous, as American farmers made their farms the most productive in the world.

Farm buildings tell us about more than styles and dates. To look only historically at the development of farms and their buildings can be misleading. In America, it is more important to examine how people moved. Where the going was flat and the farmland good, people moved west quickly and purposefully.

Where the country was hilly or rocky and the land meaner, people were left behind, both culturally and architecturally. This process has left a farm landscape rich in ethnic and personal history, where the details of farm building and planning are reminders of lives lived and land farmed.

The twentieth century has seen a wholesale change in farming traditions and economics. Family farming was once the dominant way of life in America; now, more land is farmed by large businesses than by families. The family farm has become redundant, a vestige of industrial society's past life.

The rural structures in this book show both the collapse and the continuity of the farm. Many farmhouses and outbuildings have been left to the elements, no longer useful or necessary. But there are many examples, in both America and Europe, of farm buildings being adapted to new needs rather than being destroyed.

The developers' onslaught against farmland in historic areas may be too strong; but as land and architectural preservation efforts gain strength, our own relationship to these buildings and this land grows and changes. And where original sites cannot be preserved, buildings are being moved and adapted to new regions and new uses, giving us hope for both our past and their future.

Origins

AS THE MIDDLE AGES CAME TO A CLOSE, European farmers gradually became more independent from their feudal lords, working the land to produce their own grains and vegetables and to graze their own livestock. Barns were built for storing the grain and housing the animals, and as farmers spent more time and labor on lands far from their villages, they began to sleep occasionally in their barns. As local agricultural economies grew and the time spent traveling from the village to the farm and back became increasingly ill spent, the farmer and his family moved permanently to the barn, which now had a living space at one end.

These barns were built sturdily and simply: In England and northern Europe a strong timber frame was erected and topped with a thatched, sod, or shingle roof. In Scandinavia, enormous softwood forests encouraged log construction, incorporating traditional house architecture in the barns. When a farmer and his family moved in for good, a wall was constructed between living and working spaces, to keep the smells and pests associated with livestock and grains out of the family area.

Although his living situation was removed by a mile or two from his village—at most five miles, given the poor state of the paths and roads—the farmer's life was still grounded in the village. The farmer's ancestors had been self-sufficient many generations before, but by the time modern Europe began to take shape in the late sixteenth century, technology and trade had advanced beyond the scope of the simple yeoman. Crops were marketed, rather than used only by the family, and a farmer could not forge tools, horseshoes or household equipment as well as a dedicated smith. The farmer would travel from his land to his village to get his horse shod, to have his grain milled, or to sell his cheese or other fresh farm products. And once a week he would journey farther afield, to the nearest market town, where farmers from villages all around would gather to sell their grains, animals, and produce in the central square.

And though his house was far from the village, his mind was not. Rural cultural life was still centered in the village church, and sometimes at the inn. The notion of a church parish was then more literal than it is in modern times—families depended on the church for spiritual guidance and social interaction; local farmers depended on neighboring merchants, tradesmen, and artisans; and the church depended on its members for tithes and for the life they brought to the faith.

The colonization of North America changed all of this. The first waves of settlers were primarily religious communities fleeing British persecution. In the ensuing decades, citizens of almost every European country joined the English, most notably the Germans, Dutch, Scotch-Irish, and Scandinavians. The colonists adopted social structures modeled after those they had recently left. Churches and meetinghouses were founded, enclosed villages were built, and small common squares appeared at the center of the villages. Religiously like-minded, the settlers banded together in independent communities.

As colonists began to prosper and grow more confident, a few left these protected enclaves to stake out their own land. With the almost boundless space available in America, these farmers soon put a good distance behind them and set up their farm on lands far from the nearest town. Others followed this example, and within a few decades independent farms were spread throughout the colonies, from New England south to the Carolinas.

Coming from cultures used to struggling with a dwindling supply of wood, they were astonished to find so much good straight timber waiting to be cleared, and so much land to use it on. With such abundance, materials improved, but traditional shapes remained, and the ethnic groups that defined eighteenth- and nineteenth-century American immigration created "islands" of distinct building styles.

Although wood gradually changed the shape and size of farm buildings—timber-framed buildings could be easily raised, extended, joined, and moved around—the English in Virginia and some Dutch in the Hudson Valley continued their occasional prejudice for staid red brick, and the French in Canada built half-timbered houses with steeply pitched tile roofs. Log buildings were everywhere, and it was the construction method of choice for first-time arrivals from northern Europe, and also for those moving further west. Although log buildings were seen as crude compared to timber frame houses, they could be built by one man—an advantage of no small importance on the ever-broadening American frontier.

Log building was especially prevalent among settlers from Scandinavia and northern Germany, and their simple methods of construction, which remained unchanged through much of the nineteenth century, defined American ideas of simple, sturdy, and self-reliant architecture.

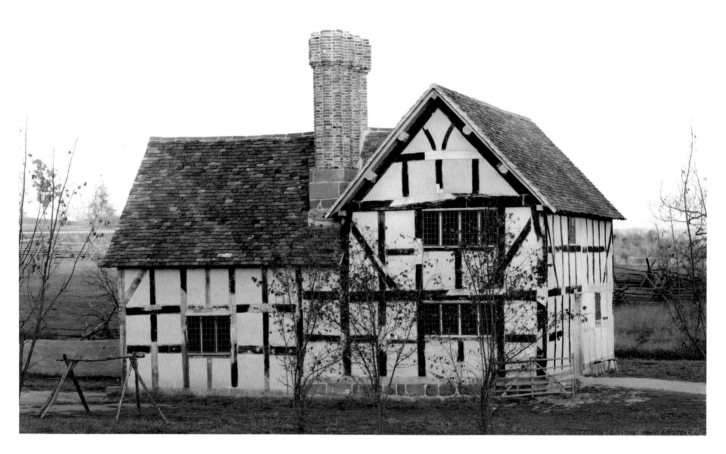

Now at the Museum of Frontier Culture in Staunton, Virginia, this seventeenth-century timber-framed house originally stood in Hartlebury Parish in Worcestershire, England. The oldest portion of the house, on the left, was part of a two-bay structure dating from the 1630s. The addition on the right was probably added in 1692, the year which appears on the date stone of the massive Jacobean chimney. The square panels were filled with wattle, or woven sticks, and daub, a clay mixture. The daubing was then covered with a lime wash that acted as a sealant.

The surviving portions of this L-shaped farmhouse are representative of the houses of prospering yeoman farmers who owned at least some of their own land and thus had the right to vote and participate in government. They practiced mixed farming with an emphasis on orchard and dairy production. Large quantities of cheese, as well as cider and perry, a fermented fruit beverage made from pears, were produced here.

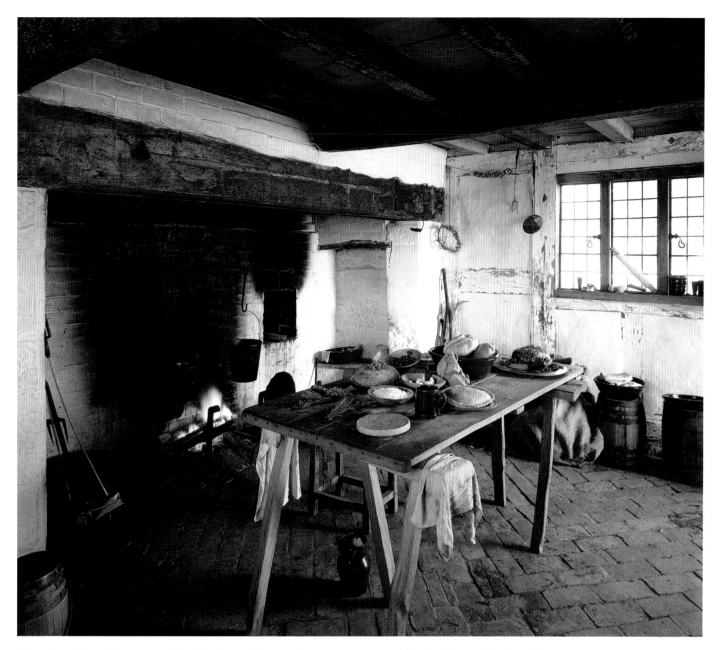

Details of the Worcestershire farmhouse's interior construction are clearly visible in this view of the kitchen—oak timbers, massive red sandstone and brick fireplace, wattle-and-daub panels, leaded glass casement windows, and period English brick flooring.

The kitchen, located in the oldest part of the house, was a service room where food was prepared and stored. There is a bake oven to the right side of the chimney wall. Meats, cheeses, and vegetables from the kitchen garden were part of the diet of yeoman families in the seventeenth century.

As freeholders with the right to vote, yeomen were among a thriving middle class of Englishmen, often just a step away from the status of gentry. Younger members of this class of English were often among those who immigrated to Virginia as well as to other colonies in the New World.

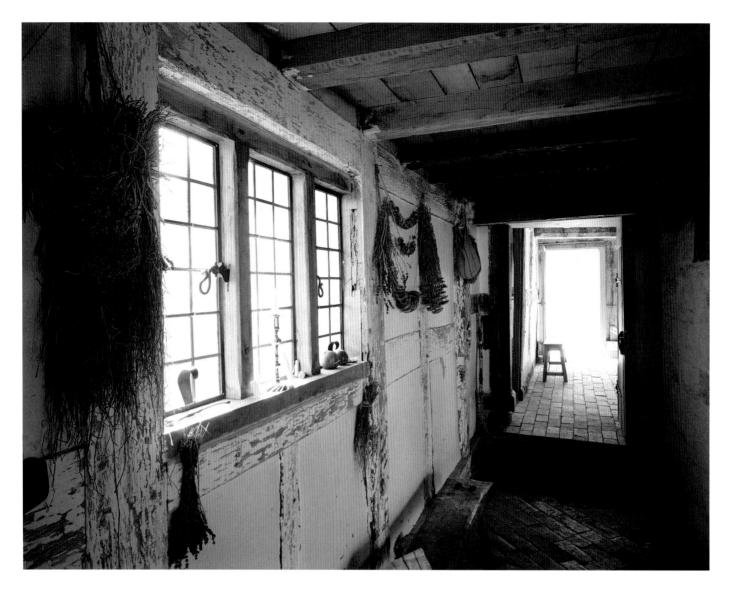

The ground floor of the English farmhouse has three rooms. From the kitchen, a visitor can walk along this short passageway to the "hall," the room beyond the doorway. The hall was the center of the home and served as a dining area and living room. Through the doorway and off to the left is the parlor, which can be entered only from the hall and which creates the L shape of the house. The parlor was the most formal room in the house, reserved for occasions when special guests were visiting. The nicest keepsakes owned by the family, such as a looking glass and Bible, were displayed in this room. Immediately before the doorway and to the left is the space that originally housed a lean-to building called a dayhouse, or dairy, where the family's perishable foods were stored.

The second floor is accessible only through the hall by a narrow, enclosed stairwell built flush against the red sandstone chimney. The unheated rooms, which are open to the rafters, were sleeping and storage chambers. The household stored clothing and linens, together with aging cheeses and grains, in the bedrooms, which were often packed with coffers, boxes, beds, and chests.

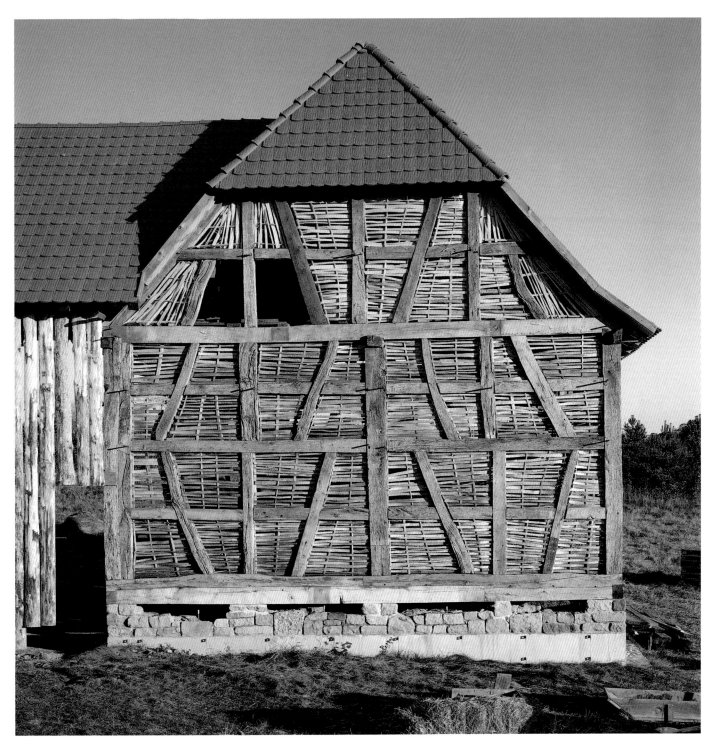

The large threshing barn being reassembled at the Museum of American Frontier Culture shows the importance of grain within the agriculture of the German Palatinate. Rye and barley were both grown in this region, but the most important grain by far was spelt, an older, hardier cousin of wheat. The construction details of the timber-framed barn can be seen in this view. Squared-off timbers resting on a stone foundation were used to create the framework of the structure. The open panels were then filled with wattles, visible here; the final stage of the process called for covering the wattles with a mud, clay, and straw mixture—daub—to create a clean and airtight building.

This three-hundred-year-old half-timbered farmhouse was once part of a "town farm" in the village of Hördt, located in the region of Germany known today as the Rhineland-Palatinate. In Hördt, as in many other villages of the region, the houses and barns were located along the streets of the village and the farmers tilled fields that surrounded the hamlet.

The courtyard plan seen here, with the house, tobacco barn, and threshing barn connected to form an L, is very common for farm complexes in this region. The house was located with the gable end toward the road; the long barn ran parallel to another road behind the house. Both the house and the threshing barn are timber-framed structures, called *Fachwerk* in Germany. The spaces between the timbers are filled with panels of wattle and daub. All three roofs are covered with clay tiles.

The oldest part of the house consists of a floor plan called *flur-kuche*, or hallway-kitchen. The front door opens into a hallway, a small square-shaped room that served as a greeting room for visitors and as a storage area. The kitchen, directly behind the *flur*, has a raised cooking hearth and served as the primary area for cooking and food preservation. The large front room of the house, called a *stube*, comparable to a parlor, living room, and dining room combined, served as the primary living space for the family. This room was heated with a stove that was fed with coals through a hole in the wall that opens into the kitchen. The narrow bedroom behind the *stube* was called the *kammer* and was the sleeping area for the farmer and his wife.

The second floor was used as sleeping space for the children and servants, and as storage for linens, while the third floor, an attic, was used for the storage of grain and other agricultural items. The room to the left of the *flur* is a later addition and is thought to have been a work area for textile production.

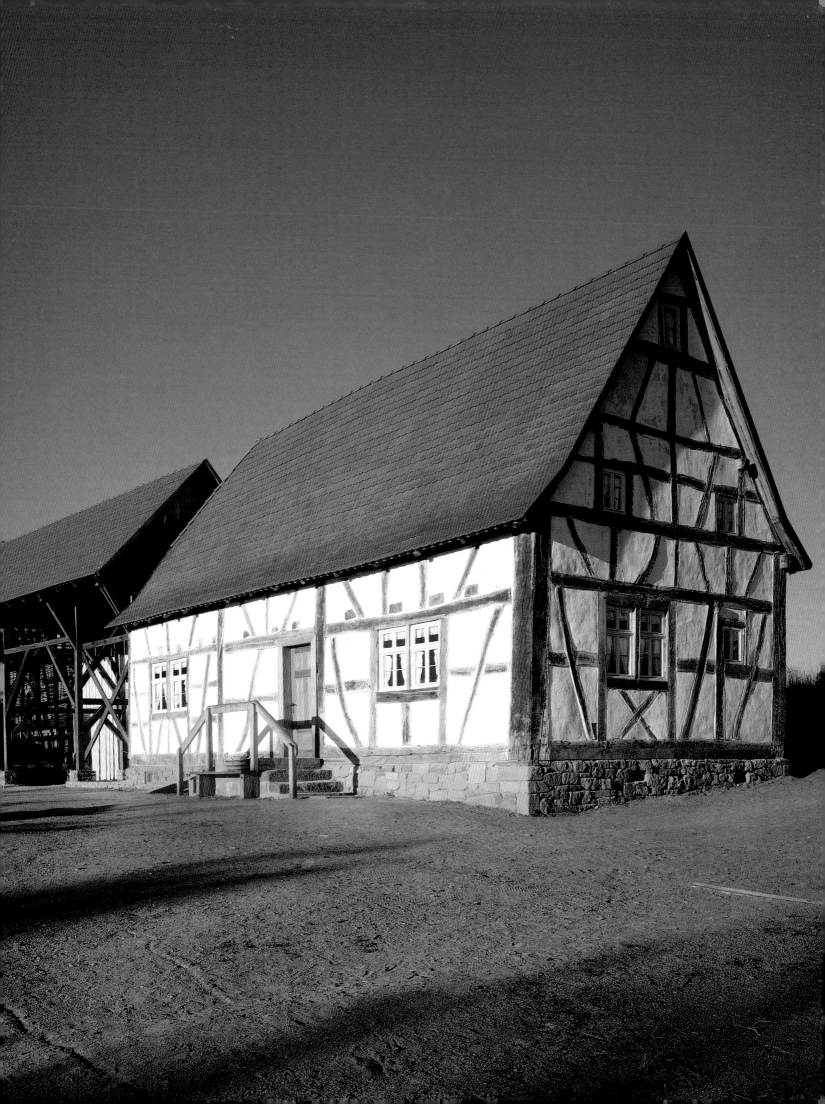

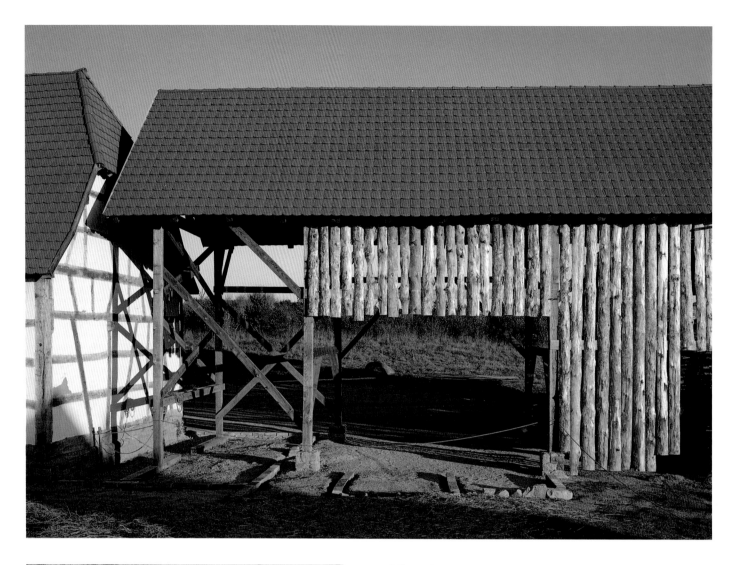

The tobacco barn connects the threshing barn and the house and reminds visitors of the "reverse immigration" that often occurred between the Old and New Worlds. Tobacco, discovered growing in the New World, was introduced into the Palatinate region of Germany as early as the sixteenth century. The loosely fitted vertical planking of the barn allows the tobacco to be air-cured.

The kitchen garden is surrounded by a wattle fence of supple saplings. Although low, this tightly woven barrier could be constructed quickly. It served to define the boundaries of the garden and to turn back small garden pests, like rabbits.

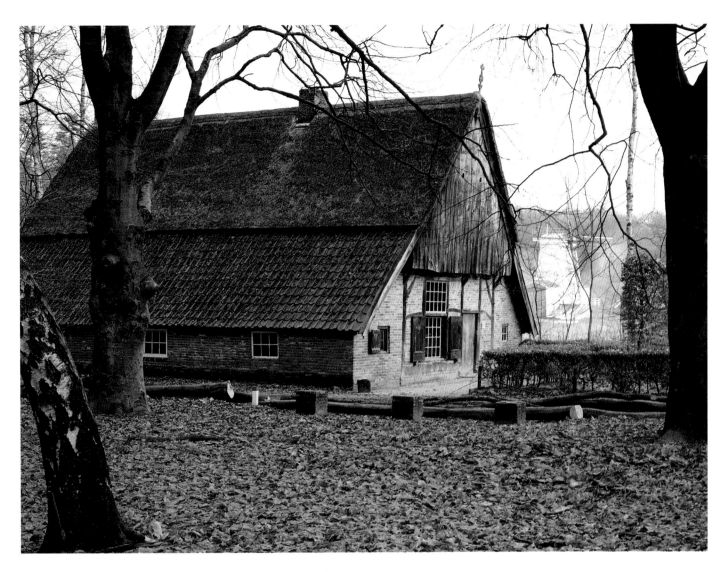

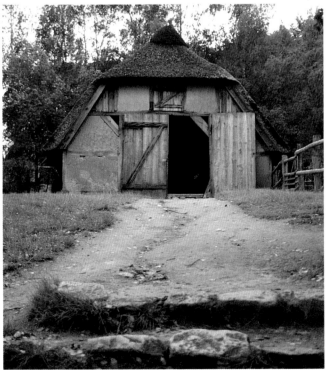

This small farmhouse-barn from the Netherlands, built about 1750, was used as both living space and barn. About one-third of the building was the farmer's home; a wall separated his family from the livestock and grain areas. In the early nineteenth century at least twelve people shared the living space, with an unknown number of animals in the barn. The sturdy house-barn has a distinctive half-thatched, half-shingle roof.

An eighteenth-century German barn, from the Schleswig-Holstein region, reveals the interaction among northern European farmers. Like the Dutch house-barn, this building has a steep thatched roof, as well as the *Fachwerk* construction that was the hallmark of German building.

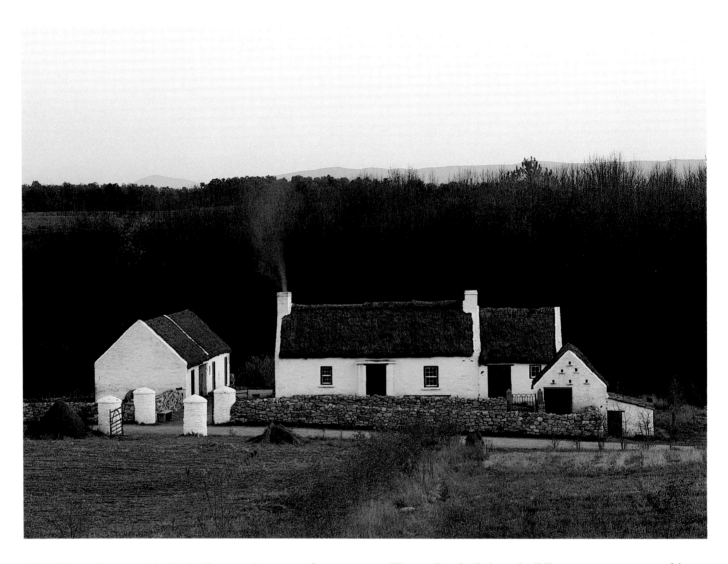

This Ulster farm, originally built near the town of Drumquin in County Tyrone, Northern Ireland, now stands in Staunton, Virginia. Like most middle- and lower-class farms in Ireland, the farm was a tenant farm, rented from local gentry who owned large tracts of arable land.

The farm has a one-story, two-room farmhouse, center, with a cow barn, or byre, added later to the right. The small outbuilding in front of the house is a pig pen, or craw, with an attached henhouse. Besides chickens, some farms had space for pigeons, which were raised for meat and eggs like the chickens; the upper level of the pig craw is a pigeon loft. The four-room outbuilding to the left has a cow byre, horse stable, cart shed, and turf store (a storage area for the fuel burned in the family's hearth).

The walls of all three buildings were constructed in three parts. Two sandstone walls were built. Then the cavity was filled with rubble to create one thick, sturdy wall. Both the interior and the exterior were whitewashed, as were the cylindrical stone gateposts. These large columns were necessary to keep the heavy iron gate, which marks the entrance into the farmyard, in place.

The roofing replicates the type of thatching typical in County Tyrone. To create a roof, the master thatcher pinned rye straw to an underlayer of sod, called scraw, with bent hazel rods, called scollops. For reconstruction, thousands of hazel scollops were imported from Ireland.

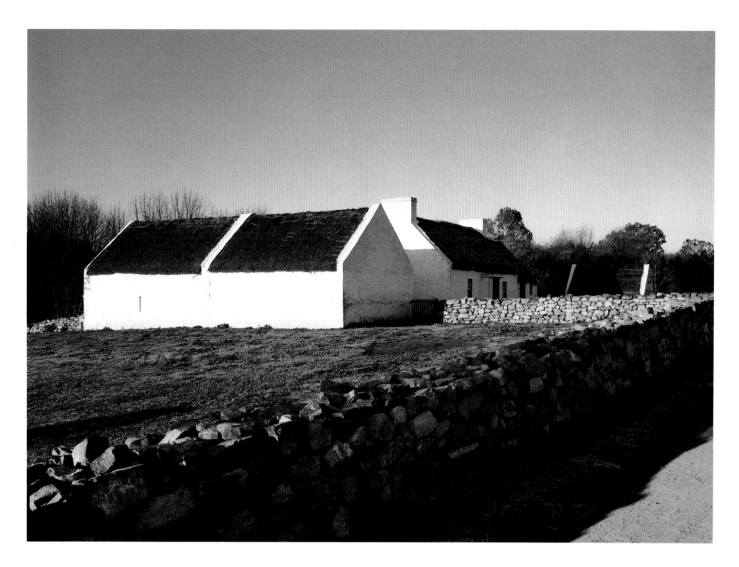

In Ireland, a country stripped of its forests, farmers had to create means of dividing fields that did not require wood. The stone walls and hedgerows on the Ulster farm site have been built in order to re-create accurately the original landscape in County Tyrone.

Stone removed from the fields was piled in rows to mark boundaries and create fences. The soil dug from ditches was piled into embankments which were then planted with thorn hedges. Hedges formed of thorny and brushy shrubs were planted along the banks of ditches and also served as demarcation for fields and as barriers to livestock. On this farm, the hedgerows have been planted with the same species of white hawthorn used on the farmstead's original site in Northern Ireland.

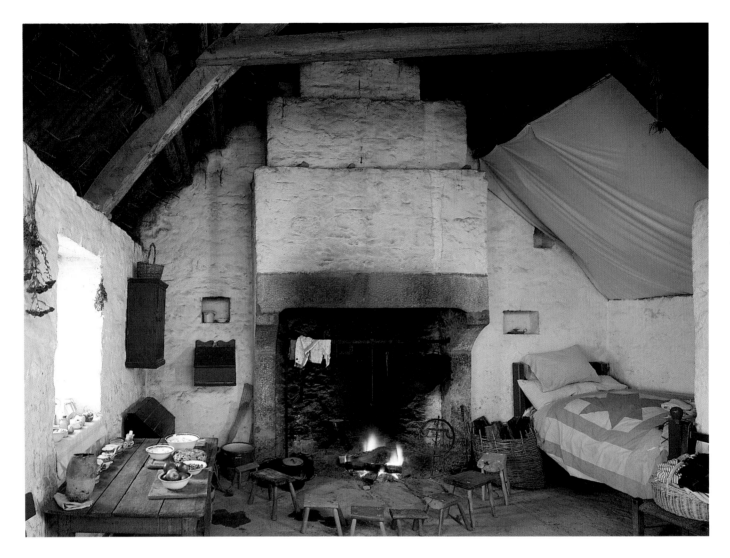

The one-story Ulster farmhouse consists of two rooms, a kitchen and a bedroom. The kitchen served the family as the overall living area. Food preparation, including cooking and churning, took place here and the family ate meals here seated around the fire on small "creepie stools." The only heat in the house was provided by a continuously burning turf fire, fueled by peat dug from local bogs and dried for use as fuel.

The bed tucked into the outshot to the right side of the hearth was considered the best in the house because of its warmth, so it was generally reserved for the farmer and his wife or an elderly grandparent. The cloth attached to the ceiling above the bed protected sleepers from dirt, which filtered down from the interior of the thatched roof. Other family members slept on the floor in front of the hearth, on the settle bed, or in the unheated second room.

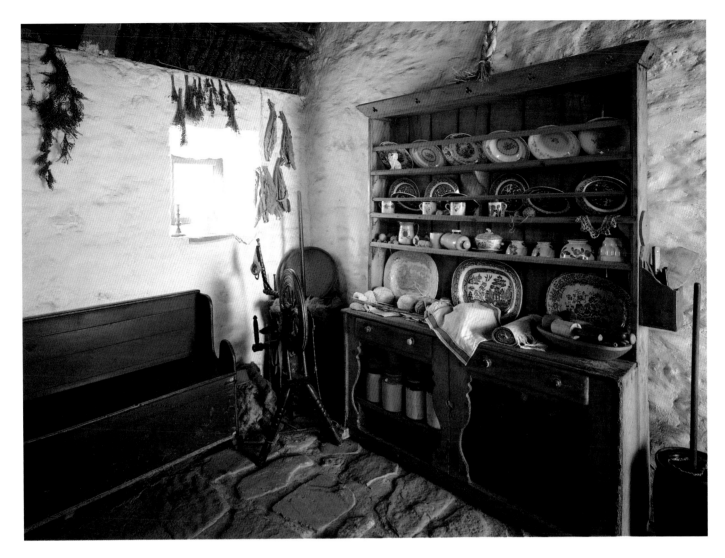

Two of the most common furniture items in the kitchen of an Irish tenant farmer were the settle and the dresser. The settle served as a seating bench during the day, but could be unfolded to create a box-like bed for family members or guests at night. The dresser, or "hen dresser" as it was sometimes called, has ancient origins. In earlier times the lower portion of the dresser was used as a nesting area for chickens, a practice that still continued in the nineteenth century among poorer farmers, but which had all but disappeared among stronger tenant farmers than those who lived in this house. The upper portion of the dresser served as a storage and display area for the family's eating utensils, china, pewter, and stoneware.

The floor of the farmhouse is made of blue clay with a flagstone walkway leading into the interior from the house's only entrance.

The corner is occupied by a spinning wheel and a churn, both representative of important occupations within the Ulster household. Many farmers in Northern Ireland raised flax and then spun the fibers into linen thread which could be woven into cloth. The area also had a strong tradition of producing butter, which was consumed in prodigious quantities and also sold to help pay the rent.

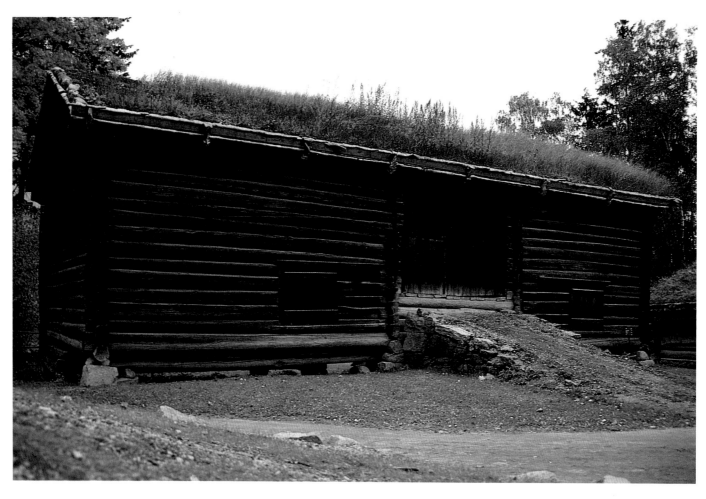

Log construction in Norway reached a high level of sophistication, even in humble buildings like this eighteenth-century barn. Long and low, the building has sharp corners and tight seams, necessary in the cold northern European climate. The earth ramp leads to a threshing floor and areas for storing fodder.

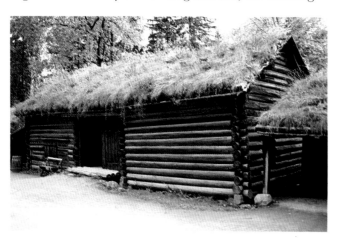

Norwegian log farm buildings, like this seventeenth-century stable from Jørisdal, were roofed with sod, well-suited to the country's damp weather. In America, the warmer and more severe climate proved sod to be an unsuitable roofing material, and settlers soon adopted shingle roofs.

This barn at Turkey Run, Virginia, is an example of an early American attempt at log building. The steep roof and log construction, elements of two different building traditions, reflects the American settler's ability to combine forms to suit the landscape, climate, and most important, availability of materials.

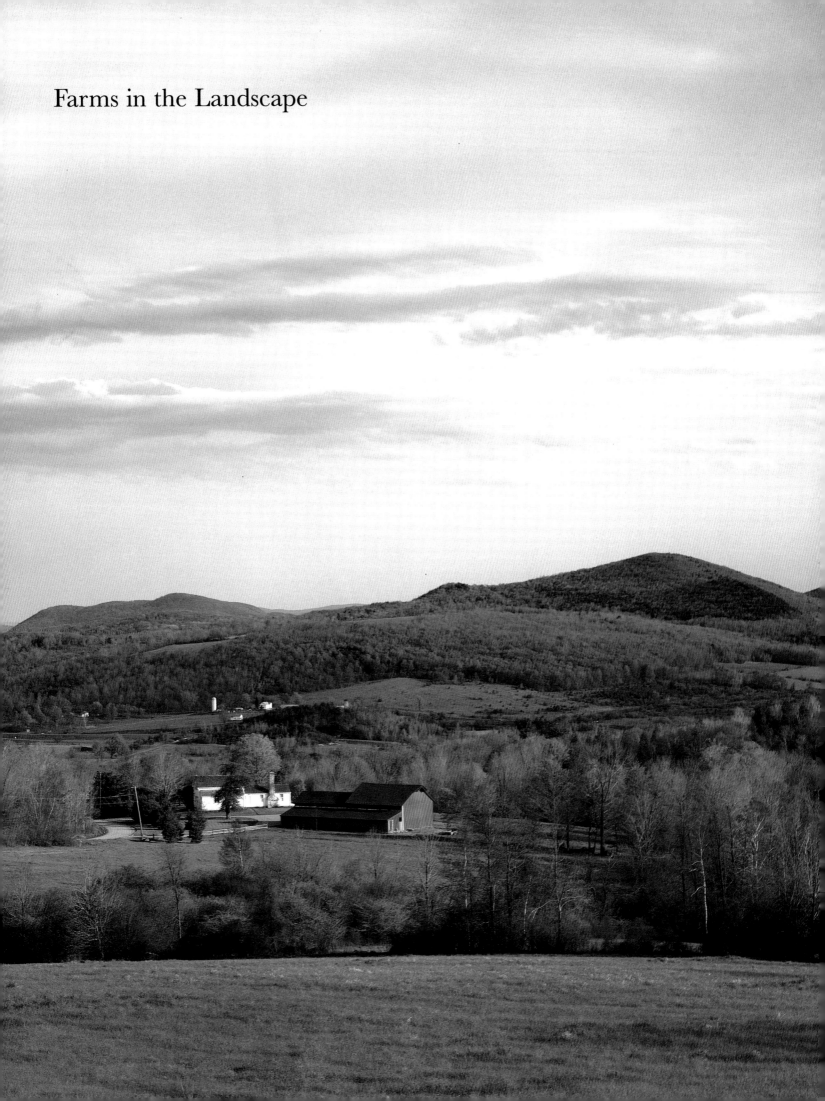

Farms in the Landscape

THE AMERICAN FARM UNFOLDS ACROSS THE LANDSCAPE GENTLY, a small complex of buildings in the middle of a vast acreage of cropland. As one travels through the countryside, the farm starts out as a small object on the horizon—a good distance from its neighbors—usually encircled by a stand of tall shade trees.

Closer, the barn becomes clearly defined, the largest structure on the farm. Near that, but not too near, is the farmhouse, and as one approaches even closer, the farm's outbuildings take on their specific characters. Close to the farmhouse are the woodshed and pump house or springhouse; on the driveway leading to the barn is the wagon house; and on grain farms, the corn crib or silo sits next to the barn.

The plan of the American farm—the disposition of buildings, the spaces between them, the orientation of the farmhouse toward the southern light and away from the weather—reflects local traditions, changing ideas about the farm, and most important, common sense.

The ethnic and regional traditions that defined rural American architecture also left their mark on the structures of the farm: An Amish farm is advertised by its "grandfather house" and the windmill and washing on the line, clear indications of the lack of electric power; the northern New England farm is recognizable at a glance because of its connected buildings; the size of barns in Pennsylvania and Ohio denote the prosperity of the land; and the complex of simple, unpainted log structures defines the Appalachian landscape.

Although the farm can appear to be a lone ship in a sea of wheat or corn, the regional and ethnic properties it shares with its neighbors reveal that the farmer and his family are a part of a larger community, members of a not-too-distant church and a friend of the nearby farmers. And in Amish regions, the farms *are* the community—the farmhouse becomes the church as Sabbath day worship rotates among farms, drawing the extended families together for meetings and prayer, for larger gatherings and celebrations, the barn is used.

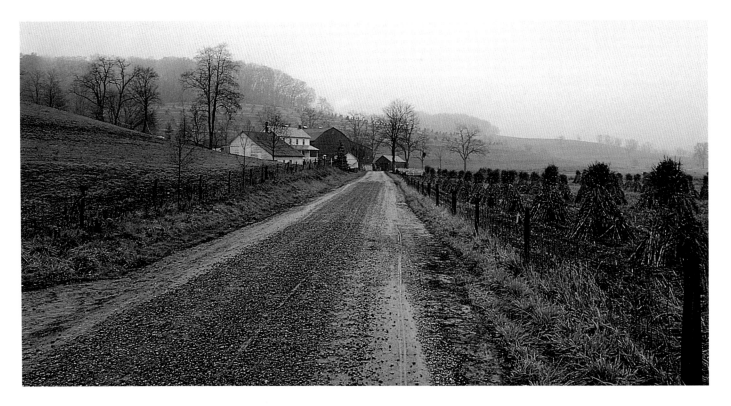

A rural road leads past an Amish farm in Ohio, running straight along property lines. During harvest season, corn is cut by hand and then arranged into distinctive *stooks*, often by the farm children.

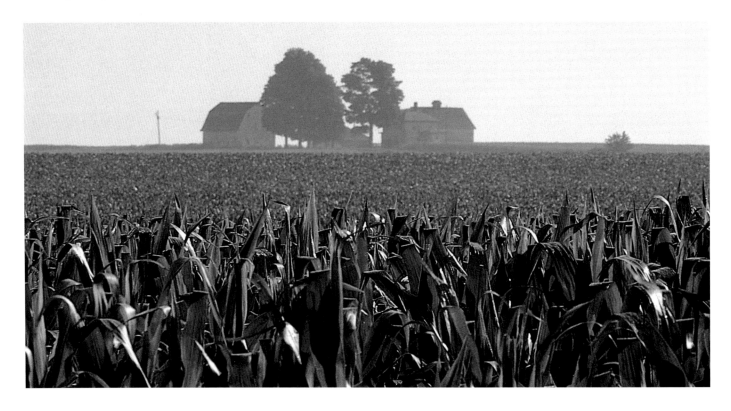

Although this Illinois farm seems isolated in the center of its corn fields, a road runs right through the farmyard. Its buildings are positioned for easy loading and access to this thoroughfare.

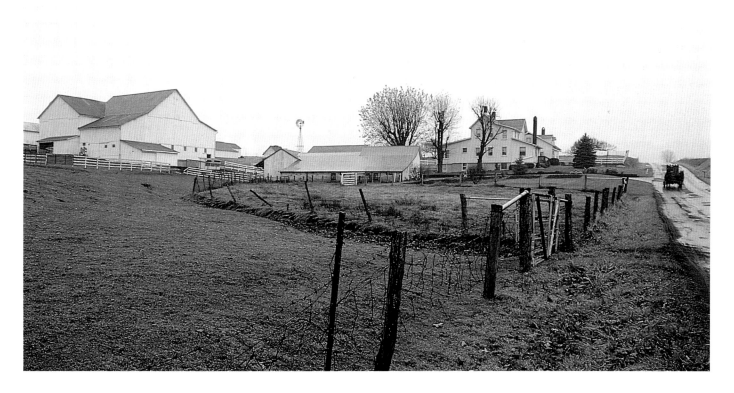

Amish farms are identified by a number of clues—the lack of power lines, the windmill, which powers the water pump, the mixture of crops, and in this image, the horse-drawn buggy traveling down the road.

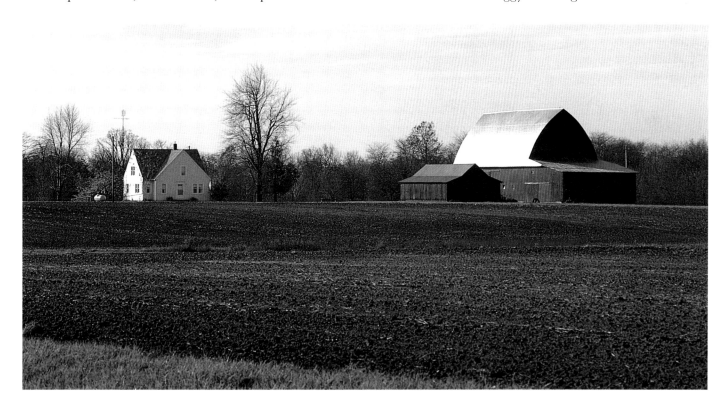

A new metal roof shines in the afternoon sun atop a balloon-framed Ohio barn.

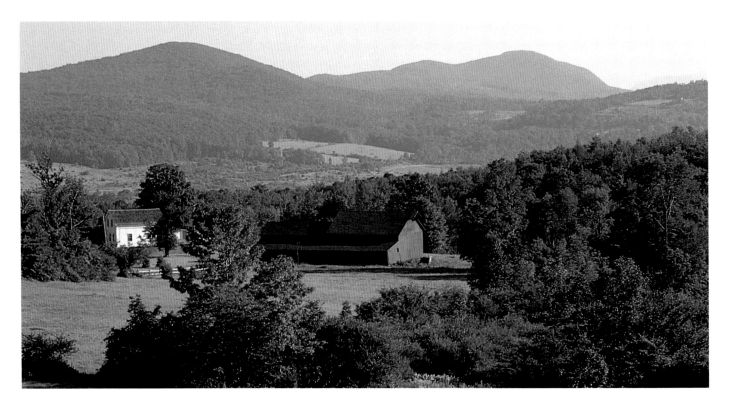

A dairy farm occupies a rare piece of fertile land in the heavily forested but ecologically fragile Berkshire Hills.

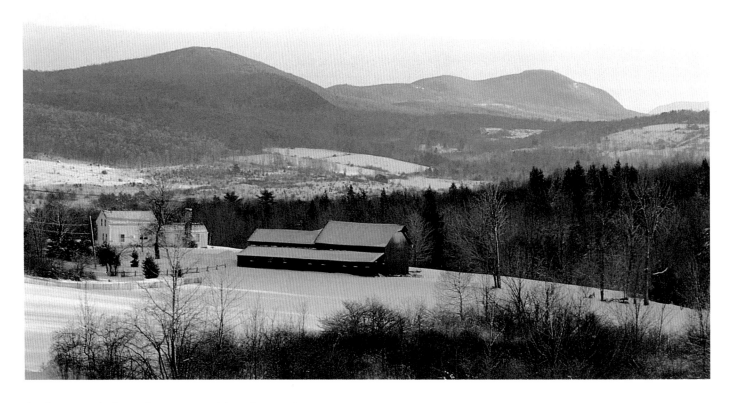

A photograph from the same position shows what summer conceals. Visible are the true extent of the fields, traces of old stone fences, and the green coniferous trees against the winter's whites and grays.

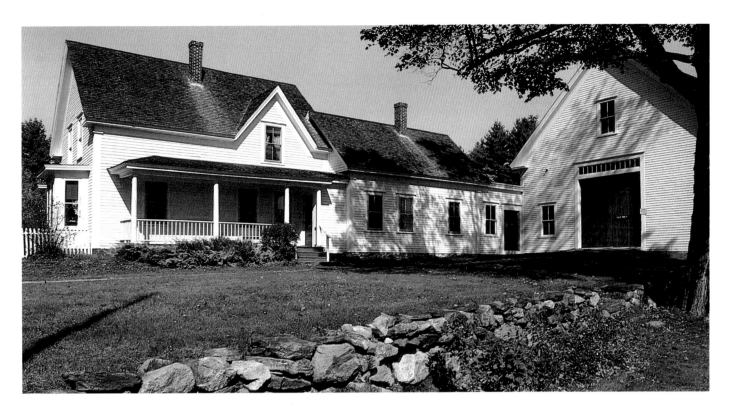

The Robert Frost Farm in Derry, New Hampshire, is a preserved, intact complex of connected farm buildings, running in the familiar progression "big house, little house, back house, barn."

New England farm buildings were connected in the nineteenth century, by moving them or with small additions. The connected buildings allowed the farm family to work through the winter in relative comfort.

One of the few truly valuable land areas in New England, the soil of the Champlain Valley is rich in silt. Without fences, there are no discrete borders between the farms, creating a continuous landscape punctuated only by the prosperous farms' silos.

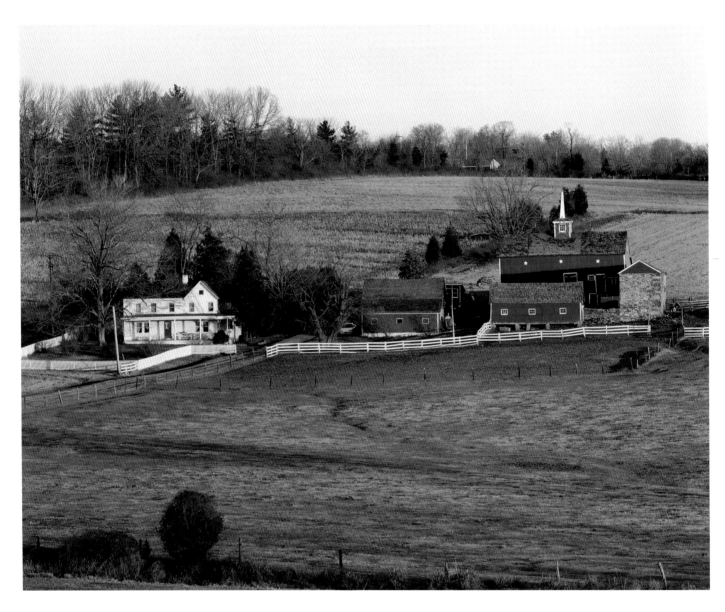

This farm in Mercer County, New Jersey, has been operated
by a single family for several generations, and the farm
buildings have evolved into a natural organization.
The white farmhouse, two smaller outbuildings, and the
large barn topped with a cupola are all surrounded by a
neat white fence, which serves both to protect the market
garden from small animals and to proclaim the borders
of the family's settlement.

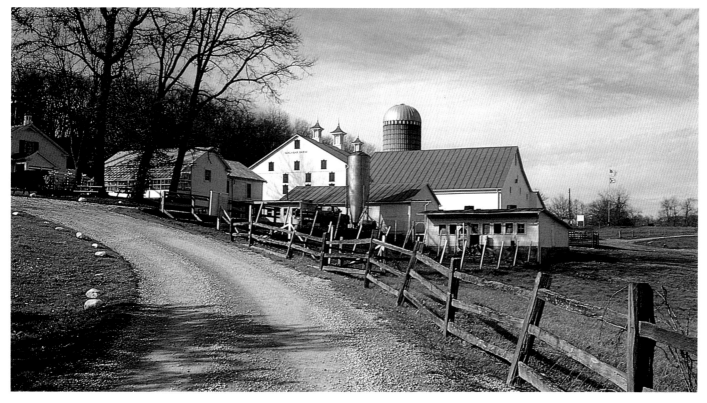

Louis Bromfield, a pioneer of agricultural practices, founded Malabar Farm in Lucas, Ohio. Today his work continues on this experimental farm, renowned for its soil conservation methods.

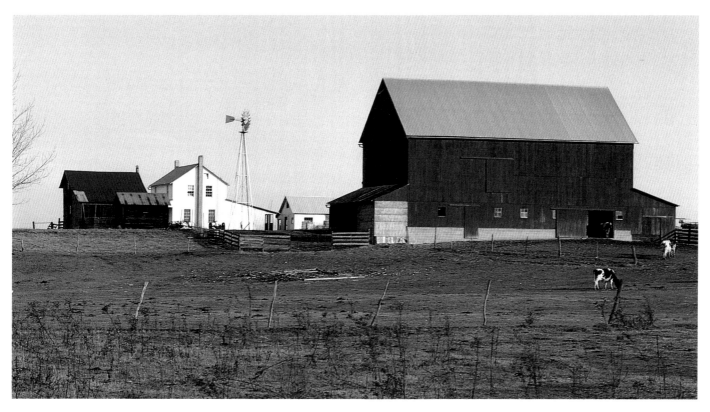

The "grandfather house" on this Amish farm in Ohio is visible in the center of the landscape. To its left is the main farmhouse, which would have been given over to the eldest son when he started a family.

The New World Farm

A farm from the Valley of Virginia. The stone springhouse in the foreground
provided the family with water and a cool place to store dairy products.
The other outbuildings on the farm include a buggy shed, chicken house,
produce shed, meat house, apiary, and a lime shed for storing pulverized lime
(used as a fertilizer and also in whitewash and mortar). The house and barns
were built in a Germanic style of log construction, while the other structures
were of stone or timber framing.

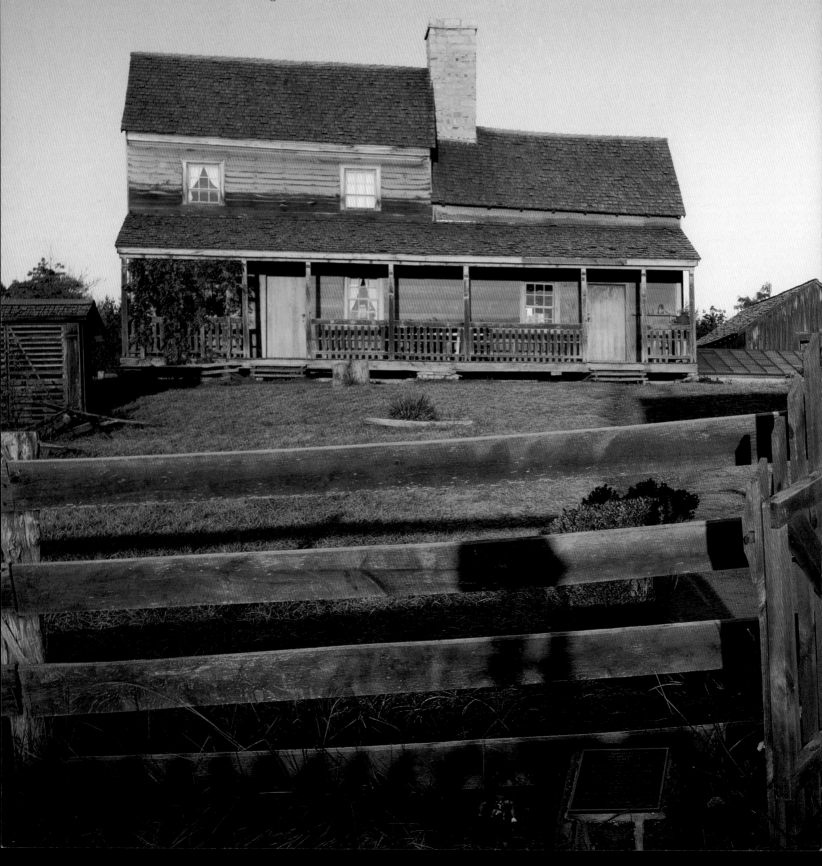

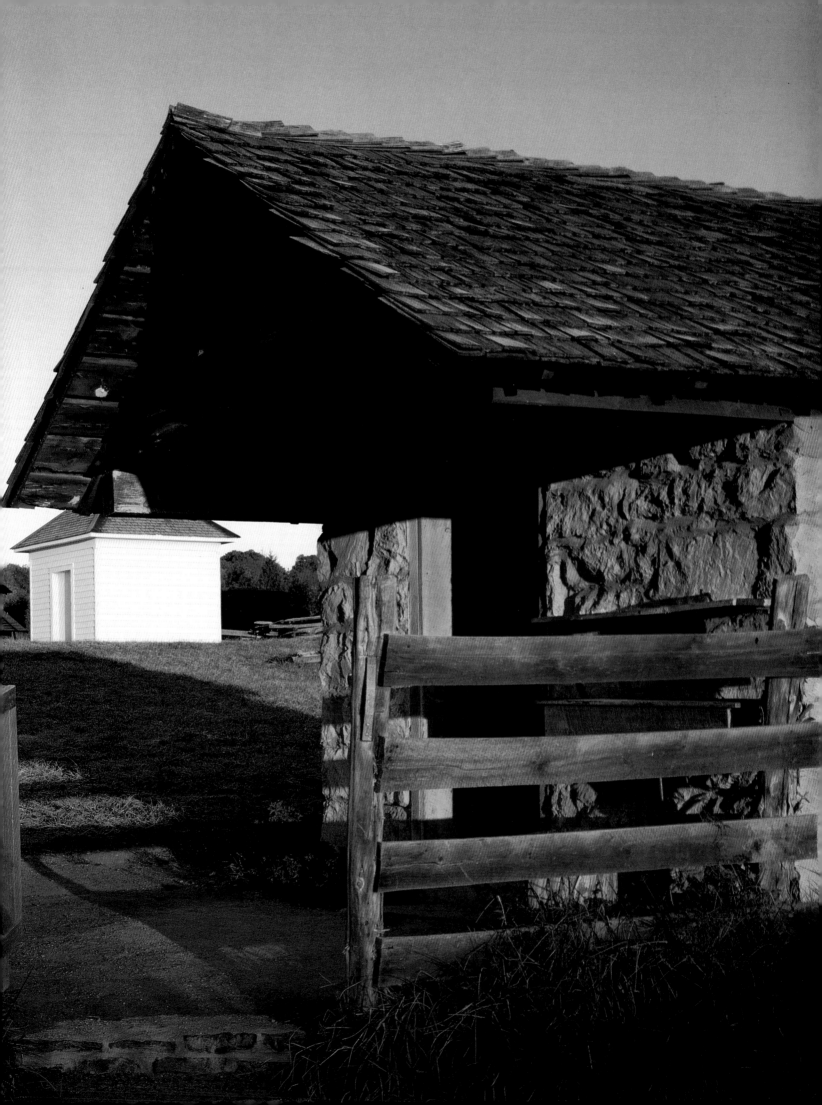

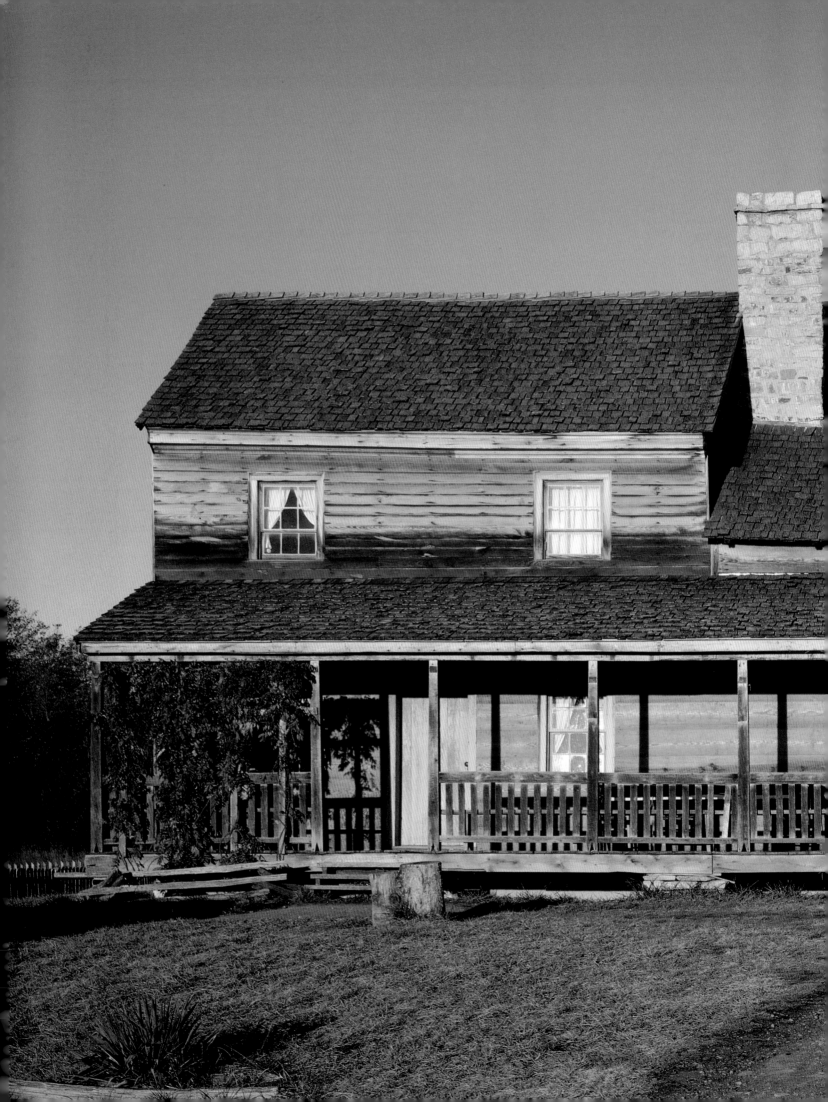

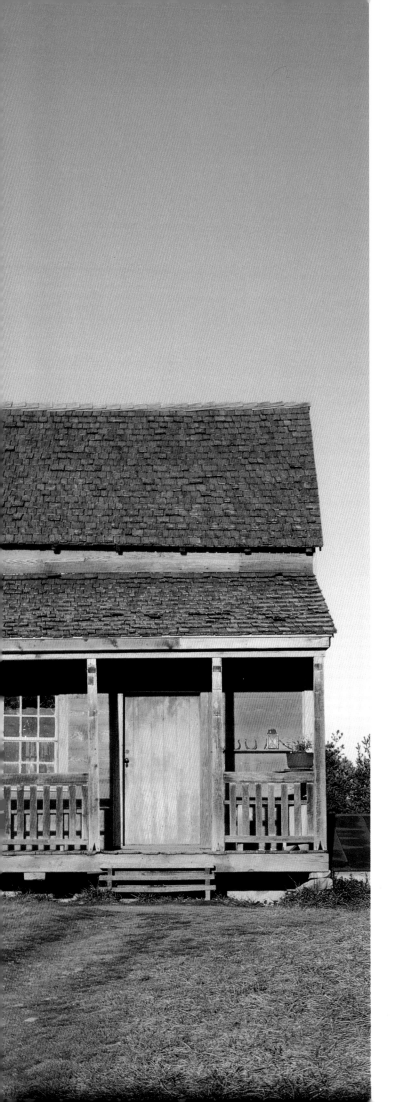

The Valley of Virginia farmstead reflects a blending of architectural traditions from Germany and the British Isles. The farmhouse and outbuildings were moved to the Museum of American Frontier Culture from a site near the town of Eagle Rock in Botetourt County, Virginia. The nineteenth-century farm features a log house, a double-pen cantilevered log barn, and a tobacco barn, all typical of western Virginia architecture in the nineteenth century.

The original section of the two-story log house is to the left of the chimney and was built in the 1830s. The rectangular house plan, with one room on each floor, an end chimney, and a central front door, reflected building traditions from Ireland and England. Oak roof shingles are the primary roofing material, although tin roofing, introduced to the area in the mid-nineteenth century, is used on the root cellar.

In the 1840s, the kitchen-pantry with a root cellar underneath was added. At this time, the entire house was covered with weatherboards and the front and back porches were added.

The porches added to the house in the 1840s made a pleasant place for the family to sit and do chores or simply relax. The back porch gave a good view of the tobacco barn. The produce shed to the right of the house was used to store vegetables from the garden and for firewood for the house's three fireplaces.

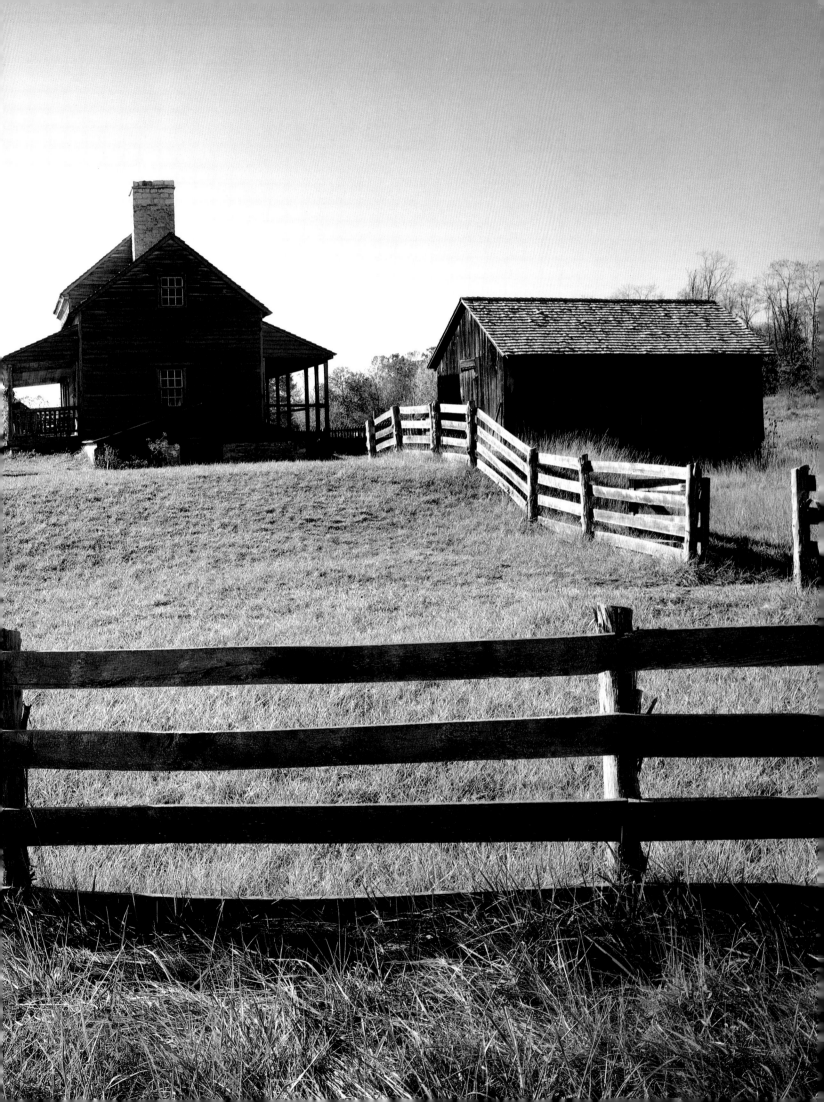

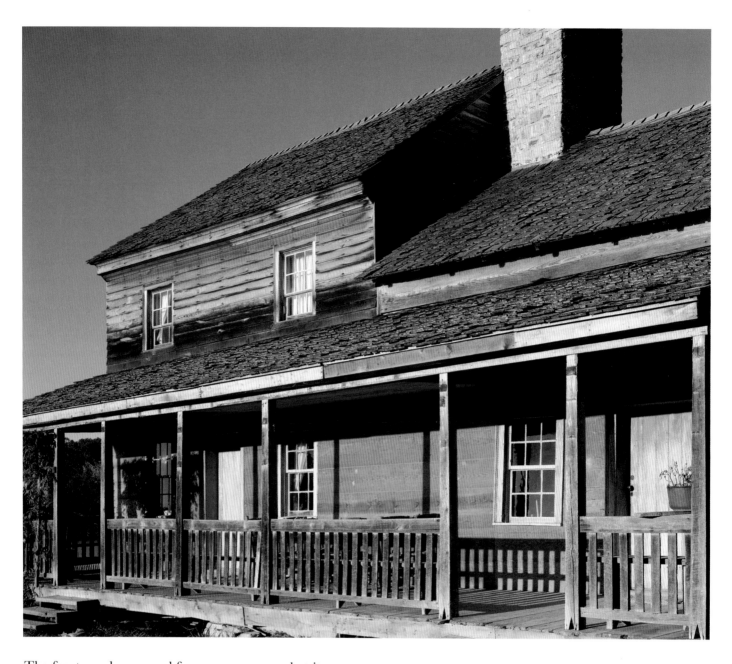

The front porch was used for many purposes, but its most important function was to shade the kitchen door and windows.

Nearly all household and kitchen chores that could be performed while sitting down were done on the porch. Peas were shelled, corn was shucked, and freshly made soap was left to settle in the shade. Farm wives would also meet on the porch to pool their labor in quilting bees.

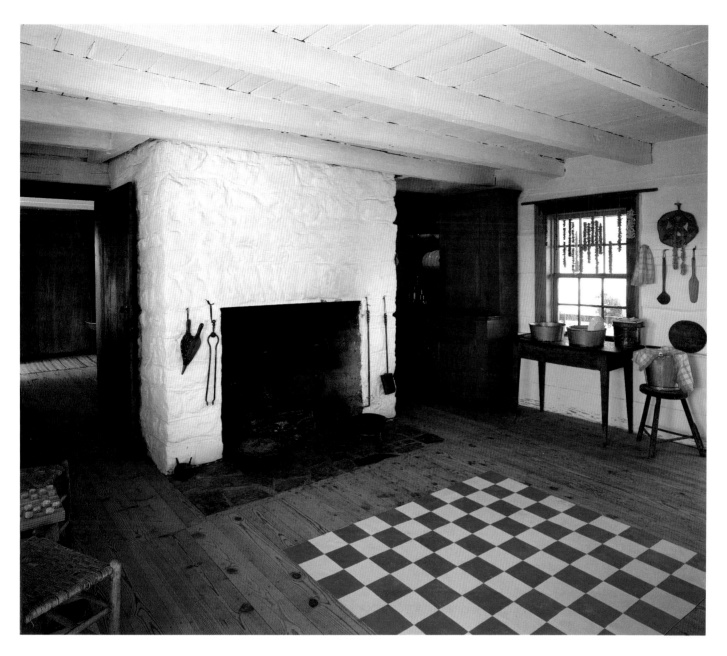

This log kitchen wing was added to the original two-room farmhouse in the 1840s, considerably improving the comfort and convenience of the home. The fireplace and the extended hearth area were used for open hearth cooking; the family dined in the kitchen as well.

Whitewashing the walls, a yearly housekeeping task, brightened and sanitized the room. The floor covering is a painted floor cloth, a sturdy piece of canvas decorated with oil paint. The resulting handiwork was an attractive, durable, washable surface that was the ancestor of today's linoleum and vinyl flooring.

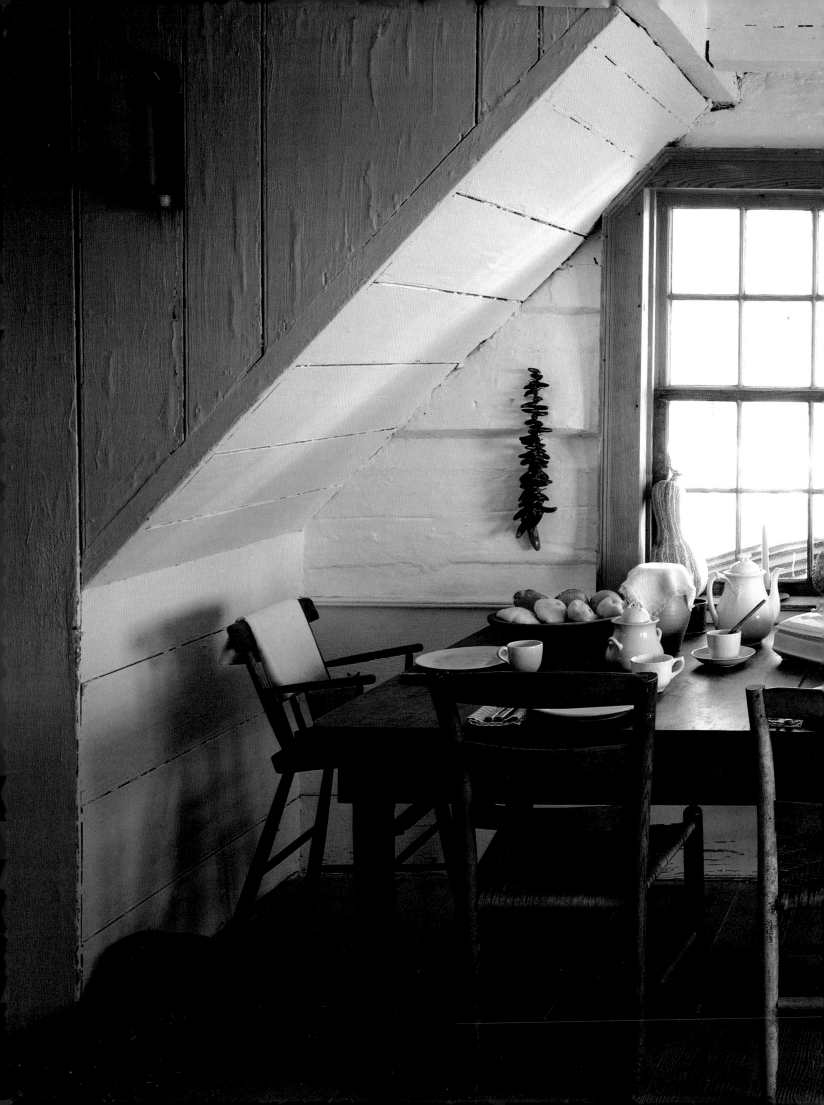

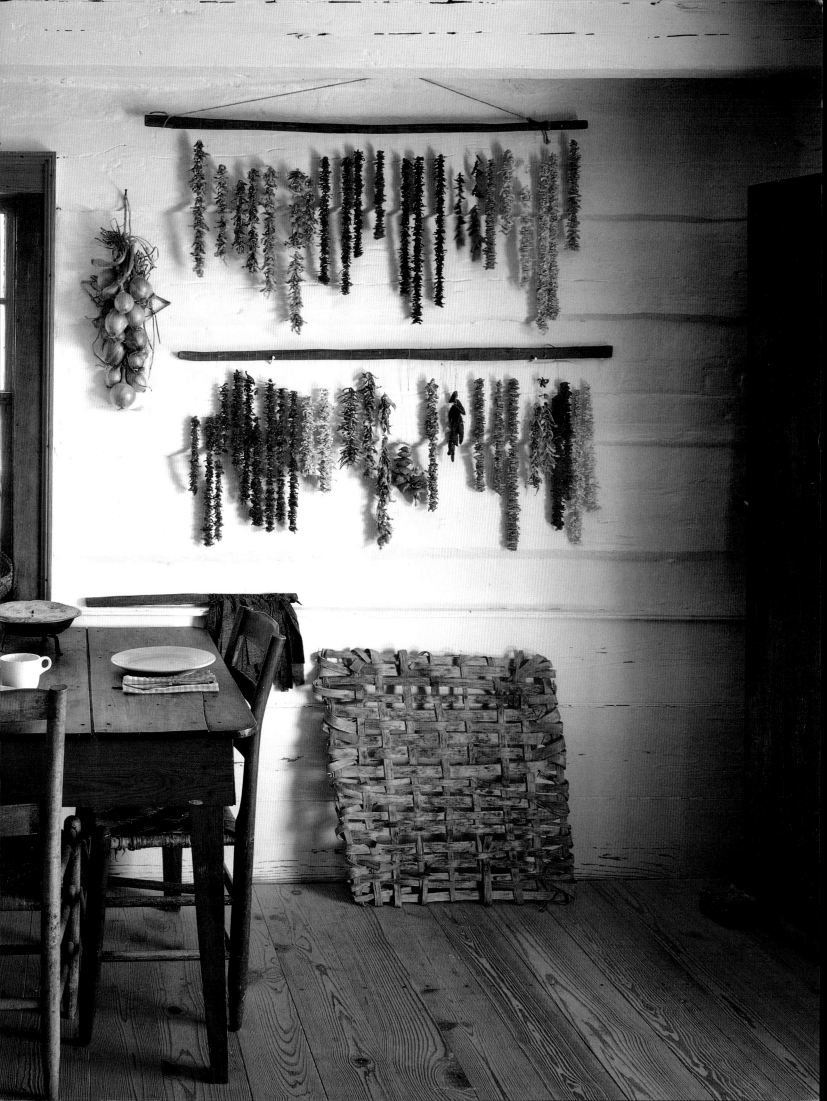

The Valley of Virginia farmhouse's kitchen table is set for a family meal; the staircase above leads to an unfinished pantry. The interior of the log house features whitewashed log walls, exposed and beaded ceiling joists, molded chair rail, and enclosed corner stairwells.

Hanging on racks against the whitewashed wall is part of the harvest from the farm's orchard and kitchen garden. Carefully sliced and dried green beans, tomatoes, peppers, apples, squash, and pumpkin wait to be reconstituted, by being soaked in water, for winter meals.

The Peaks of Otter area, in the Blue Ridge Mountains of Virginia, became a working community when Thomas Wood first settled in the area around 1766. Like many settlers, Wood brought his family from Pennsylvania, and they constructed this cabin on what is now known as the Johnson Farm.

In 1852, John Therone Johnson and his wife, Mary Elizabeth, bought the four-room cabin from James Joplin. The mountain farm they established remained in their family for three generations. With their thirteen children, the Johnsons raised sheep, grew potatoes, and operated a distillery in a nearby hollow, making apple brandy that was sold to a nearby hotel at the Peaks.

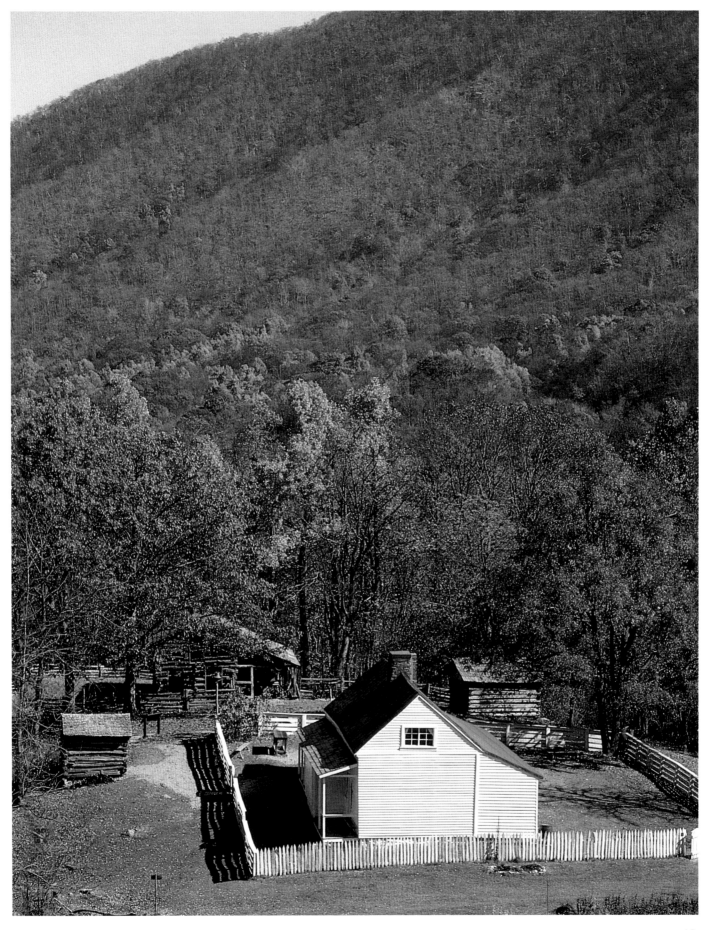

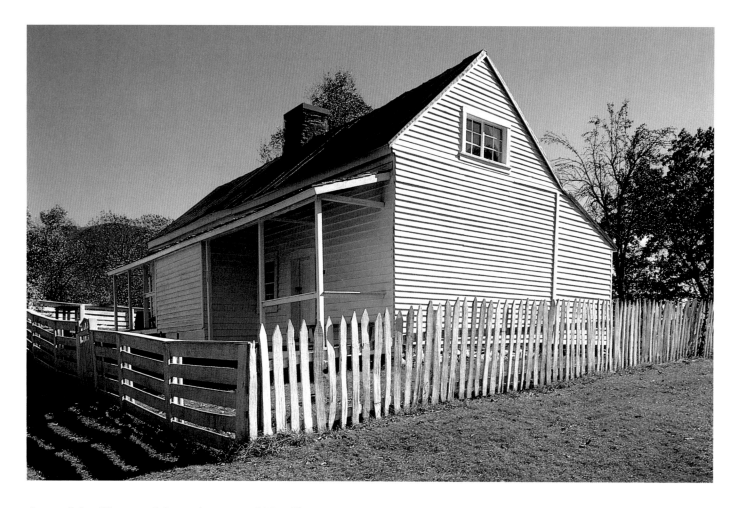

Jason, John Therone Johnson's son, and his wife, Jennie, brought the house to its present appearance with the addition of a dining room, kitchen, and various porches and storage rooms.

After Jennie Johnson's death, their daughter, Callie Missouri Johnson, and her husband, Mack Bryant, became the third generation to farm the same land. Like their parents and grandparents, the Bryants made a living on the farm but also supplemented their income with outside work: Mack served as the local "veterinary," their nine children helped out at the nearby Mons Hotel, and Callie sold flowers from her gardens to the hotel and guests.

After the Blue Ridge Parkway acquired the Peaks of Otter, the last family members sold the farm to the National Park Service in 1941.

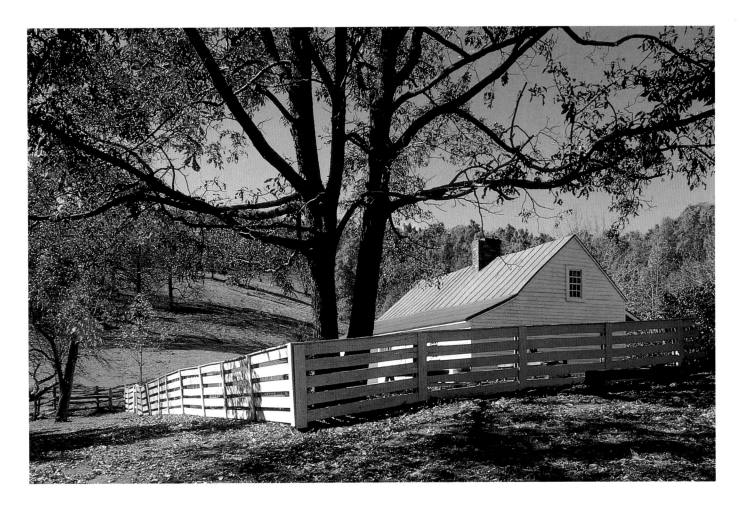

The Johnson's favorite son, Jason, bought the farm from his parents in 1884 and farmed with his wife, Jennie, and their seven children. Although Jason was born with a club foot, he was active in planting and other responsibilities, often working from horseback or on his knees. The family worked with neighbors in large apple and peach orchards on the terraced sides of Flat Top Mountain. The best apples were shipped to England; the rest were made into gallons of apple butter every fall in communal "stirrings." Jason and Jennie also took in guests when the Mons Hotel was overbooked; their children ran errands and served as guides. One son became a doctor and practiced in the community until he was in his eighties.

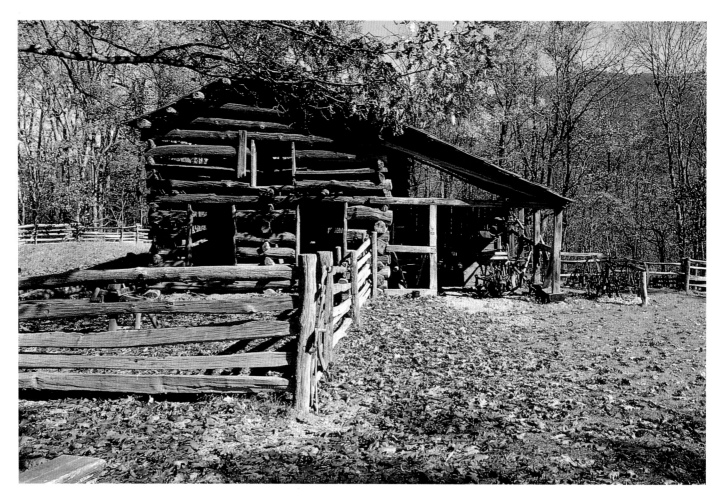

Today, the Johnson Farm's restored buildings include the farmhouse, springhouse, corn house, meat house, and this log barn with farm machinery from the 1930s. The wagon extension was added later to accommodate the growth of the small family farm.

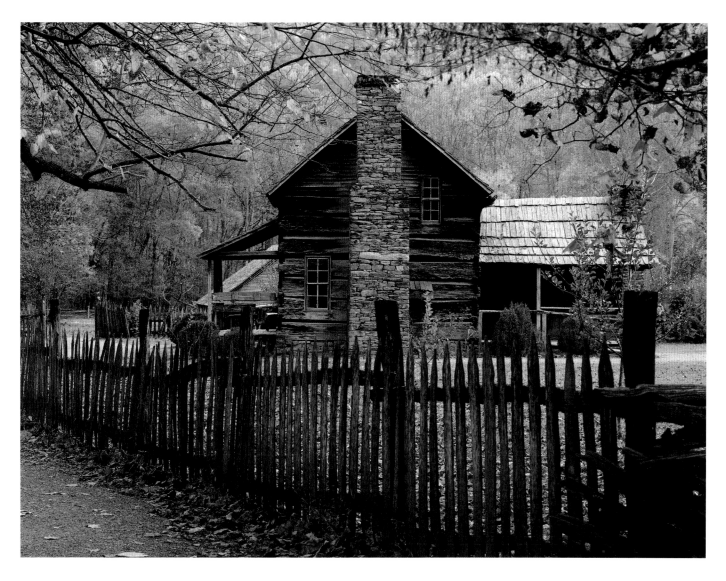

The farmhouse at the Mountain Farm Museum in North Carolina was built in 1901 by John E. Davis, a master craftsman who took the trouble to "match" the log walls—he split a chestnut tree trunk in half, then used matching logs to construct each wall. He was also an itinerant cooper who made and sold barrels, buckets, and churns, and also made furniture.

Davis moved to this area in the 1880s as a renter, eventually marrying and buying land of his own. He built the farmhouse over two years in his spare time from trees cleared from the house site, choosing to build with logs over readily available lumber from sawmills for reasons that may have included his desire to use the trees cleared from the site and to do the work at his own convenience.

This was home for Mr. Davis, his wife, and their five children (three of whom the Davises put through college). On the first floor are a front room or main living area, which typically included one or more beds, a kitchen addition, and a small partitioned-off bedroom. The upstairs is one large open room. While the house may seem small by modern standards, rural families spent a great deal of time away from the house on chores in every season, so it probably did not feel crowded. In addition, the porch served as another room in warm weather.

The Davis family lived here for seventeen years, then sold the house to Joe Queen, whose family eventually made the house available to the Mountain Farm Museum, where it was moved in the early 1950s.

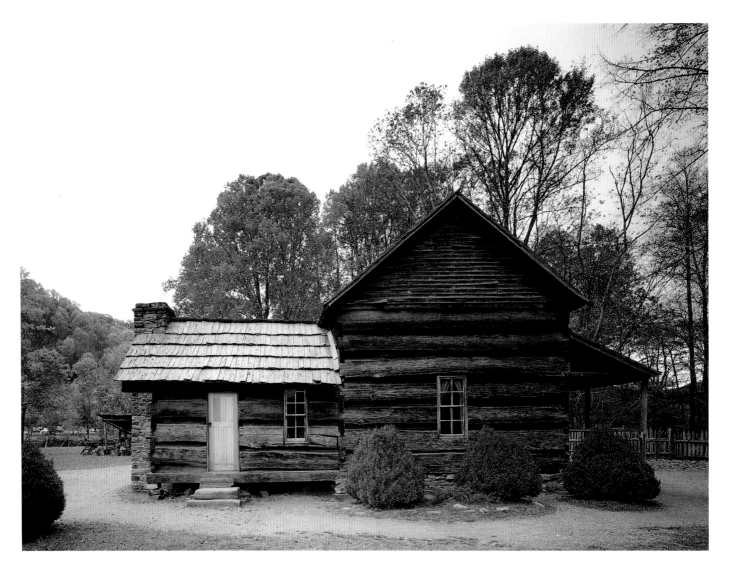

The south side of the Davis-Queen farmhouse shows the kitchen addition at the rear. The house is raised on stone piers and does not have a cellar. The rocky ground in this region made digging root cellars hard work, so some families dug an opening into a hillside and finished it with a roof and door to serve as a "tater cave."

A closer view of the same side of the Davis-Queen farmhouse shows the chinking that John Davis used between the chestnut logs. In the late 1950s, he recalled that he did not use mud daubing, which required annual maintenance because it dried out, was bored into by insects, and washed away in hard rains. Instead, he used rived boards, or long pieces of wedge-shaped wood, like long shingles, and inserted them into the chinks.

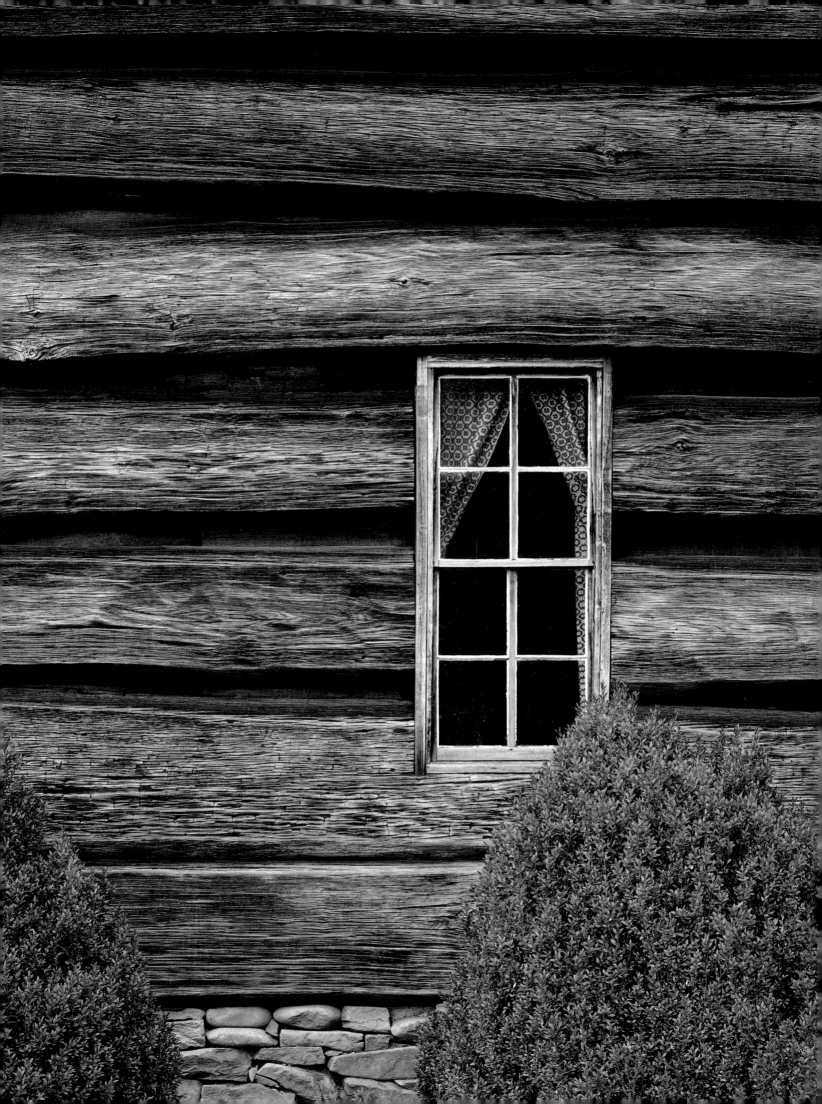

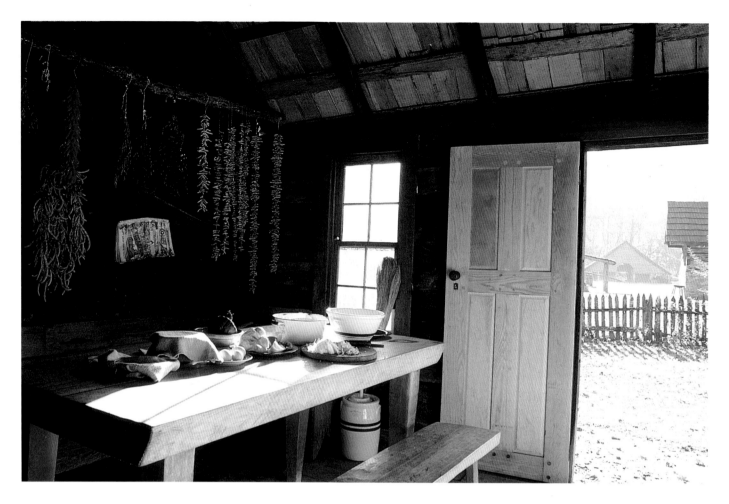

The Davis and Queen families cooked on the kitchen hearth while they lived in the house—neither household chose to buy a cookstove. As a result, the heat from the embers kept the kitchen warm year-round, and warmer than comfortable in summer. The kitchen's two doors and window helped provide cooling cross ventilation.

The heat from the kitchen fire may be part of the reason that there is no direct access from the kitchen to the house. Another reason is probably structural. In log construction, the walls are the load-bearing supports. Fewer doors meant sturdier walls.

Two of the Davis boys—aged four and eight—helped their father by collecting stones for the chimneys with an ox-drawn sled. Fieldstone chimneys were typically dry-laid without mortar. Mud, when used, served merely as daubing to fill in the chinks between rocks to improve the chimney's draft. This is a view of the north gable end.

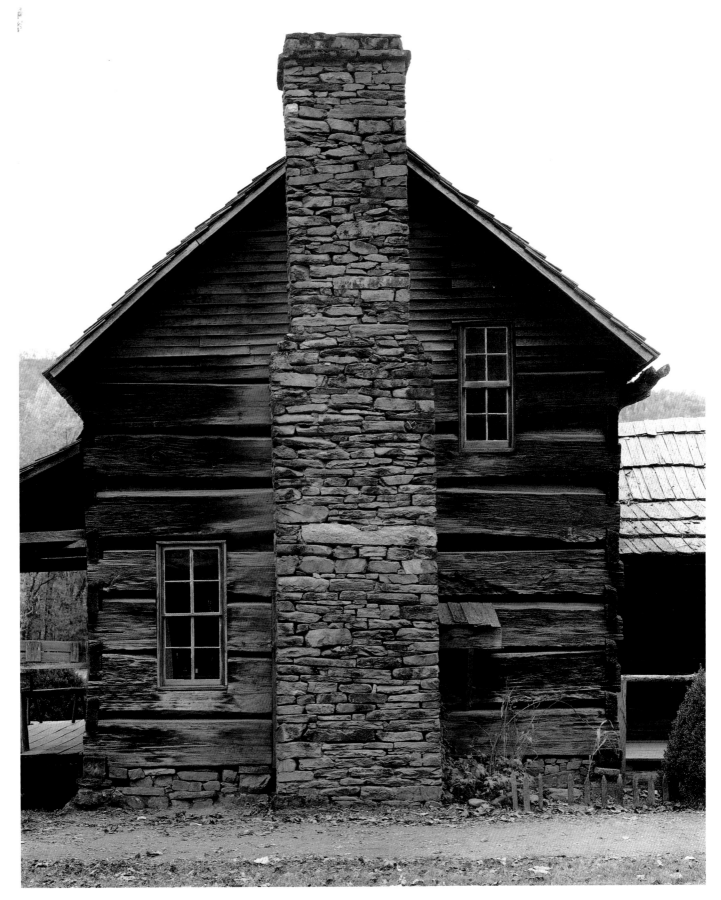

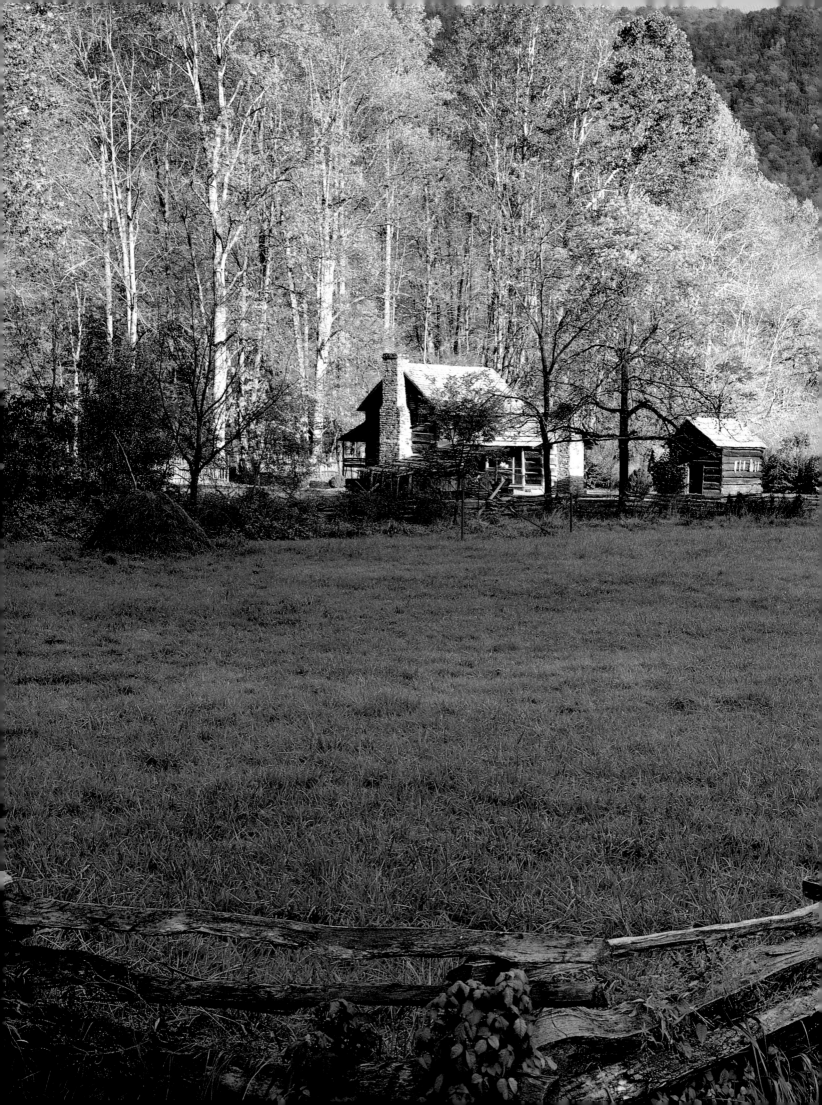

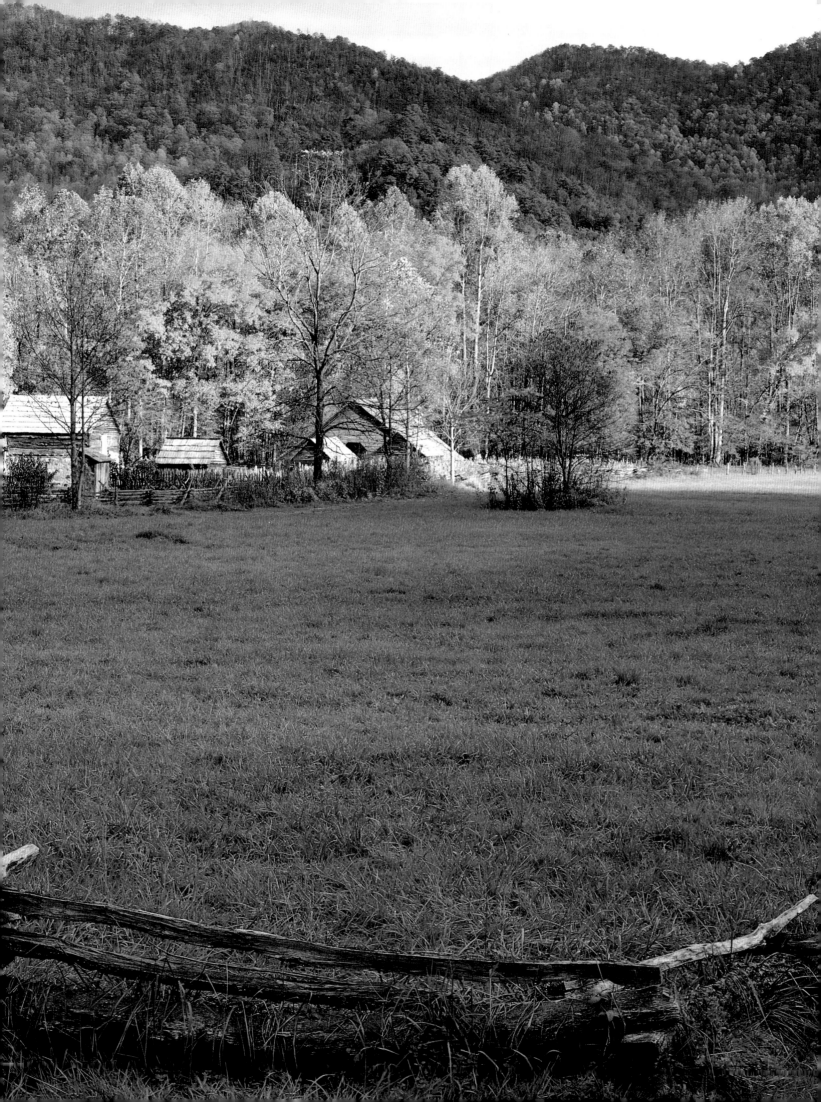

preceding pages

In the late 1700s, pioneers moved from the valleys of Pennsylvania and Virginia and the Carolina lowlands into the river valleys of North Carolina, including this valley of the Oconaluftee River. The settlers, about a third of whom were second, third, or fourth generation Scotch-Irish families, found their way here, where they met Cherokee people. The Smokies were a small part of the Cherokee territory.

The view from the barn at the Mountain Farm Museum looks out to the corn crib and gear shed (on the left), another corn crib, and the chicken house and apple house in the distance. The corn crib and gear shed was a dual purpose building where the farmer stored corn and kept equipment including sleds for transporting stone, plows, wheat cradles, yokes, harnesses, and corn husk collars.

The two-story apple house was built into a hillside on its original site, providing direct access to both lower and upper floors from ground level. The apple house held summer apples on the upper floor, and firmer winter apples below. The thick rock walls below the log construction helped insulate the apples in freezing and hot weather.

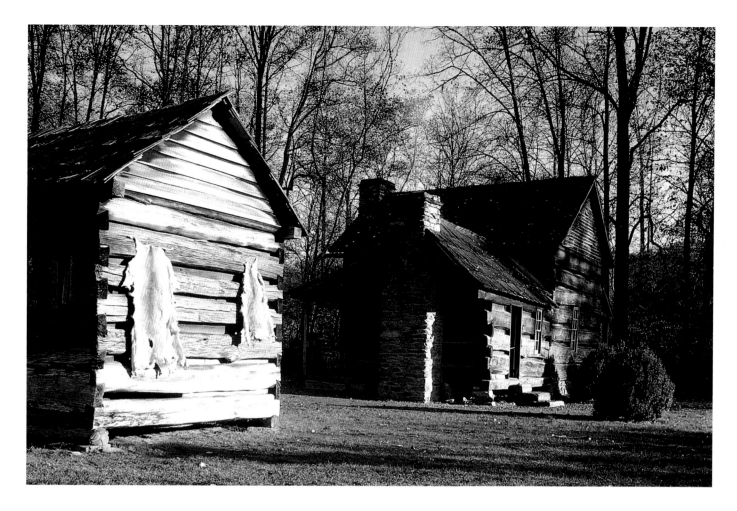

Cured meat, primarily pork from farm-raised hogs
and also game such as bear and venison, was stored
in the meat house. Hogs were favored as a source of
meat because they were so self-sufficient. Farm
families turned their hogs loose to root in the woods
all summer, then herded them in the fall for
slaughtering.

In this log meat house, meat was covered with salt, a
precious, purchased commodity, after butchering
season in cold weather. In the spring, the meat was
typically coated with pepper, salt, and molasses, then
smoked to form a hard crust. Chemical ingredients in
the smoke and pepper helped retard the growth of
bacteria. When the meat was cured, it was hung from
poles spanning the interior of the meat house, or
placed back on the shelves.

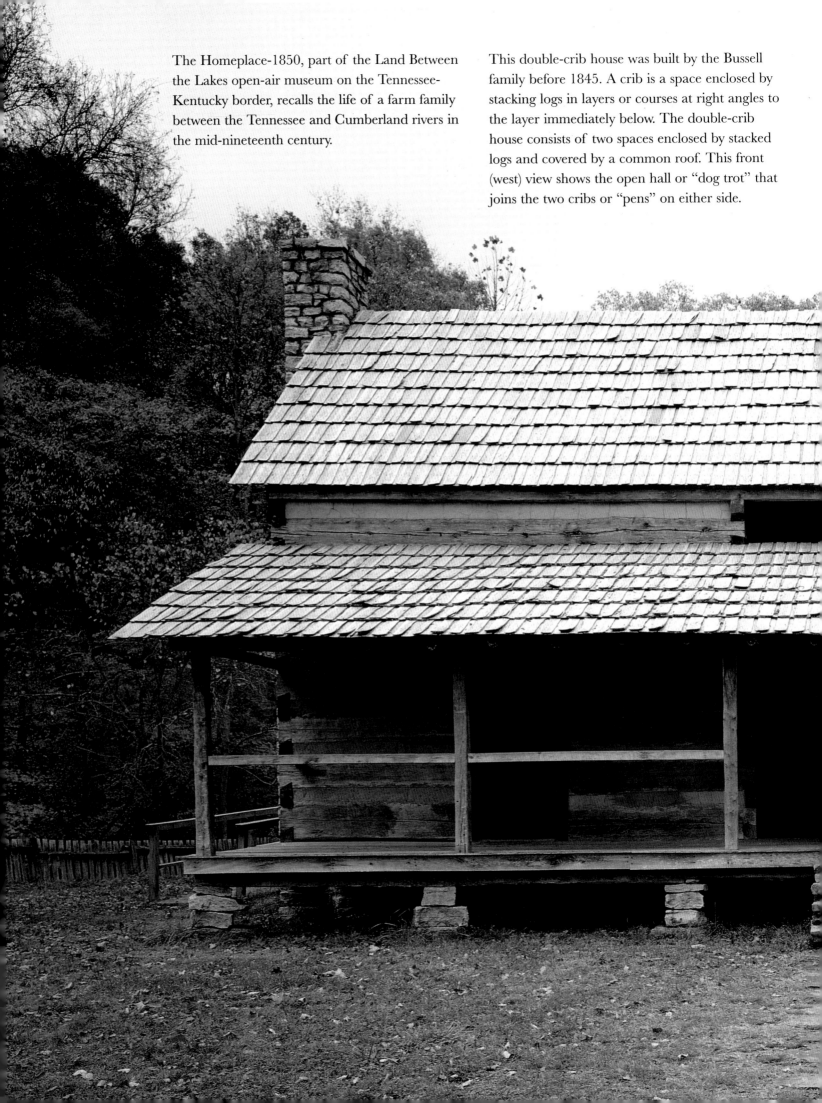

The Homeplace-1850, part of the Land Between the Lakes open-air museum on the Tennessee-Kentucky border, recalls the life of a farm family between the Tennessee and Cumberland rivers in the mid-nineteenth century.

This double-crib house was built by the Bussell family before 1845. A crib is a space enclosed by stacking logs in layers or courses at right angles to the layer immediately below. The double-crib house consists of two spaces enclosed by stacked logs and covered by a common roof. This front (west) view shows the open hall or "dog trot" that joins the two cribs or "pens" on either side.

The dog trot was favored in the South because it made an airy, cooler place for the family to eat or do chores in warm weather. The family could also enjoy resting on the full-length porches on the front and back of the house. There are five rooms altogether: a main front room (where the family dined and the parents slept), a parlor, a girls' room, a boys' room, and a kitchen addition in a separate crib on the back of the main house.

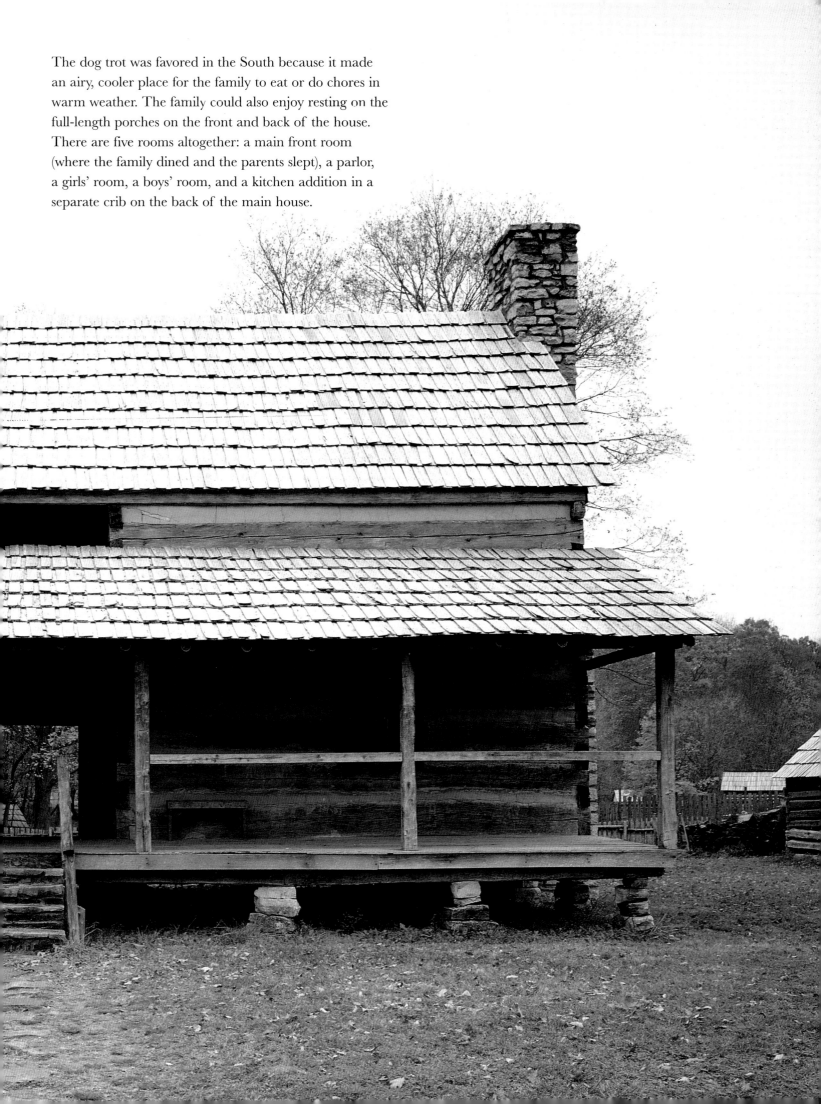

The back (east) view of the double-crib house shows the main log house with the kitchen addition on the right. The roof extends over an open space between the main house and the kitchen, creating an open hall area in the back porch that runs the length of the building. The construction of the kitchen addition is typical of the area, with log walls and clapboard gables.

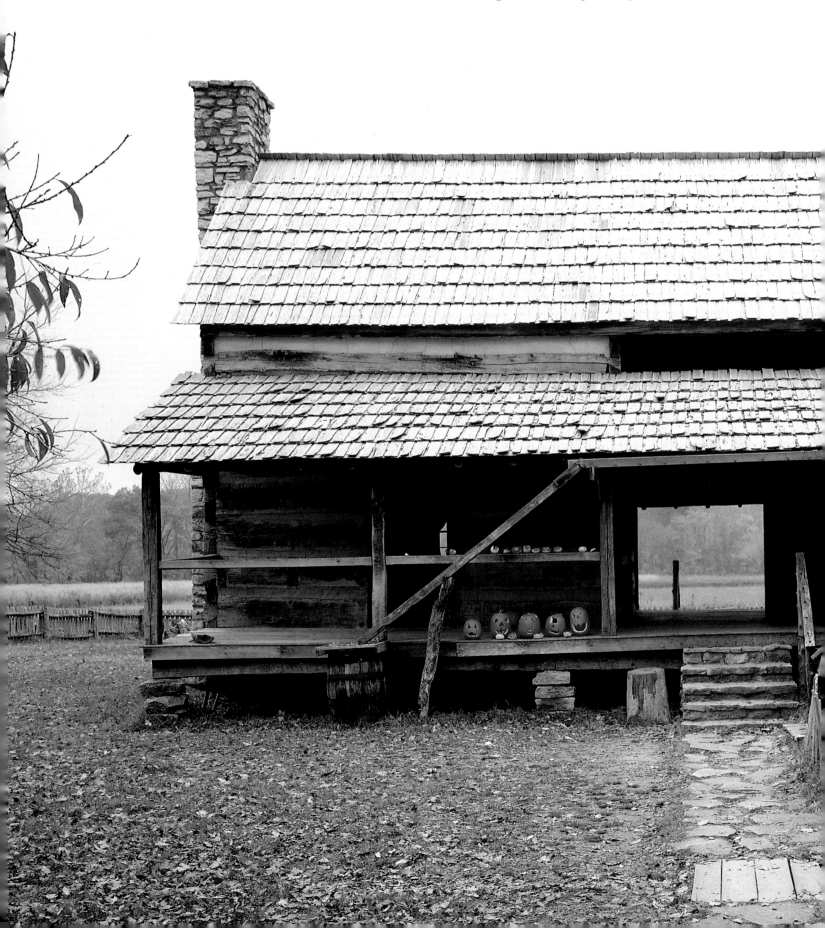

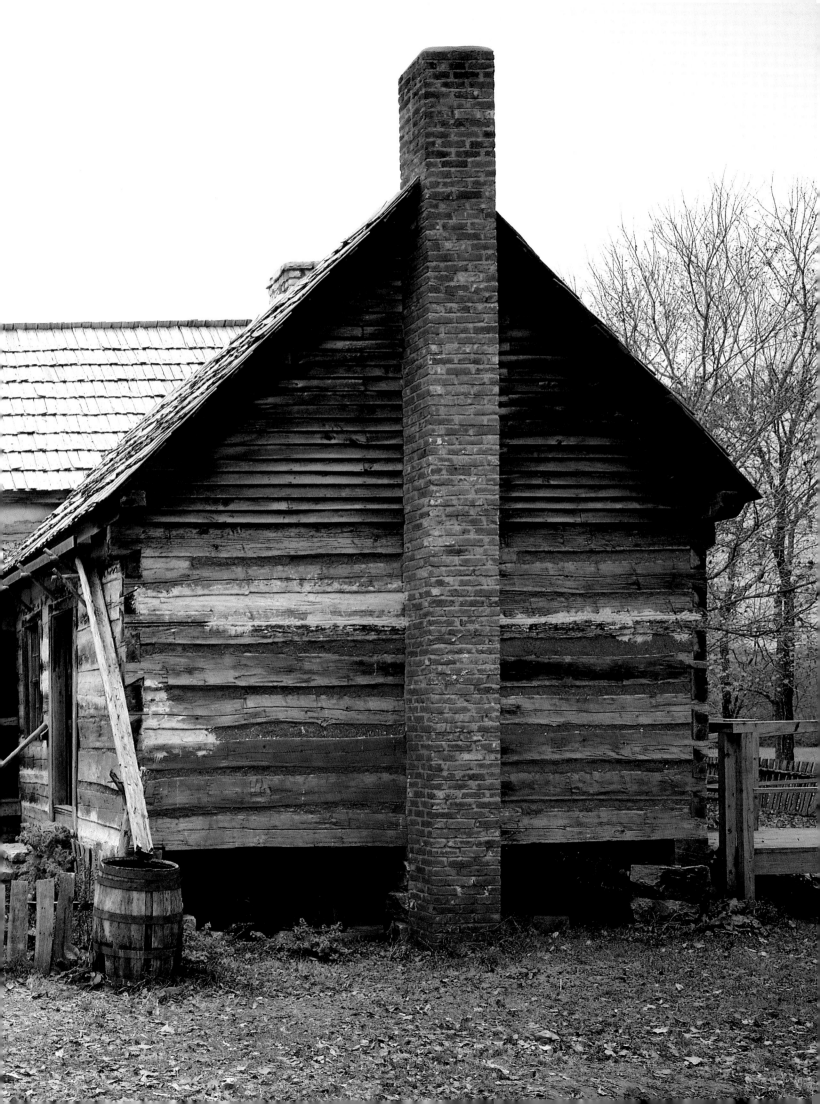

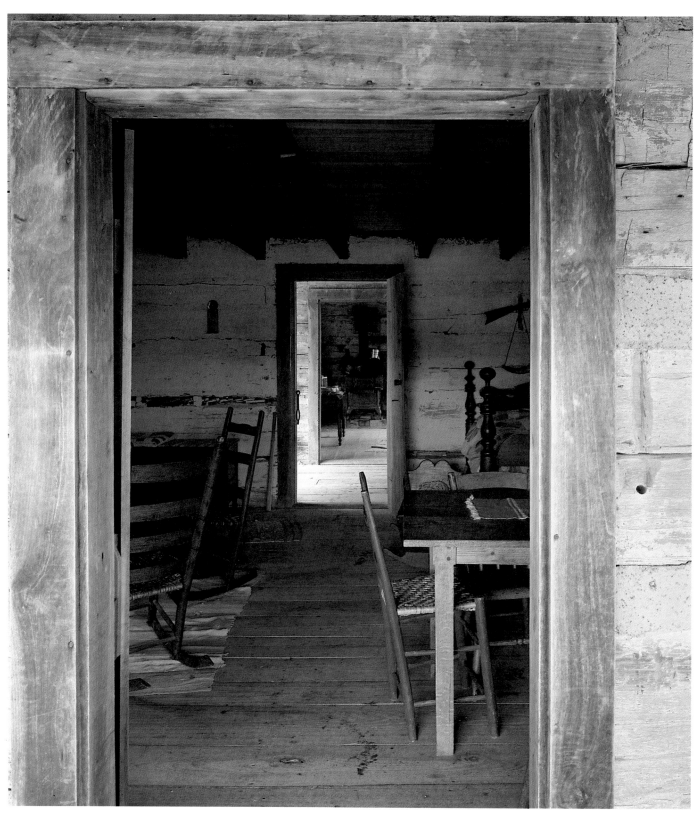

A view through the door of the double-crib house looks into the main living area, a combination dining room and bedroom, through the open hall, and beyond into the kitchen addition.

opposite

A homemade corn-husk mop rests in the kitchen door of the double-crib house. Holes in a board were filled with bundles of twisted corn husks, which provide an abrasive texture that effectively loosens dirt.

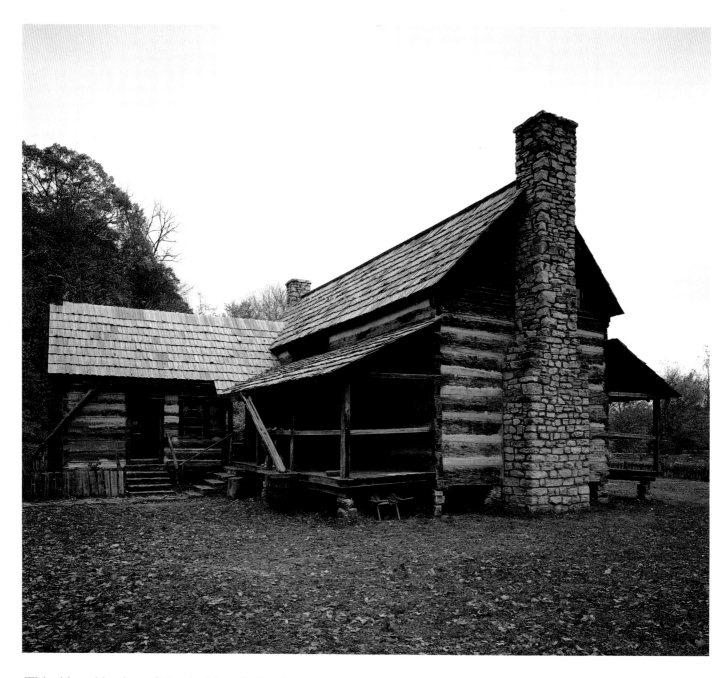

This side gable view of the double-crib farmhouse shows the rubble-stone chimney, which is built outside the house, as was usual in the southern states. The upper story, which contains two windowless bedrooms, is accessible only through a staircase in the open dog trot passage. Visible in the background is the smokehouse; after meat was cleaned and salted, it was cured in the smokehouse for two to six weeks. Because of the value of good meat on the frontier, the smokehouse was the only building on the farm to be kept locked.

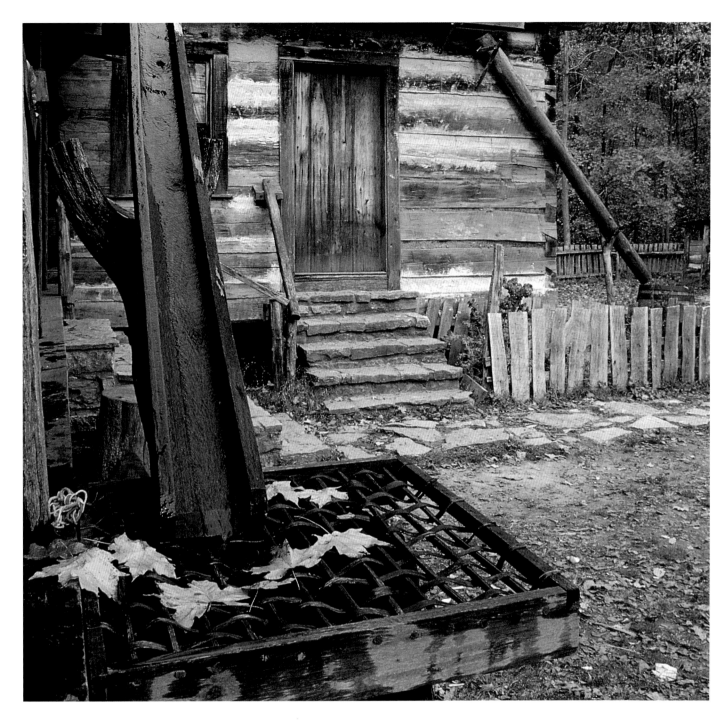

Drain gutters on the back side of the double-crib
farmhouse channel rain water into a barrel. Rain
water was used primarily for washing and laundry.
The "leaf screen" is actually a rack used for drying
wool or vegetables. It doubles as a screen to keep
debris out of the rain barrel, although that is not its
primary function.

following pages
The kitchen of the double-crib house is furnished
with a cast-iron cookstove, which brought the business
of cooking off the floor of the hearth to a more
comfortable waist height. The ladder leads to the loft
over the kitchen, which serves as additional storage
space for foodstuffs and kitchen supplies.

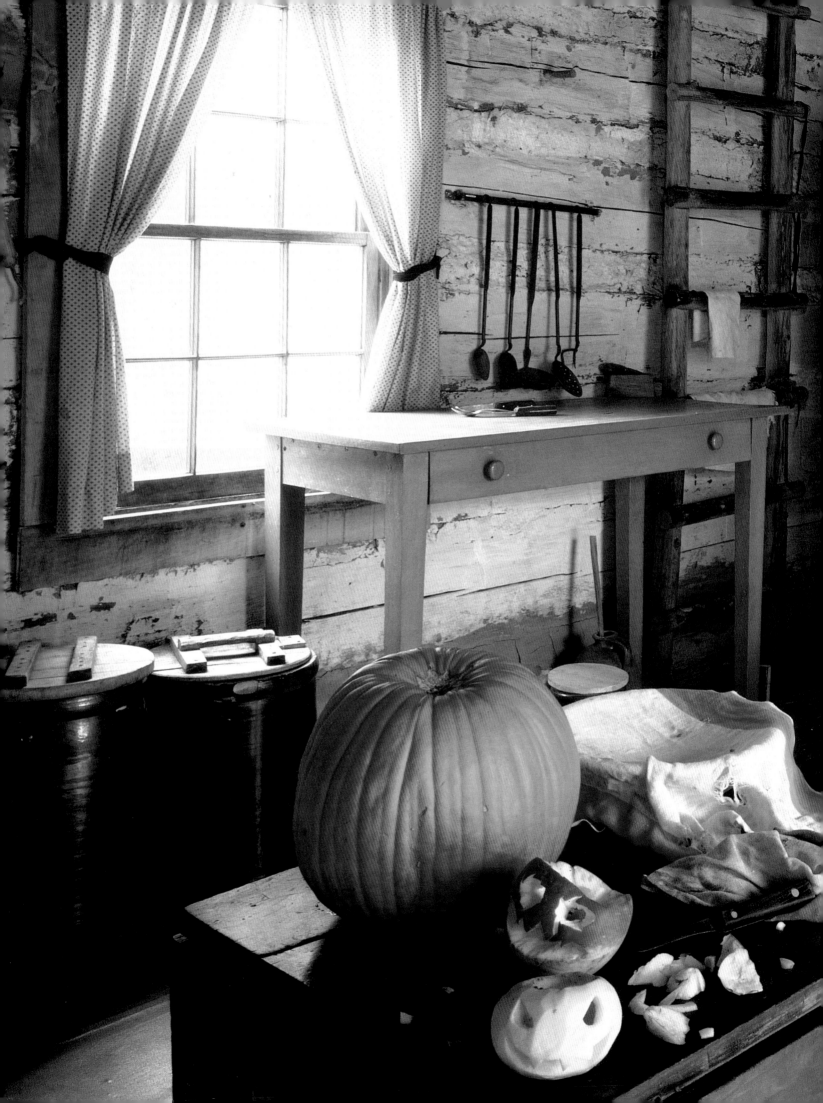

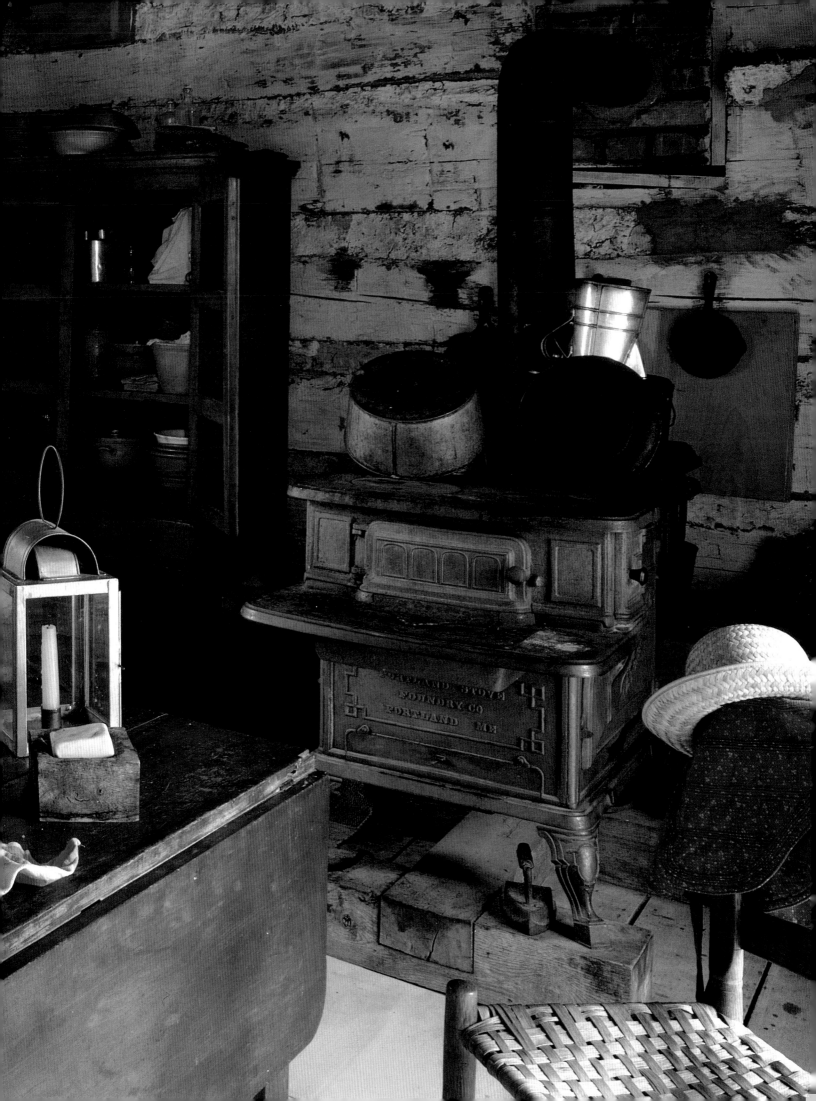

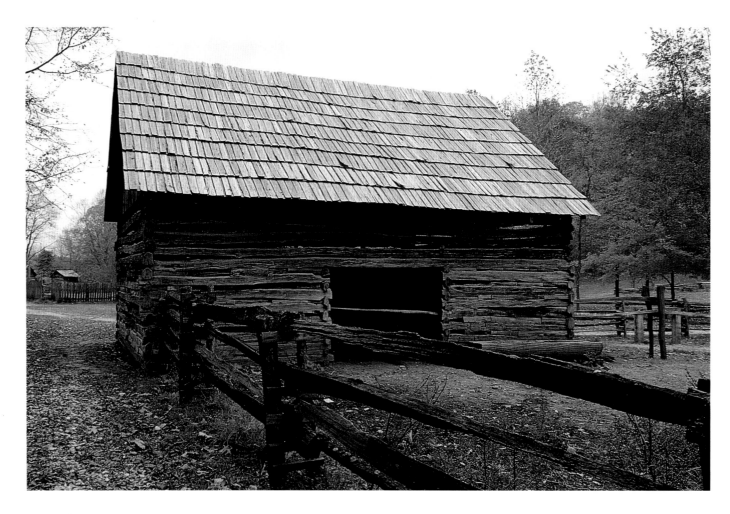

In addition to the double-crib house, the Homeplace has more than a dozen other period farm buildings, including four barns for different purposes. Horses were the favored draft animal in this area in the mid-nineteenth century; this horse barn is typical of the double-crib type in the area between the Tennessee and Cumberland rivers.

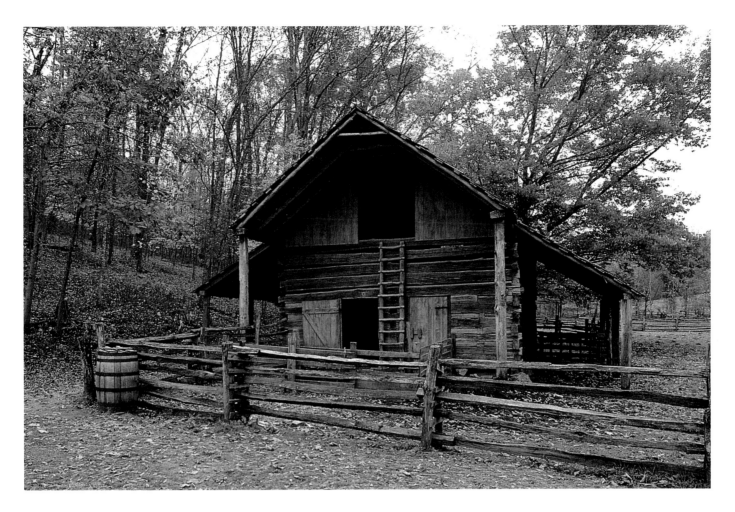

The ox barn was used in several different ways. Hay and straw were stored in the loft and corn fodder, or stalks and leaves, in the two back cribs. Cattle were fed from mangers in the two front cribs. Oxen were primarily used as draft animals for the heavy work of hauling logs and pulling stumps as the forests were cleared to make fields for corn and tobacco crops.

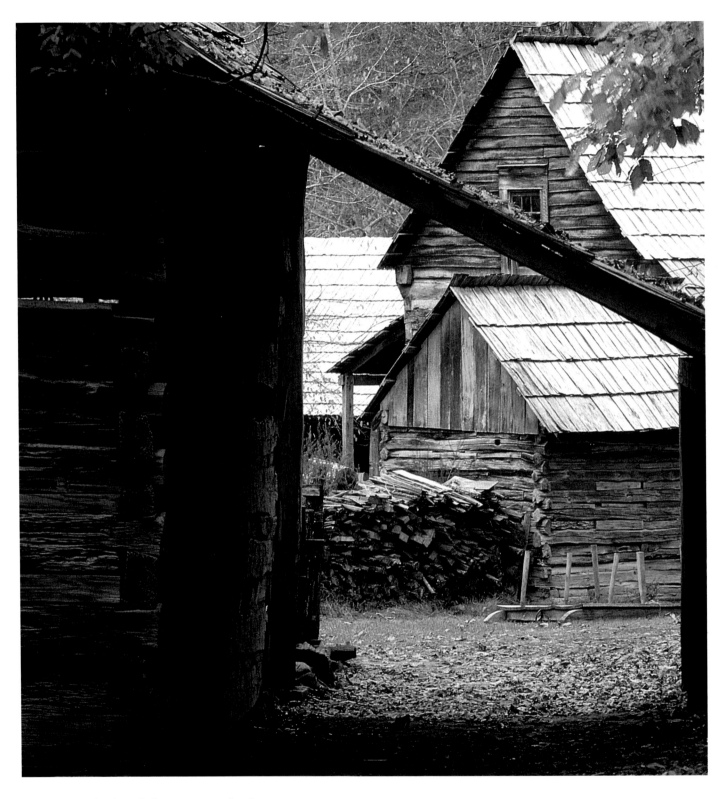

One-room single-crib houses were the first permanent
shelters built by the region's early settlers. Understandably,
the families built bigger and more comfortable homes as
soon as they could, so most single-crib houses have been
lost to time and decay. This example was constructed of
original materials from about seven buildings.

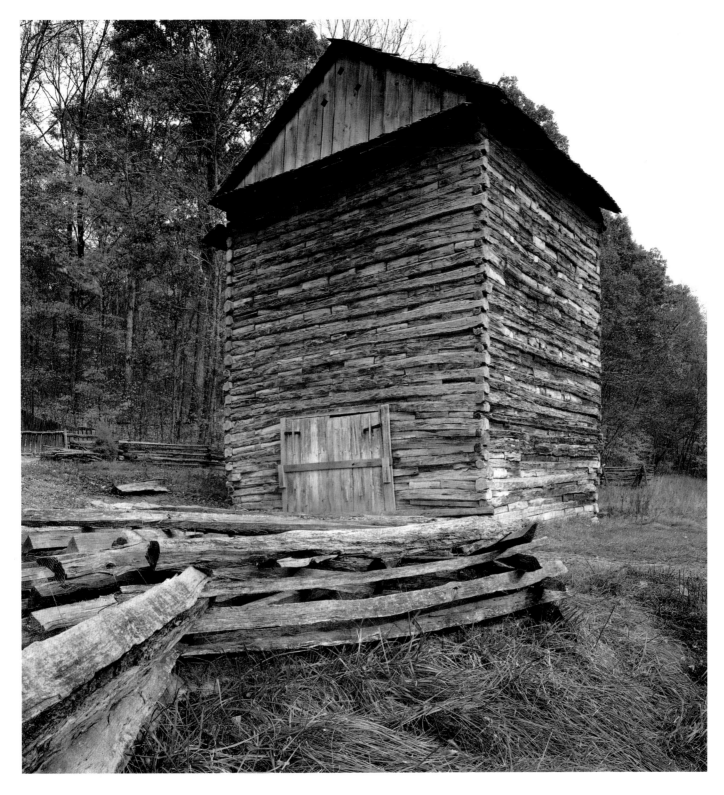

The tobacco barn at the Homeplace is typical of barns built in the mid-nineteenth century to cure dark-fired tobacco, although it is about twice as large as earlier examples. By 1850, tobacco was becoming an important commercial crop in this area, moving west from the Piedmont.

Dark-fired tobacco is cured, or dried, by the heat and smoke of small fires built on the earthen floor of the tobacco barn. The barn functions like a chimney: the heat and smoke are drawn upward through the hanging tobacco, drawing the excess moisture from the leaves, stems, and stalks of the plants.

Cobblestone Farm in Ann Arbor is an outstanding example of a pioneer Michigan farm house that has survived virtually unaltered by time. The cobblestone house was built in 1844 in the Classic Revival style. It was owned by Dr. Benajah Ticknor, a U.S. Navy surgeon who invested in this Michigan farm while his work took him on tours of duty in the Mediterranean, South America, Southeast Asia, and China. Dr. Ticknor sent his brother, Heman, to buy the land and manage it for him.

In 1835 Heman Ticknor bought 183 acres of land and moved into a small frame house with his wife and seven children. That portion of the house probably exists today as the dining room and servant's room of the wooden kitchen wing. In 1844 Dr. Ticknor ordered the construction of the cobblestone addition and the kitchen ell. This outstanding example of cobblestone construction was inspired in part by the area's abundance of small boulders left thousands of years earlier by a retreating glacier.

In 1881 the farm was sold to William Campbell. Three generations of Campbells worked the 225-acre farm and kept the house essentially unchanged for the next ninety-one years. The house was recorded in the Historic American Buildings Survey of 1936 and placed on the National and State Registers of Historic Places in 1972. In 1993 the house was repainted its original cream color, based on paint analysis.

Today, the house interprets the period from 1845 to 1860, when Heman Ticknor and his family lived there full time and Dr. Benajah Ticknor moved back and forth between this home and his travels.

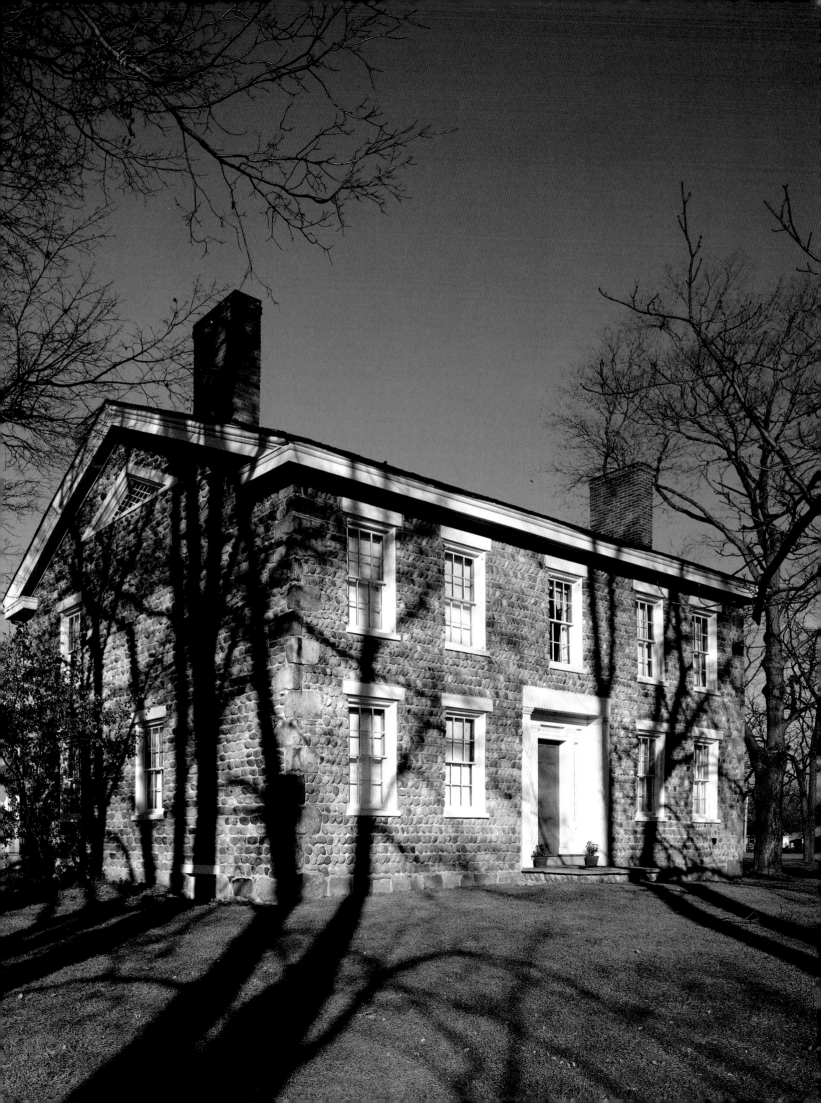

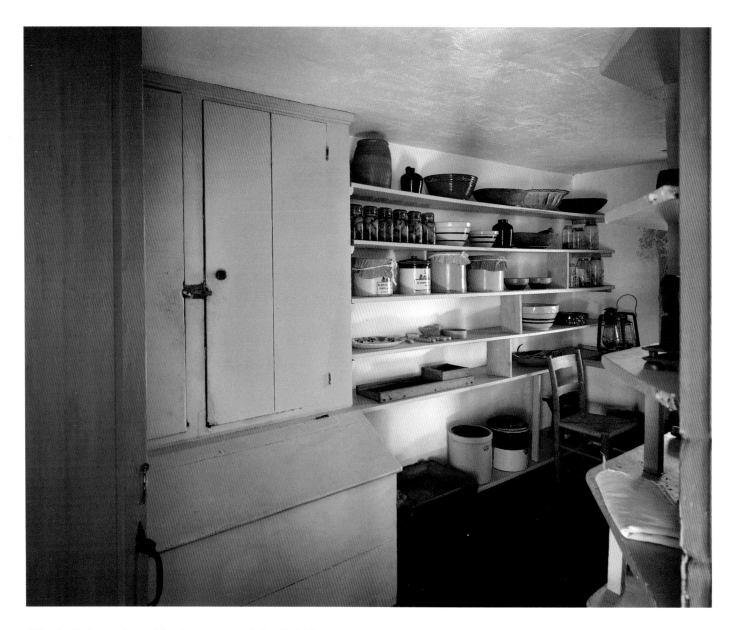

The built-in cupboard in the pantry of the Cobblestone
farmhouse provided storage for preserves in the upper
section, over bins for flour and sugar below. The crocks
and glass jars are characteristic containers of the period.
The tray-like object on the bottom shelf is a butter
worker, used to remove all traces of buttermilk from
newly churned butter. The wooden item on the shelf
above is a slaw cutter, or encased blade for efficiently
slicing cabbage into sauerkraut.

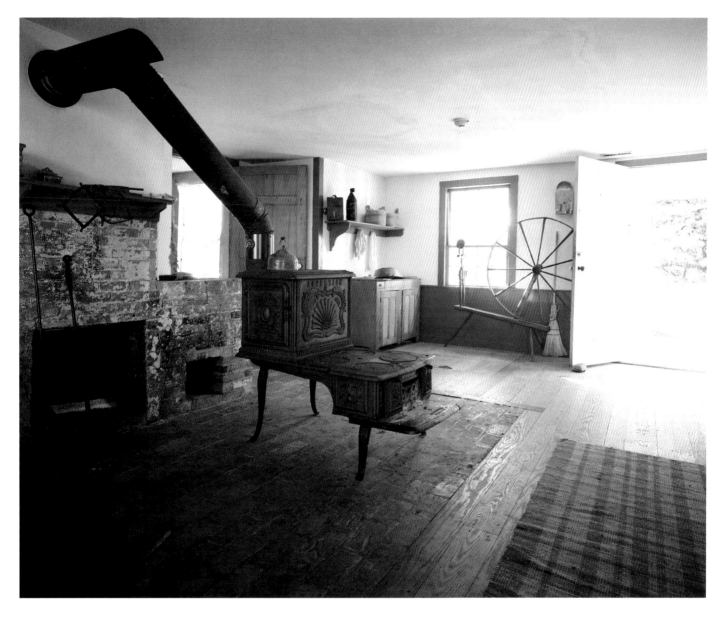

The first floor of the kitchen ell of the Cobblestone farmhouse contains the original dining room, kitchen with fireplace and bake ovens, pantry, milk pantry, wash room, privies, and wood shed. A trapdoor with a leather handle provides access to a stone-lined cistern in the floor, a convenient source of water right in the kitchen. The large, built-in arch or set kettle was used for steaming puddings, cooking vegetables in quantity, and the like.

The 1861 Jewett and Root "Sovereign" cookstove is of the type used by the Ticknors during the period. The deep brick hearth helped to reduce the danger of fire from embers falling onto wooden floorboards. The spinning wheel belonged to the Campbell family.

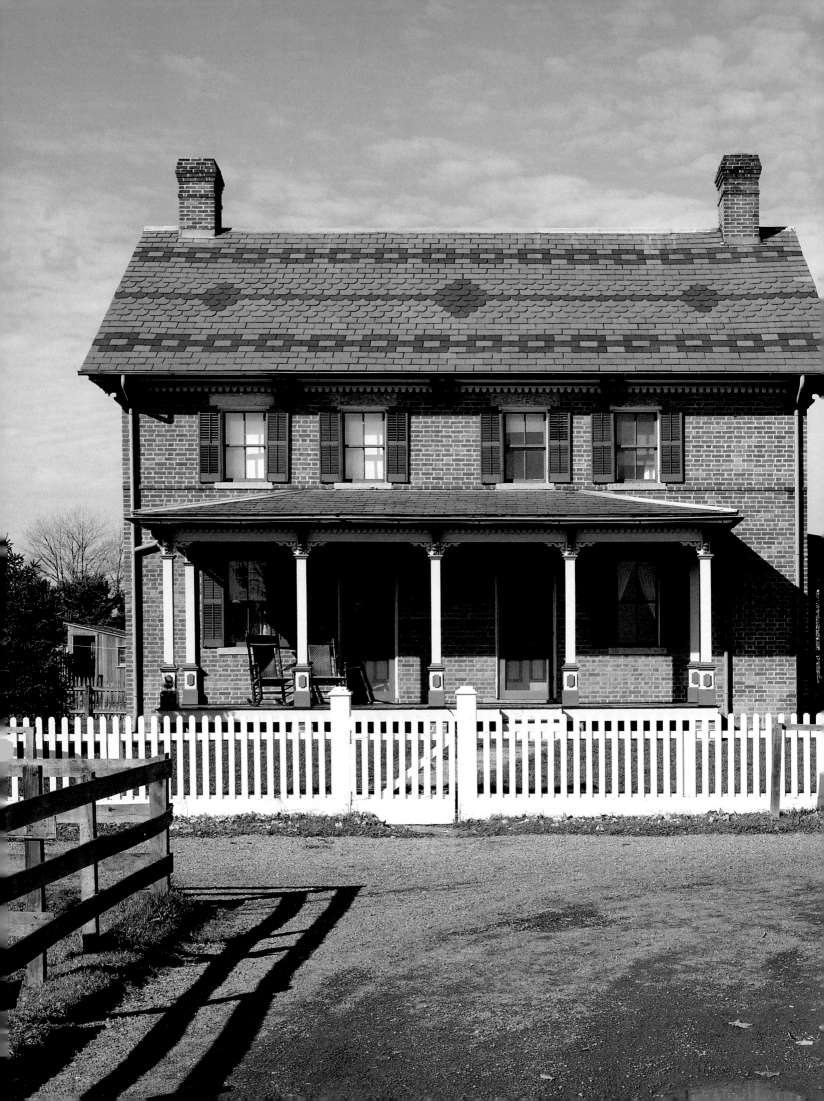

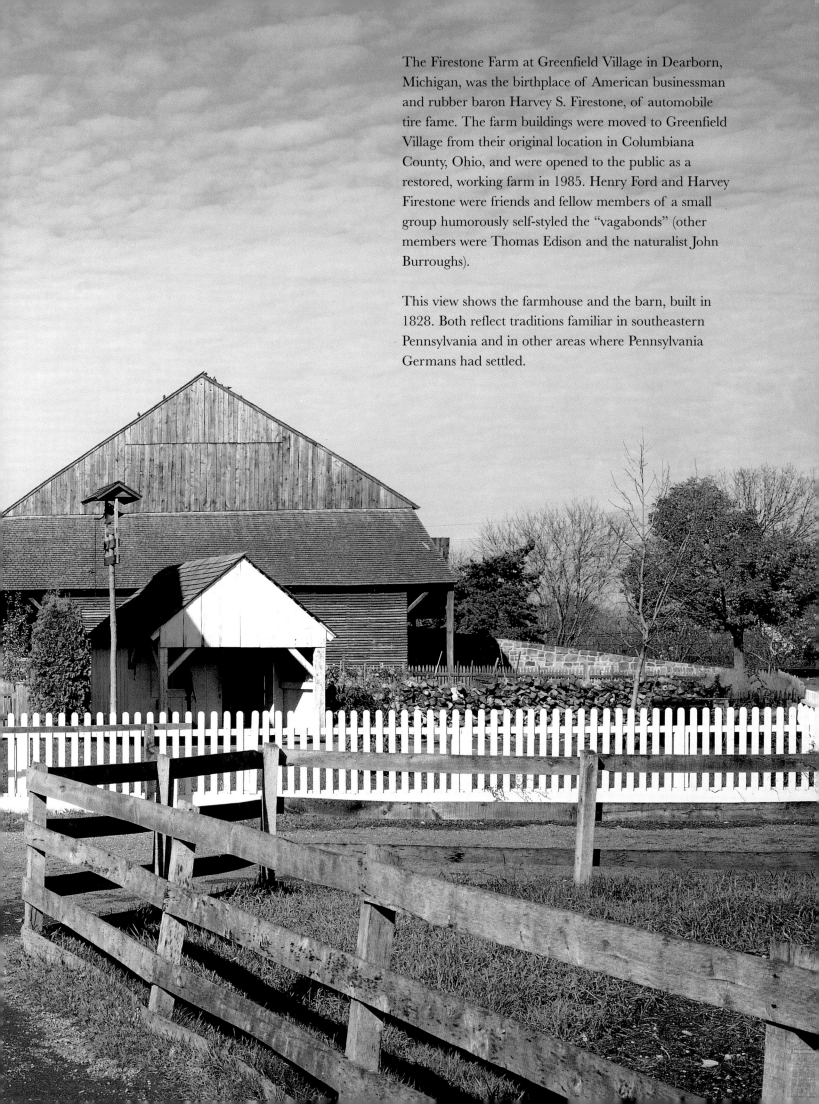

The Firestone Farm at Greenfield Village in Dearborn, Michigan, was the birthplace of American businessman and rubber baron Harvey S. Firestone, of automobile tire fame. The farm buildings were moved to Greenfield Village from their original location in Columbiana County, Ohio, and were opened to the public as a restored, working farm in 1985. Henry Ford and Harvey Firestone were friends and fellow members of a small group humorously self-styled the "vagabonds" (other members were Thomas Edison and the naturalist John Burroughs).

This view shows the farmhouse and the barn, built in 1828. Both reflect traditions familiar in southeastern Pennsylvania and in other areas where Pennsylvania Germans had settled.

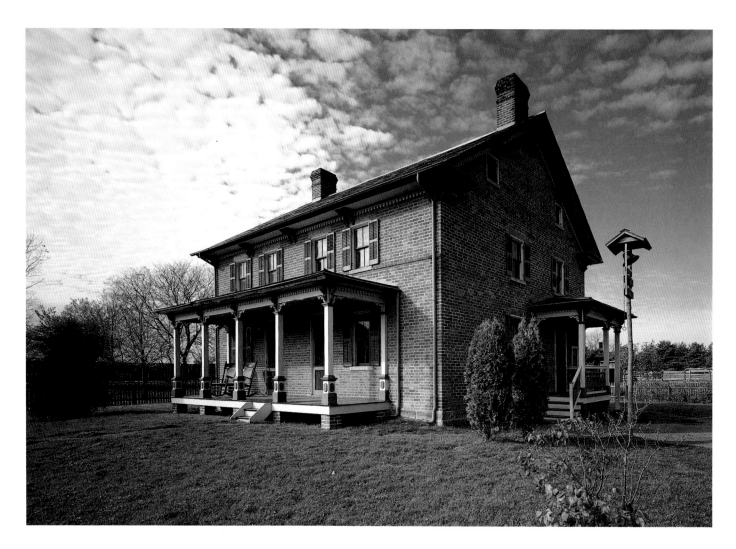

When it was built in 1828, the Firestone farmhouse was a very traditional "four over four" Pennsylvania German farmhouse, with four upstairs rooms over four downstairs rooms. The double front doors are the distinctive feature of the exterior.

The rooms on the first floor had mixed public and private uses: the *kuche*, a large kitchen that also served as a casual eating area; the *stube*, a more formal living, dining room, and parlor; and the *kammer*, a sitting room or bedroom in the back of the house.

Four interconnected bedrooms on the second floor opened into each other in a way that did not allow for privacy. The interior of the house featured exposed wooden ceiling joists and wooden board walls painted in bright, chalky colors.

The Firestones remodeled the house extensively in 1882, eliminating the vestiges of its Pennsylvania German origins and providing a modern appearance, from the ornamental front porch and roof slates to stylish wallpaper and dropped plaster ceilings inside.

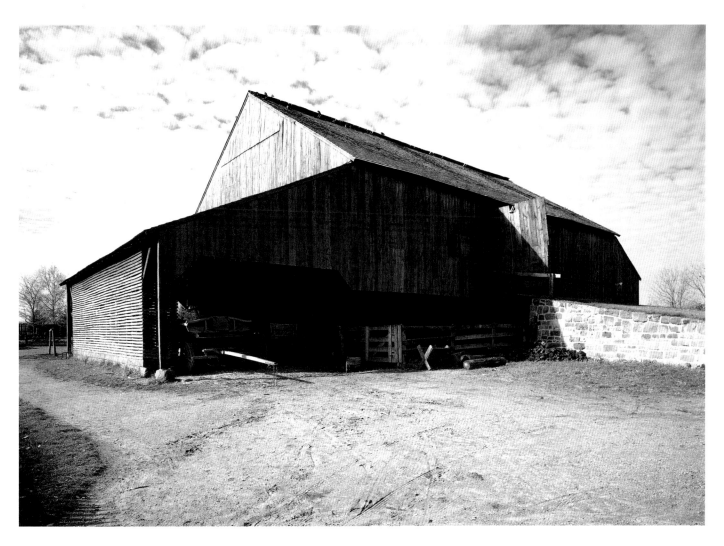

The large barn built by the Firestone family in 1828 was very close to the Pennsylvania German barn-building tradition. It is also typical of those built in eastern Ohio. Such barns were large two-story structures with threshing floor, granaries, and hay mows on the upper level over stalls for livestock below. If the barn could not be sited against a natural hillside, an earthen bank or ramp was constructed to allow the farmer to drive a team and wagon into the upper floor, giving barns like this the common name of "Pennsylvania bank barns."

The Firestone barn was made of hand-hewn white oak posts and oak and beech beams, cut from the Firestones' land, and sided with oak boards prepared in a nearby water-powered sawmill. The drive-through corn crib and machinery shed, on the left, is a distinctive part of many Pennsylvania German barns. The barn is also distinguished by having a double fore-bay, the portion of the upper section that hangs over the lower section. Generally, there was one fore-bay, on the side without the ramp or bank. The Firestone barn has a fore-bay on each side.

The gable end of the Koepsell farmhouse, built about 1858 and now part of the Old World Wisconsin open-air museum, shows the distinctive German *Fachwerk* half-timbered construction. Heavy framing with diagonal bracing is filled with brick to form a strong, continuous wall. This method of framing had been used in Europe since the Middle Ages; it first appeared in America in German settlements in Pennsylvania and Virginia but was soon supplanted by American styles. The great nineteenth-century waves of German immigration introduced *Fachwerk* construction to the Midwest, where it was used for several generations.

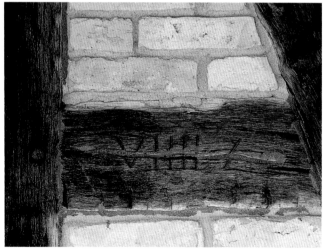

The Roman numeral nine is carved into one of the farmhouse's framing timbers. American farm buildings were raised after the frame was cut and measured—hand-cut marks like this ensured the proper arrangement of timbers when the community came together to raise the structure.

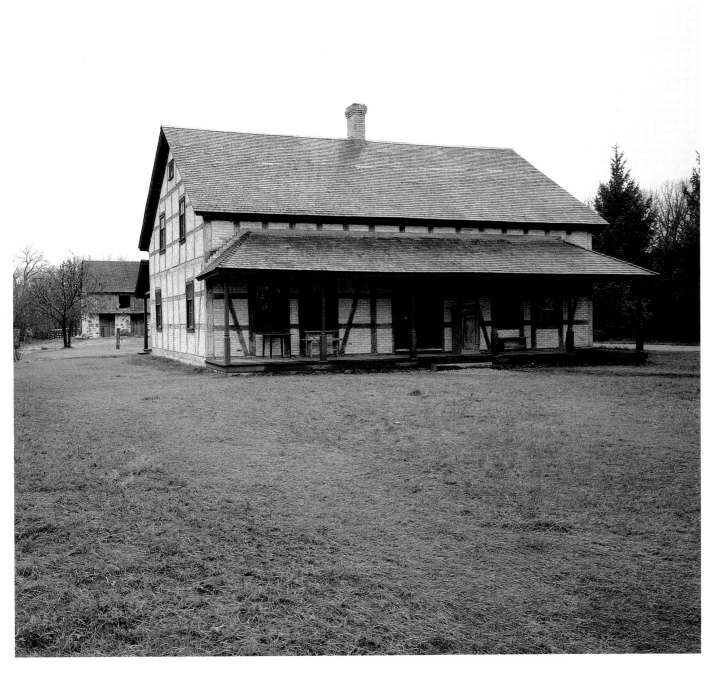

By 1839, several hundred immigrants had journeyed from Milwaukee into the countryside to establish Wisconsin's first German agricultural community at Freistadt. These Pomeranian-born farmers led the way for the more than 700,000 Germans who lived in Wisconsin by 1900.

This farmhouse was built around 1858 in the town of Jackson in Washington County by Friedrich Koepsell, a carpenter and master builder, and was home to a Pomeranian family for many years.

The first German immigrants to the upper Midwest had built crude log structures, but as their farms became prosperous, they acquired the resources to build more elaborate *Fachwerk* buildings. Proud of their German heritage, they displayed on the exterior of their buildings an evocation of the land they had left behind.

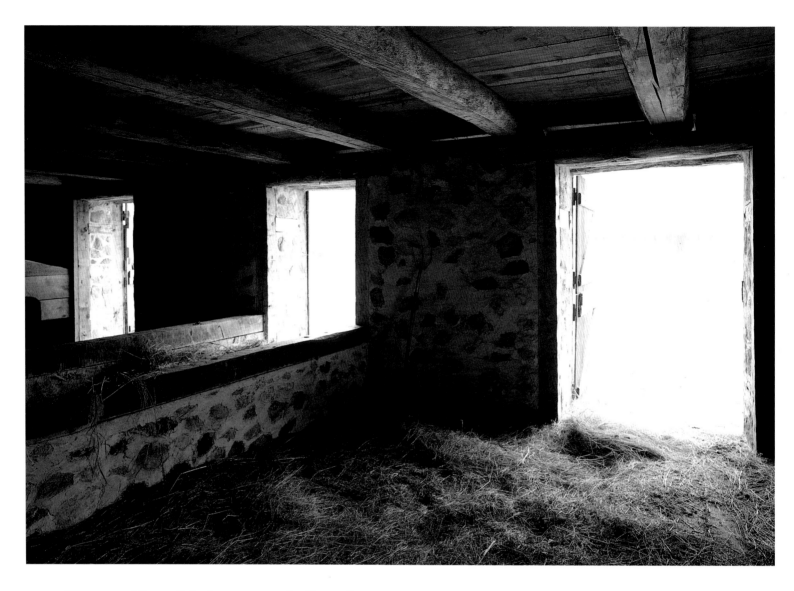

The ground floor of the barn now at the Koepsell German Farm has an unusual stone feeding trough, built at the time of the barn's construction. The door at the end of the trough allowed for easy maintenance and cleaning; feed could also be pitched to animals just outside the barn. Also visible here are the massive rubble-stone walls and floor joists that support the upper two stories of the barn. The Koepsell farmhouse is seen in the background.

Germans built sturdy barns for their livestock soon after establishing their farms. One farmer, Johann Kerler, wrote in 1849: "I could not bring myself to leave cattle out in the open during the cold months as the milk would freeze in the cow's udder."

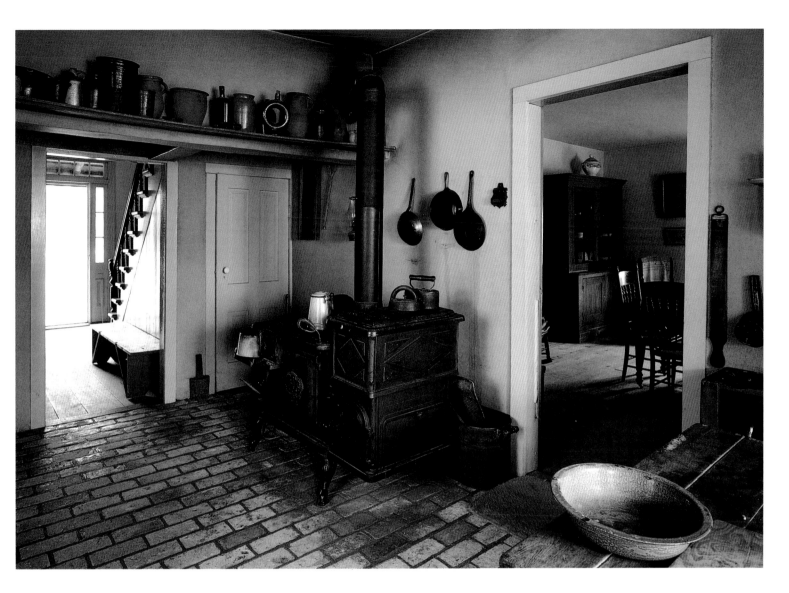

The *Fachwerk* exterior of the Koepsell farmhouse immediately marks the building as German, although details such as the Federal-style sidelights beside the front door and the smooth plastered interior walls reveal that it is an American house.

This mid-nineteenth-century kitchen has an easy-to-clean brick floor, a good amount of open space, and an iron cookstove. The introduction of the cookstove in the early nineteenth century led to the rapid abandonment of open hearths; as one historian has written: "The pleasant old fireplace with its swinging crane of well-filled pots and kettles, hearth spiders with legs, and bake kettles and tin bakers to stand before the blazing logs and bake custard pies in, all went down at once and disappeared before this stove without so much as a passing struggle."

following pages
The family of Mathais Schottler, who moved from Germany to Wisconsin as a boy, established farms throughout Washington County. These farm buildings have been restored to their 1875 condition, when Mathais and his wife, Caroline, were working to diversify their farm in a depressed economy.

The simple log construction methods that the northern German immigrants brought with them worked well in the upper Midwest, where wood was plentiful and good. One or two men could do much of the work, squaring logs, cutting notches to create true corners, and filling in the gaps with nogging.

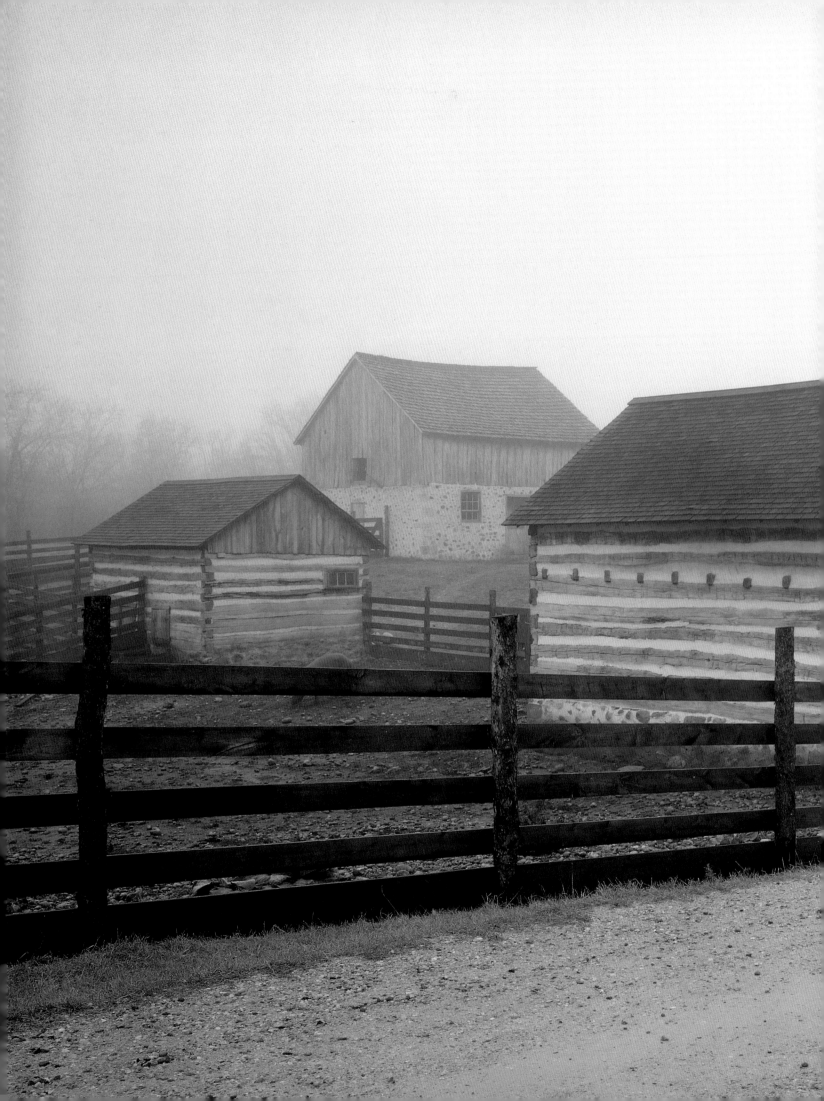

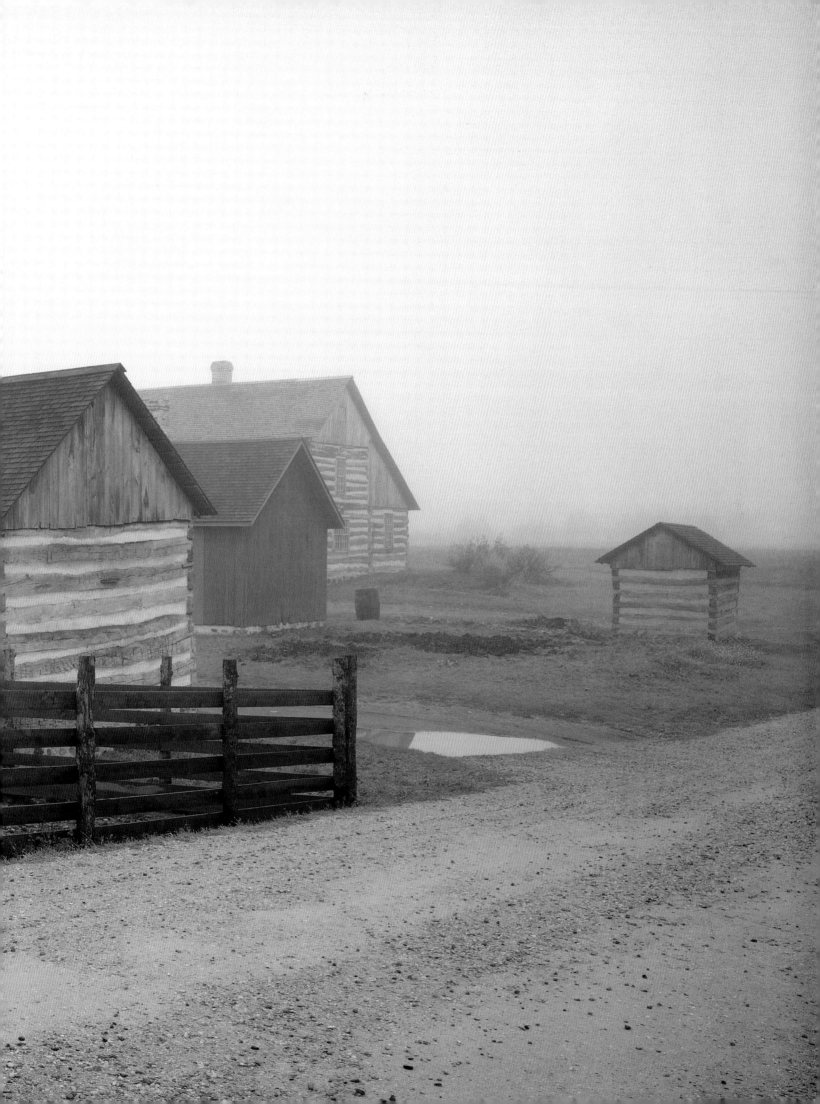

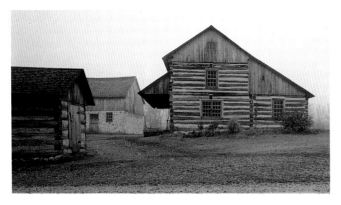

The Schottler farmhouse, built around 1847, has a pent porch roof cantilevered from the main frame of the house.

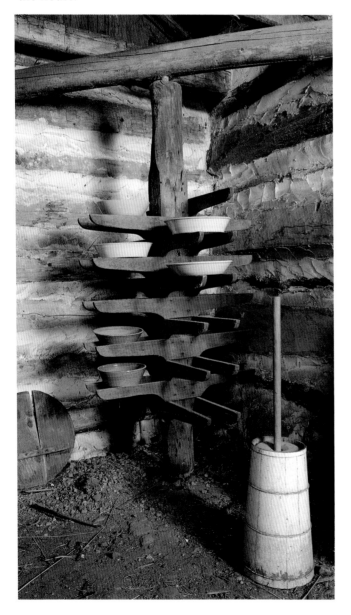

The shelves in the corner of the kitchen addition hold milk while it settles, allowing the cream to rise.

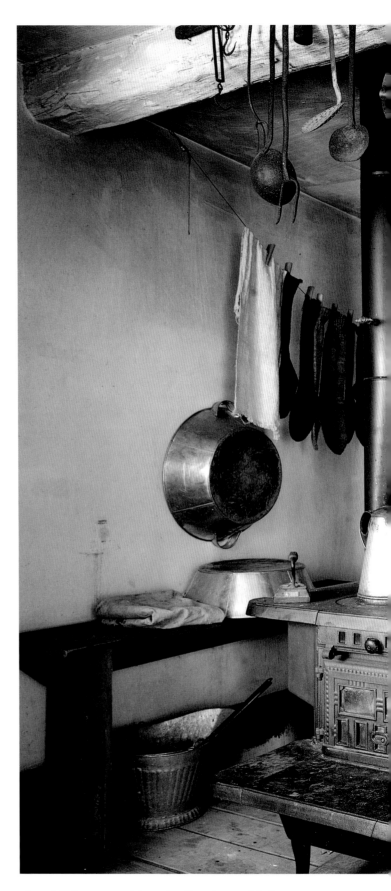

In addition to cooking, the farmhouse kitchen was also the site for all the washing and ironing.

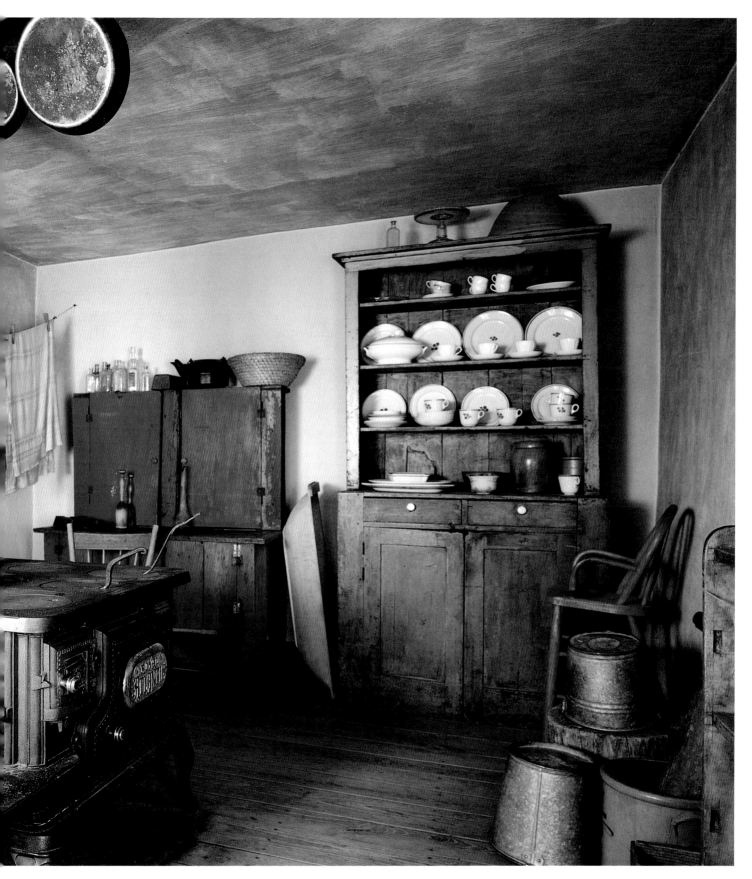

Water was heated in a large pot, like the one hanging at the left, and the linens and clothes were scrubbed by hand. In winter, they were carried up to the attic to dry; in good weather, they were hung outside.

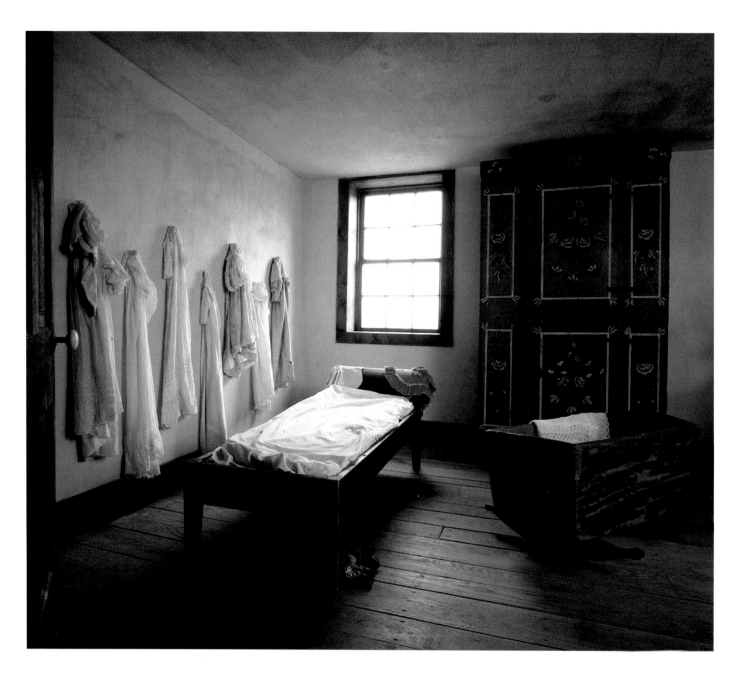

The girls' bedroom of the Schottler farmhouse is
furnished typically, with a narrow bed, a cradle, and
a freestanding cupboard or wardrobe, painted in the
German country style. Nightclothes are hung on
pegs; in the mid-nineteenth century, cotton was an
expensive material, so linen made from locally
produced flax was used for many clothes.

Like many farmers, the Schottlers had a large family,
with eleven children. Children contributed greatly to
farm- and housework, attending school irregularly,
when they were not needed at home.

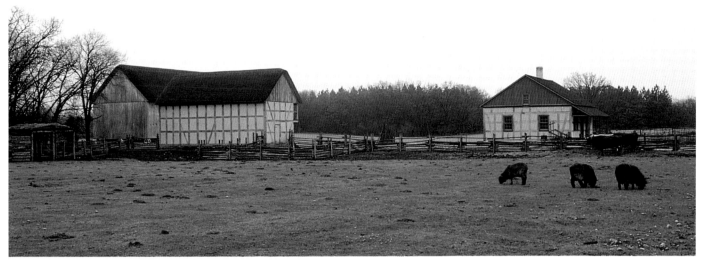

The Schulz farmhouse and barn are good examples of the elaborate and time-consuming *Fachwerk* method, resembling a typical farm on the north European Plain.

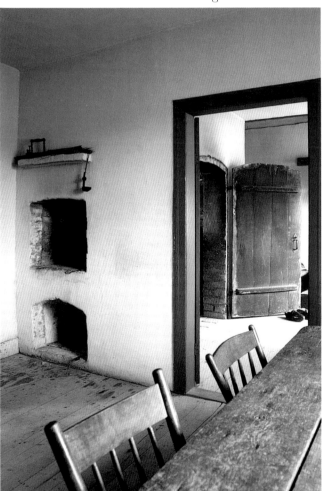

The Schulz farmhouse has a bake oven built into the wall of the kitchen. The niche under the oven opening is a clean-out for removing ashes.

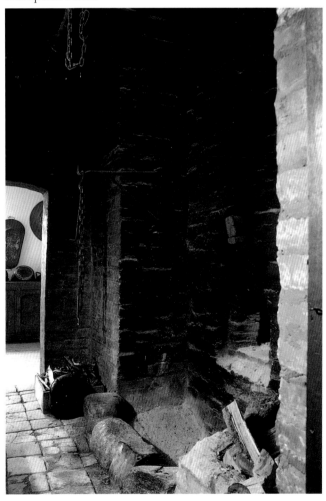

The Schulz farmhouse's large kitchen hearth was abandoned soon after the house was built in favor of a cast-iron cookstove.

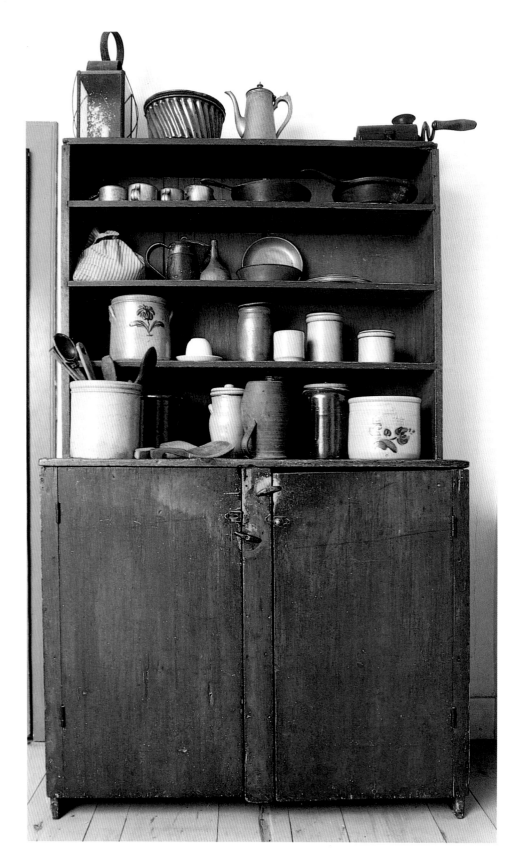

A kitchen hutch in the Schulz farmhouse provides display space for a varied accumulation of crocks, utensils, and household articles such as lanterns and funnels. Since they were used continually for over a century, the handles, latches, and hinges have worn out several times, although the original paint survives.

90

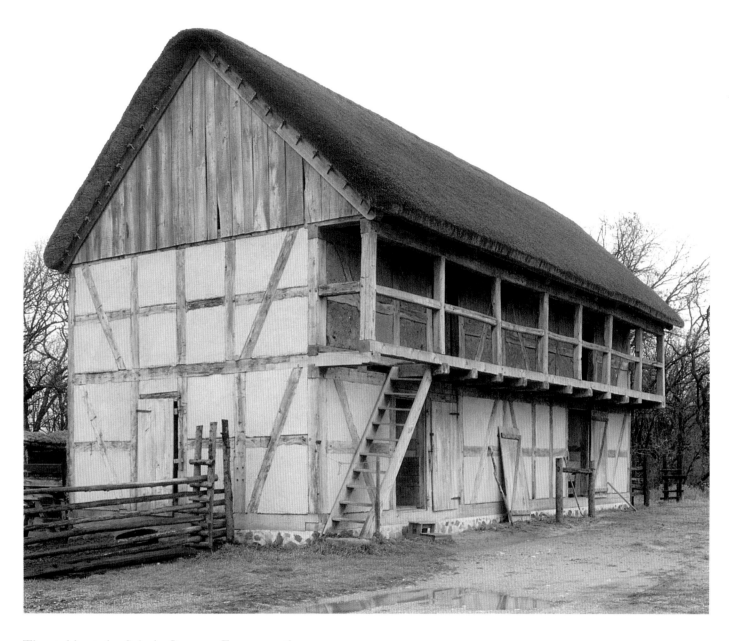

The stable at the Schulz German Farm uses the traditional *Fachwerk* construction, with plaster and straw nogging between the frame timbers. The thatched roof and porch balcony give the stable a very European appearance; thatch was a rare roofing material in America, having been replaced by shingles during the Colonial period. As with their use of *Fachwerk*, the nineteenth-century German immigrants reintroduced the style, although it soon gave way to shingle roofing again.

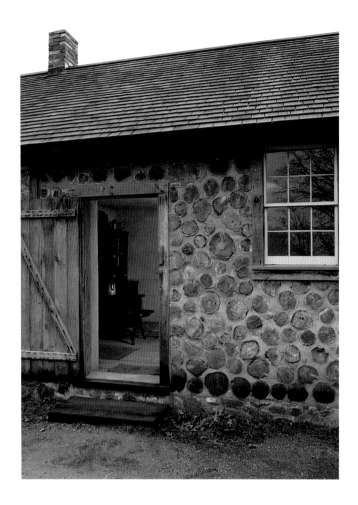

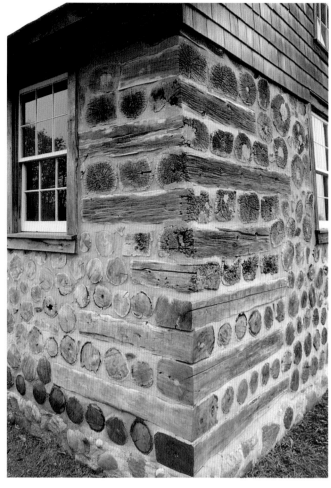

Many Polish immigrants moved to Wisconsin in the late nineteenth century, with about a third settling on farms. This house, built by a Polish farmer for his aging in-laws, originally stood close to the large main house that they had earlier shared with the farmer and his household. The building, restored to its appearance of around 1900, was originally shared by the family and their farm animals, a common building tradition in Europe that saw only limited acceptance in America.

Its distinctive stovewood construction is found only in Wisconsin, northern Michigan, and Quebec. Stove-size logs are stacked, much like firewood, and mortared in place. This labor-intensive method took advantage of the large stands of small trees in the local forests, and could be accomplished by an individual.

Supporting the corners of a stovewood building was the trickiest part. Cornerposts were sometimes used, although the solution used on the Kruza farmhouse is much more common. Squared lengths of log were stacked at the corners, much like stone quoins in masonry walls.

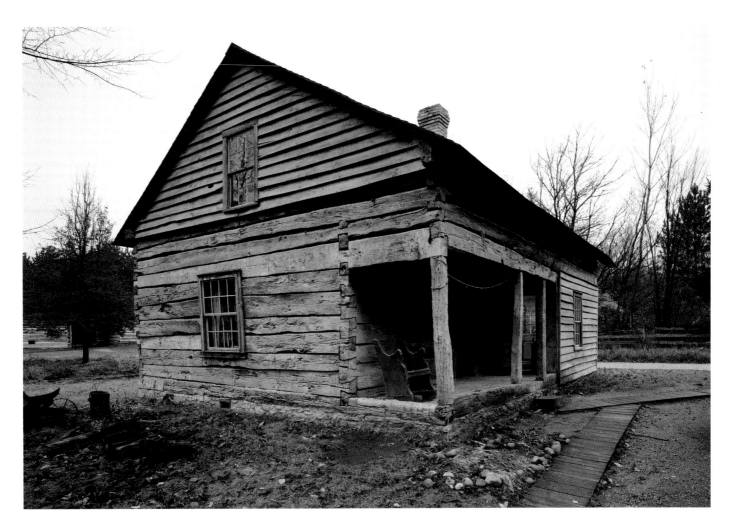

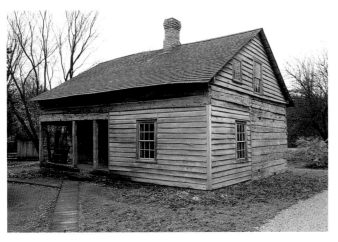

When it was built, the porch of the Anders Kvaale farmhouse was open along the length of the house. As the family grew, more space was necessary, and a portion of the porch was walled in and permanently converted to a living area.

In the early 1840s, Wisconsin began to attract many Norwegian immigrants, who were more likely than other immigrants to settle in the countryside and farm. By 1870, nearly half of the area's Norwegian immigrants were farm families.

The Kvaale farmhouse, built around 1848, reflects traditional log-building techniques that characterized Norwegian-American settlements. Almost all of the early houses constructed by Norwegians share the plan of this one, with three rooms of unequal size on both the ground and second floors and a long gallery, or *sval*, running the length of the second floor, above the porch. By the time this house was built, the immigrants were picking up some American construction methods, such as the lapped siding on the second-floor gable and the neat, squared-off corners of the logs.

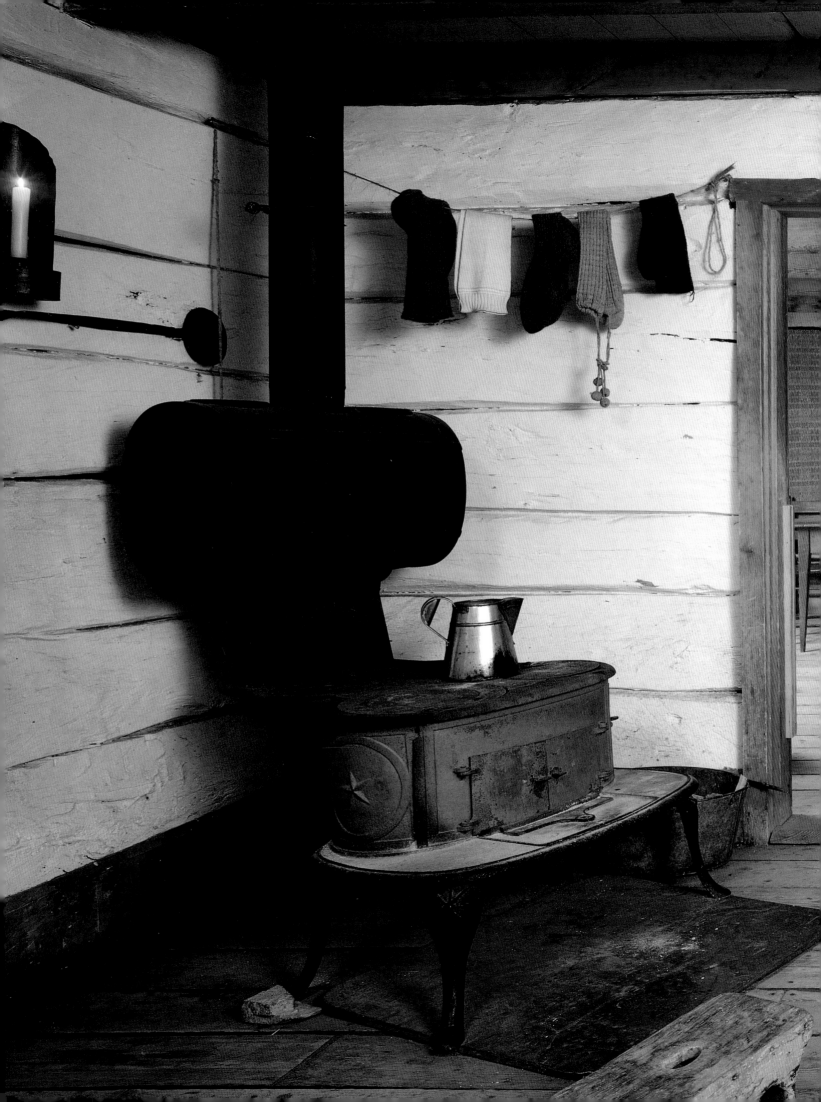

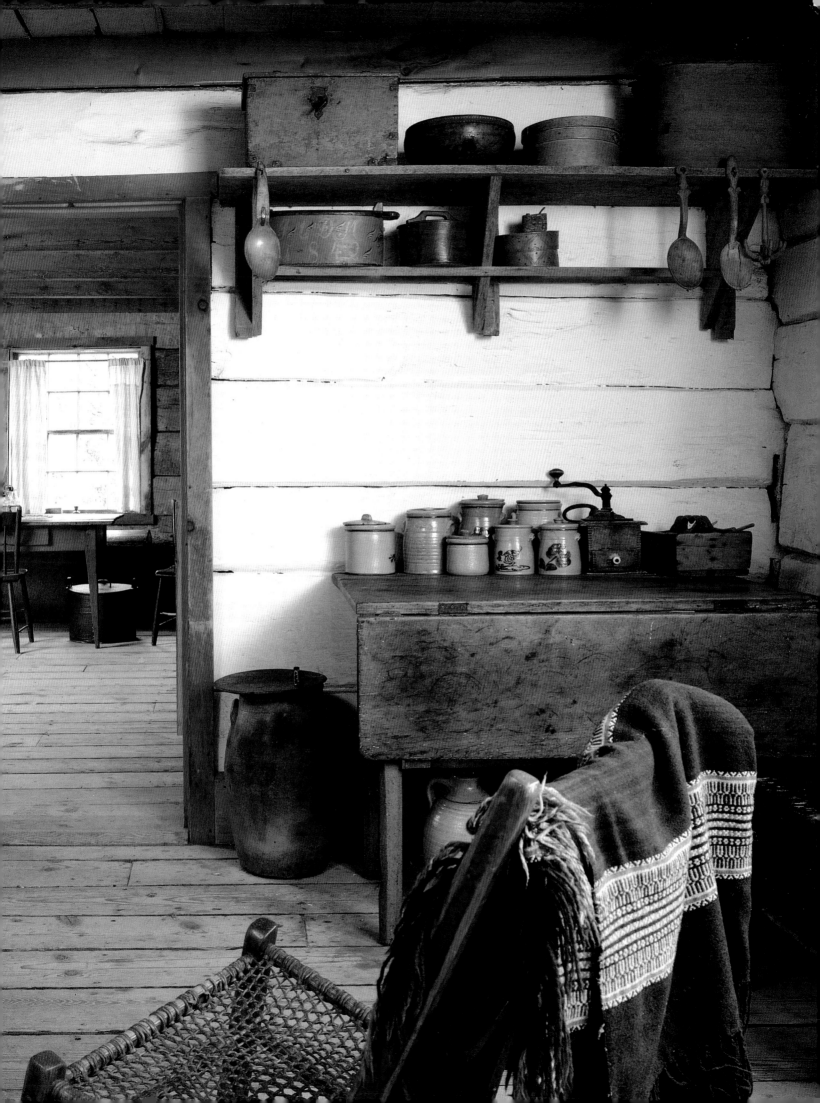

The kitchen of the Kvaale farmhouse has the furnishings of a typical Norwegian-American farm of about 1865. Visible through the door is the front hall or living room.

This double-crib barn was originally built for the Sorbergshragen family in Vernon County, Wisconsin. The two cribs, separated by a central drive-through, sheltered horses and cattle. The space above the barns was used as a granary; the log construction was left unnogged on the second floor to provide ventilation.

This outbuilding from the Lisbakken farm in Vernon County, Wisconsin, is a modification of a *stabbur* or storehouse. It was used to keep the family's supplies, including clothes, canning supplies, and flour.

The log corn crib in the rear was built for the Dahlen family in Vernon County, Wisconsin. In the foreground, a simple nineteenth-century wagon still has some corn in it from the last harvest.

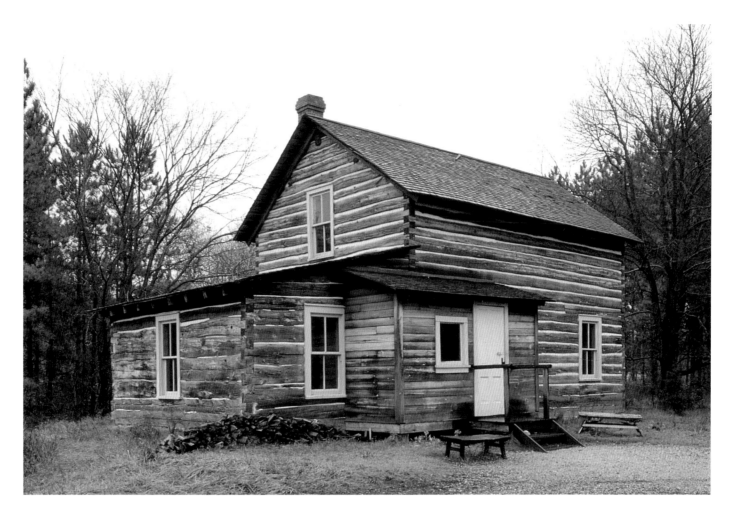

Between 1864 and 1920 more than 300,000 Finnish immigrants came to America. By the 1890s, when the Rankinen family arrived in Wisconsin, homestead land was still available only in the far-northern counties. Jacob and Louisa Rankinen settled a claim in the town of Oulu in Bayfield County. The house has been restored to its 1897 appearance.

The land in the upper Great Lakes region is not as rich as that further south, and the Finn farmhouses were smaller than those in more prosperous regions. Some historians have suggested that the multiple rooflines common in Finnish houses were meant to give the impression that the farm had more buildings on it.

left
The stable, viewed from the Rankinen farmhouse kitchen, was used to shelter cattle. To lessen the danger of fire, there was a generous amount of space between Finnish farm buildings.

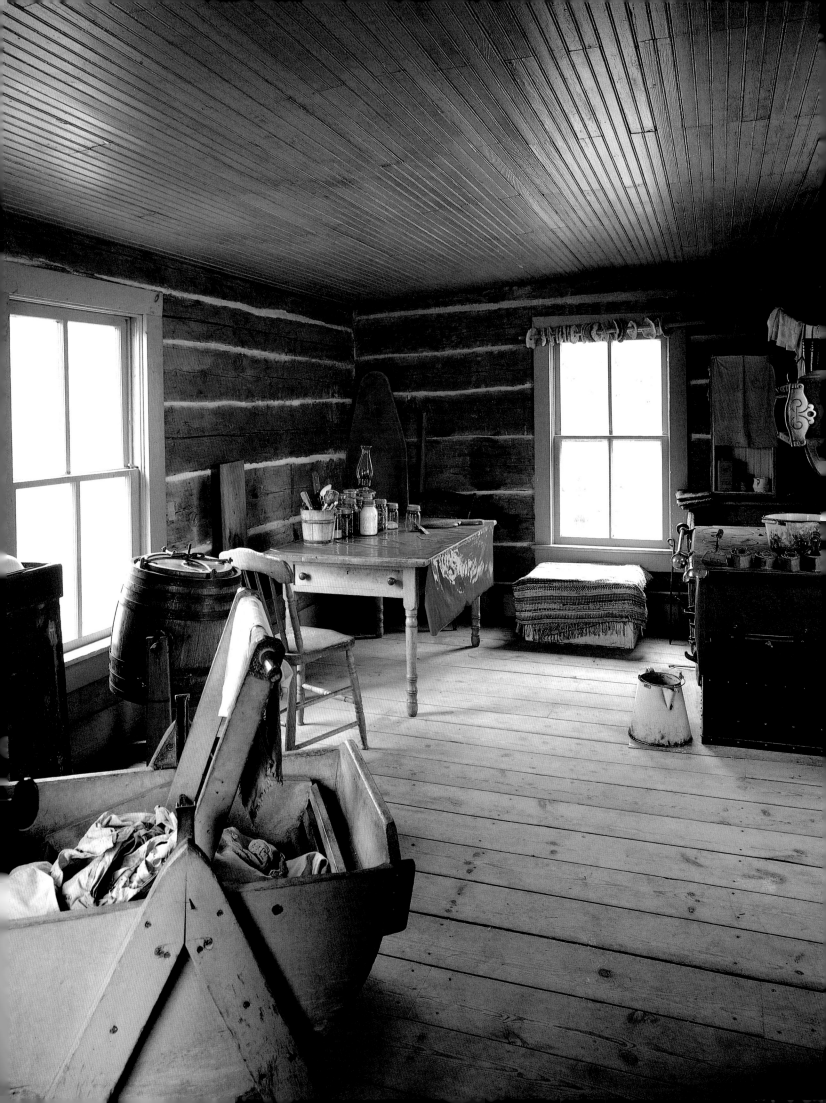

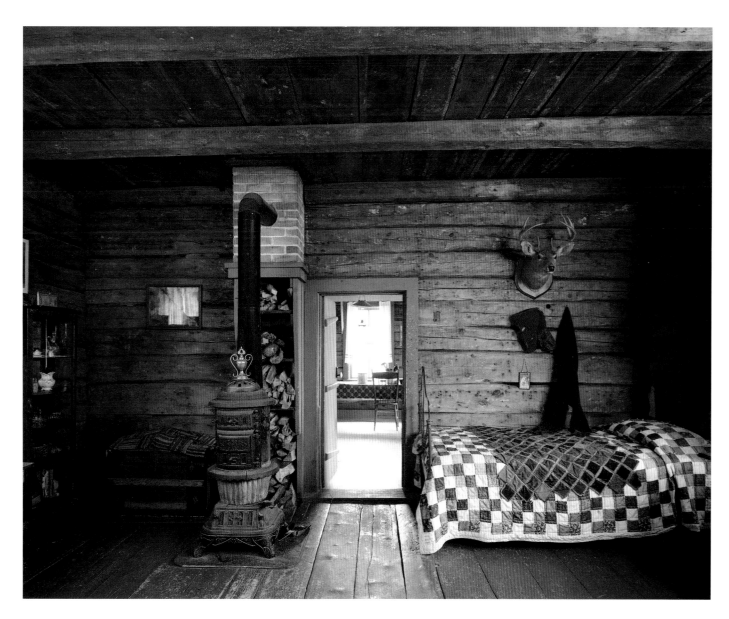

left

The furnishings of the Rankinen farmhouse kitchen are characteristic of turn-of-the-century Finnish farms in Wisconsin. The Finns' furniture was simple and homemade, and open wall shelves held the household's treasured items. Some of the labor-saving devices that were finding widespread acceptance at the time are seen here, including an early rocking washing machine in the foreground and a barrel butter churn behind it.

The simple painted lath ceiling added considerably to the amount of light available in the kitchen, making the farm wife's work there more agreeable.

The Ketola family farmhouse, built in stages from 1894 to 1900 in Bayfield County, Wisconsin, is an excellent example of Finnish log construction. The bedroom in the Ketola farmhouse opens into the kitchen. Patchwork quilts, like the one covering the bed, were made in the farm wife's spare time and were the only warm coverings available for the long winter months.

following pages

The late-nineteenth-century cast-iron cookstove in the kitchen of the Ketola farmhouse features elaborate decoration, enlivening the kitchen and radiating more heat from its increased surface area.

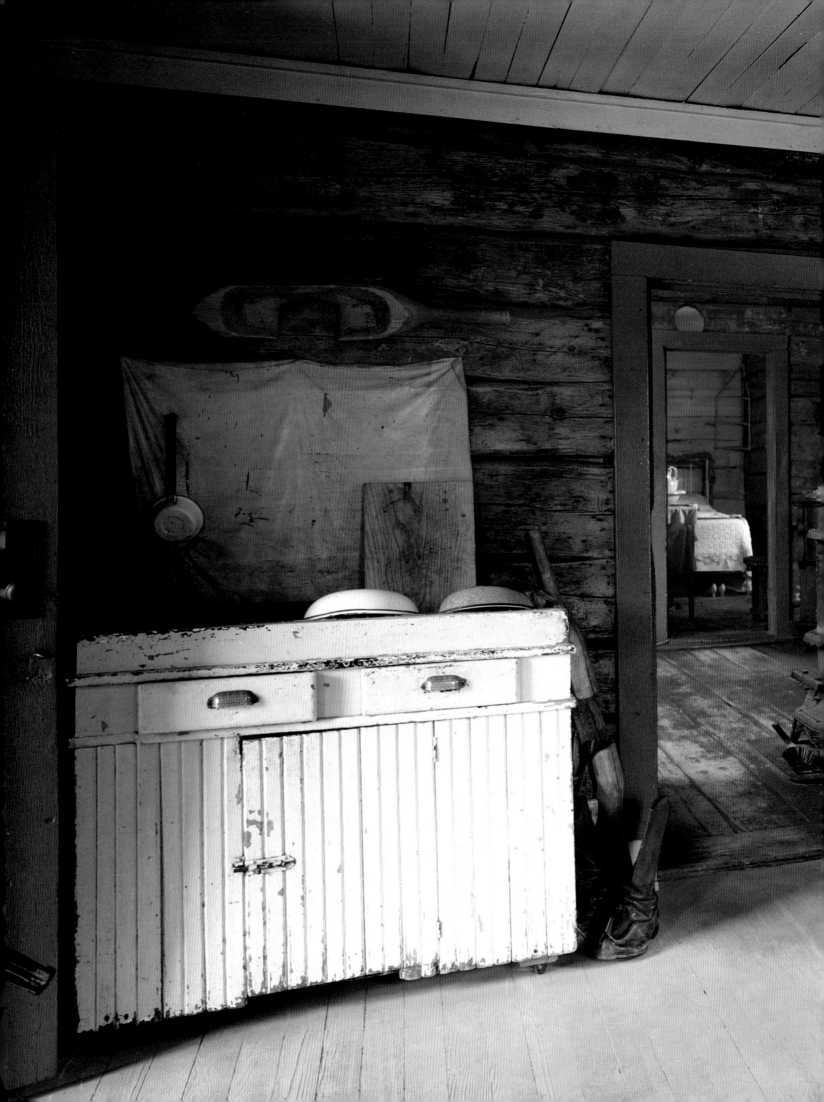

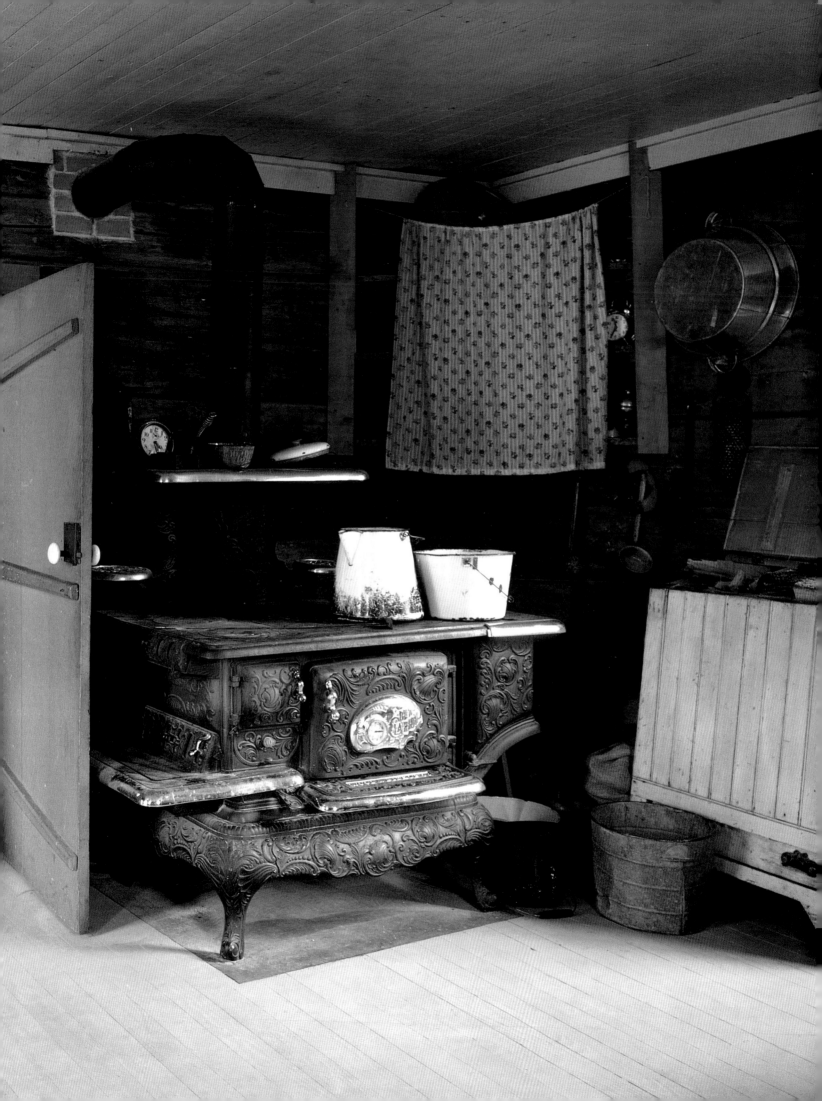

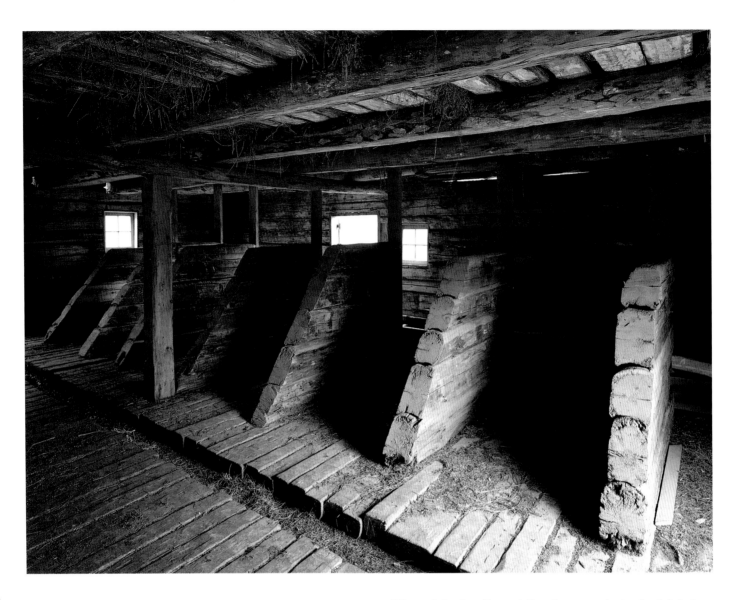

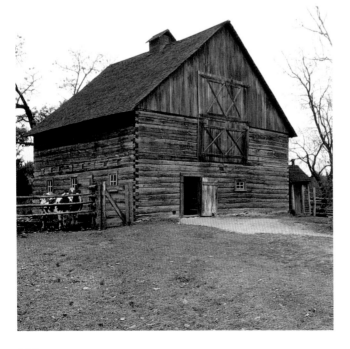

The original stalls and flooring remain in the Makela family's stable, originally built in the town of Maple in Douglas County, Wisconsin.

The sheer abundance of wood in northern Wisconsin allowed the Makelas to build a stable of enormous solidity, where even the stalls and floorboards are made of squared-off whole logs.

left
The large barn built for the Kortesmaa family around 1910 in the town of Oulu in Bayfield County, Wisconsin, housed dairy cattle and had storage space for hay in the second-story loft.

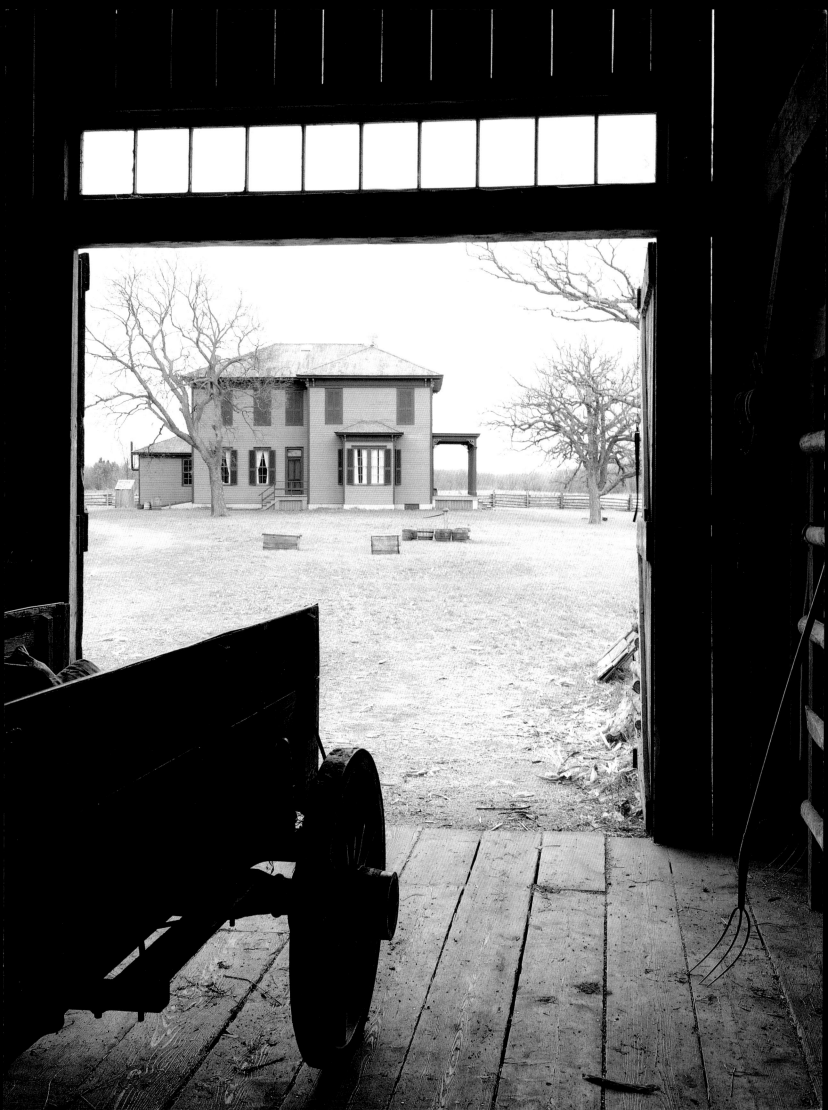

preceding page

The Kelley farmhouse in Elk River, Minnesota, is framed by the barn door. The barn and the first house built on the property were erected for Oliver Kelley in 1850, when he decided to stay and farm the land he had bought on speculation. The second house was begun in 1876 on the foundation of the first, which was torn down. Kelley liked the location, facing the Mississippi River and a comfortable distance from the barn.

The transom windows above the door were a modern feature when the barn was new. The gaps in the siding help ventilate the hay stored on this main level to keep it dry and free from rot and the threat of spontaneous combustion. The well and hand pump can be seen in the yard between the house and the barn. There were two pumps on the farm, one for animals and one for people.

right

Oliver Kelley's home was designed as a stylish showplace in the highly fashionable Italianate villa style, a mode of building familiar to Kelley from his years living and working in Washington, D.C. It was a style particularly ill adapted to the climate of northern Minnesota. The high, twelve-foot ceilings and very long windows made the house difficult to heat, and the flattened roof did not shed heavy snow.

The exterior paint has been matched to the original colors, a peachy tan with chocolate-brown trim. The trees are native to Minnesota. On the right are burr oaks, which flourish in the sandy prairie soil, and on the left is a hackleberry, which favors rivers.

The house was never finished while Oliver and his second wife, Temperance, owned the property. During summers in the late 1870s and 1880s, the Kelleys' four daughters occupied the only three finished rooms in what remained essentially a shell of a house—a bedroom, kitchen, and woodshed. The house, finished by subsequent owners after the turn of the twentieth century, included a parlor and office on the first floor and a large master bedroom and nursery upstairs.

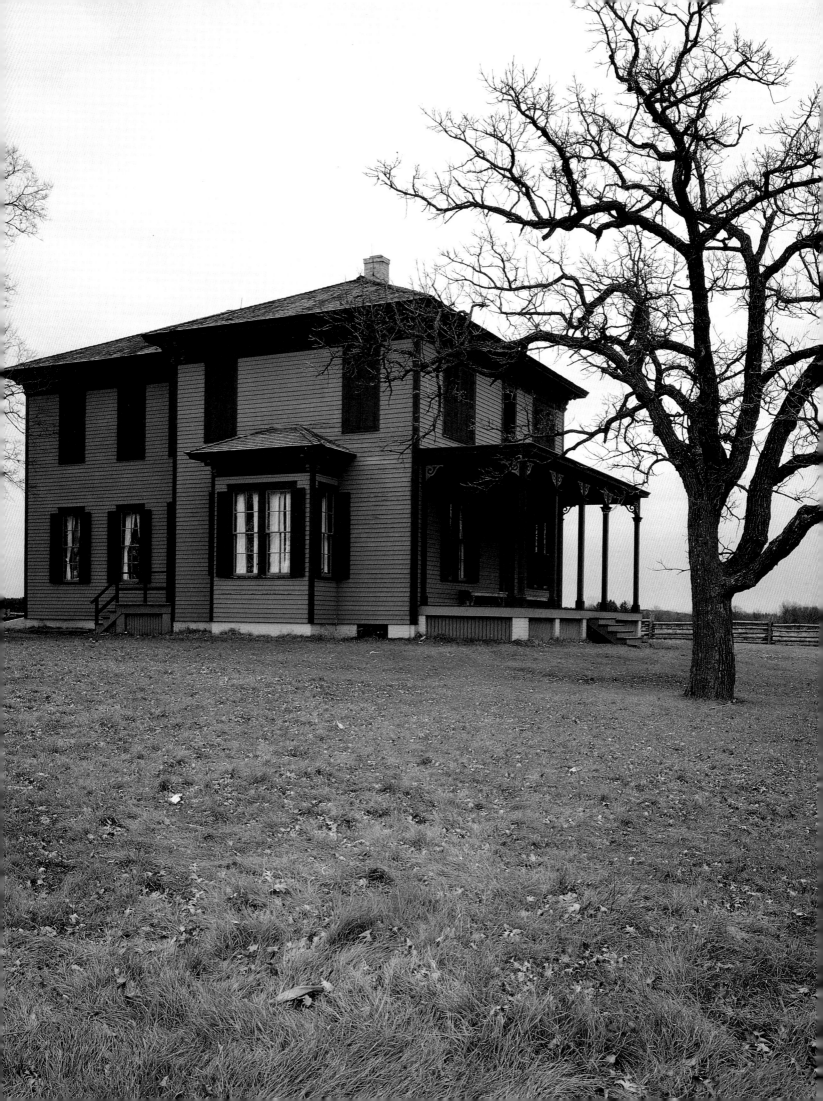

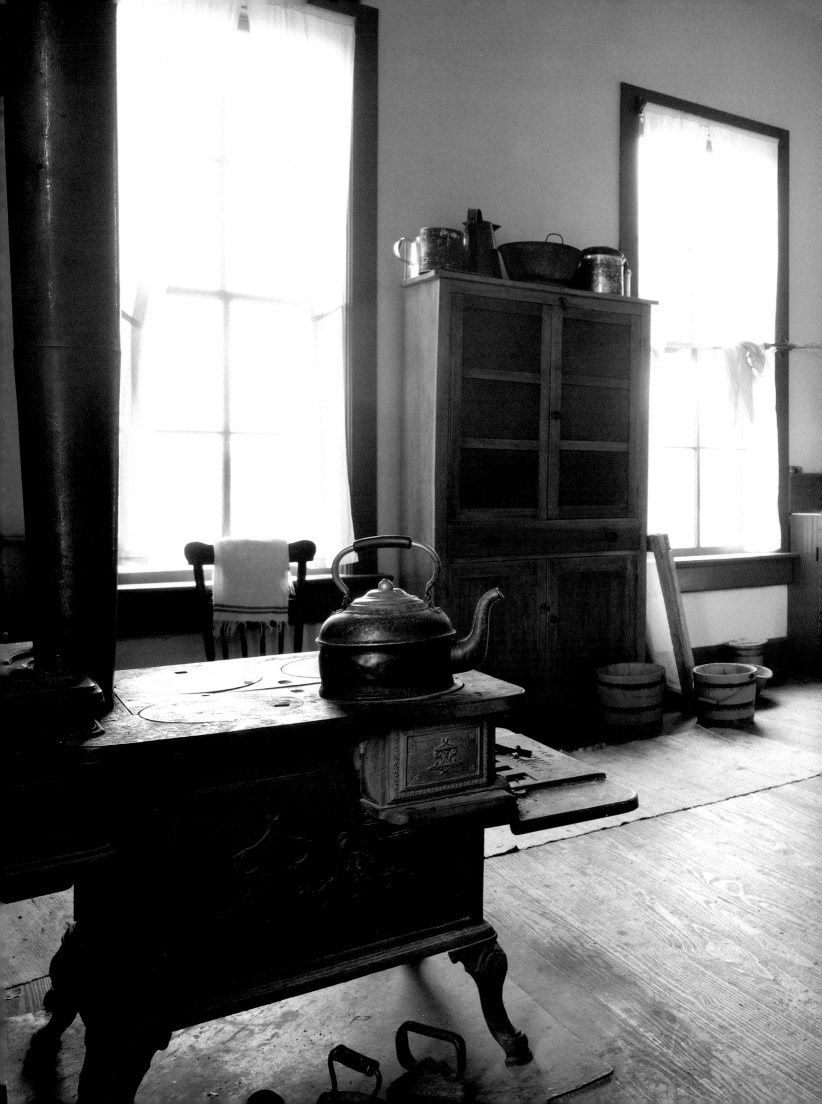

The kitchen was one of three finished rooms used by the Kelley daughters when they spent summers in the house. It is representative of mid-nineteenth-century farm kitchens, when all-purpose rooms began to give way to more specialized rooms as families grew more able to afford larger houses. Ordinarily, the family would have dined in a separate dining room, but the unfinished state of the house meant that the Kelley daughters ate their meals in the kitchen, too.

The twelve-foot ceilings are not unusual for the Italianate style. The room's colors—red woodwork, yellow walls, and brown floor—have been matched to traces of the original color scheme.

Kitchen furnishings characteristic of the third quarter of the nineteenth century include a cook stove, a pie safe between the windows, a shelf clock, tinware by the dry sink, a work table, water pails for the kitchen pump, outside in the yard, and a kerosene lamp (brighter and more convenient than candles).

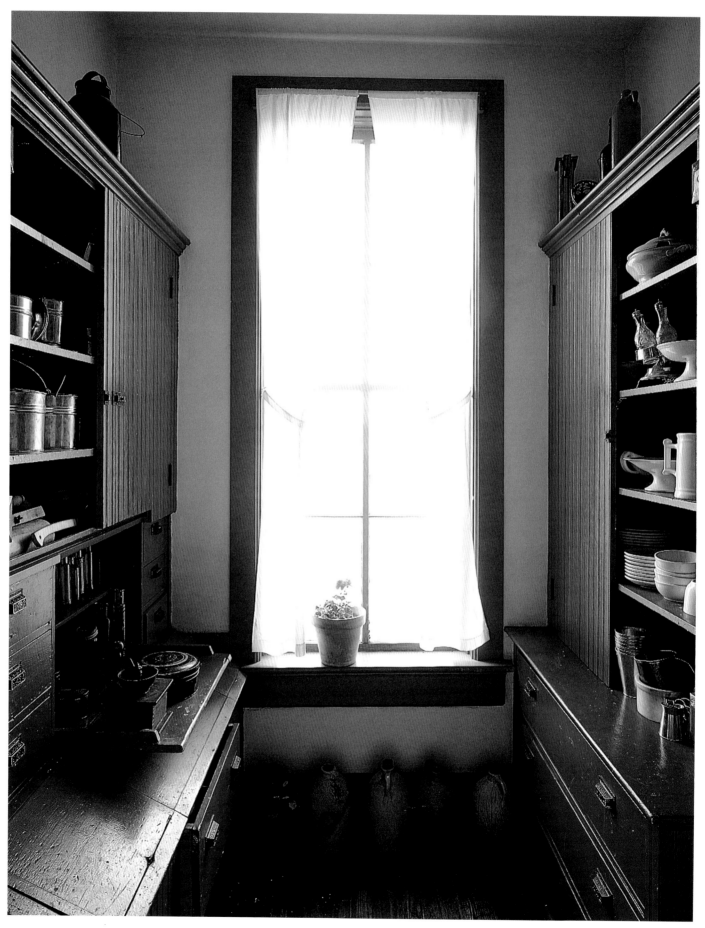

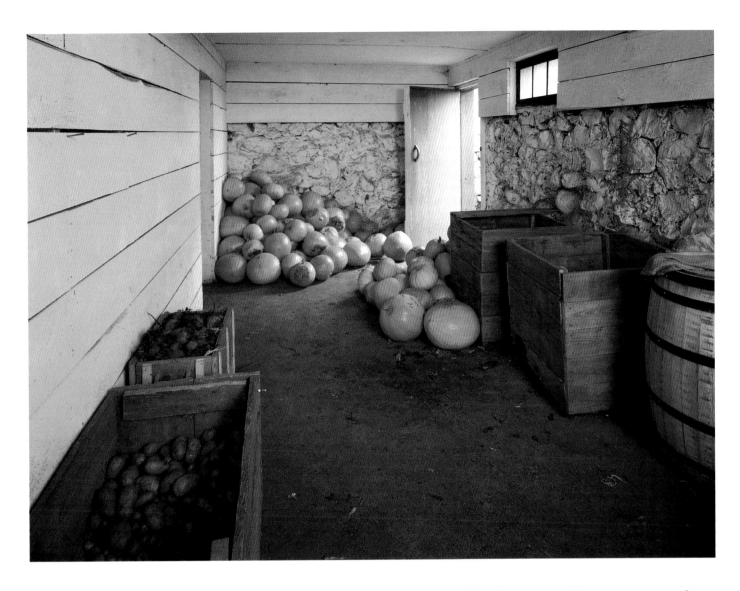

The pantry off the kitchen in the Kelley farmhouse has a cupboard for storing dry goods—flour, sugar, spices, and the like—on the left. The flour bin in the lower left of this view holds more than a hundred pounds. The drawers were for spices and utensils.

The cupboard on the right side holds plain white ironstone china, the Kelleys' choice of everyday dinnerware. The jugs on the floor below the window hold homemade vinegar, including tomato and sorghum vinegar.

The plain white muslin curtains and color scheme, which matches the kitchen, are accurate to the period.

The Kelley farmhouse root cellar was a most modern convenience when the house was built because it was directly accessible from the kitchen by inside stairs, saving the family and hired help an outside trip in the winter. The left door leads to a cold storage space for dairy products, another convenience, since most households had to walk to the springhouse to fetch butter, cheese, and milk. The room was whitewashed yearly to brighten and disinfect it.

Today, the cellar stores the historic varieties of root vegetables that the farm raises. The bins hold potatoes and rutabagas between layers of earth. In the nineteenth century the pumpkins would have been grown as food for livestock

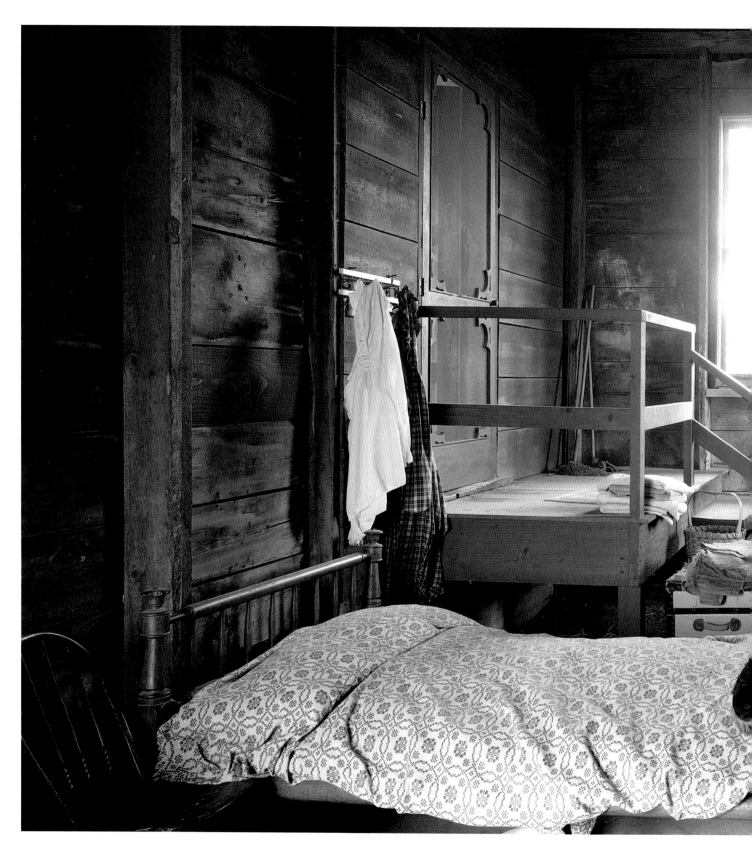

This small lean-to on the back side of the Kelley farmhouse was built later to serve as storage space. The addition was also used to house hired farm workers during the summer; even with the stove, the thin walls made it inhospitable in the harsh Minnesota winters.

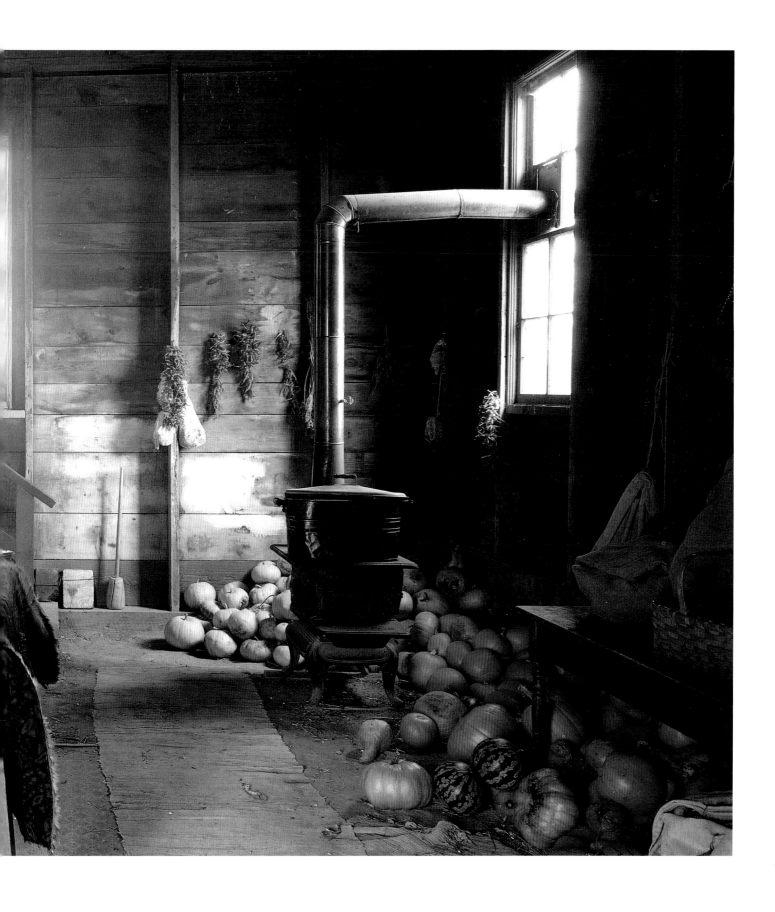

The window sashes in the Kelley kitchen garden serve as a hot bed to prolong the growing season in northern Minnesota. Here, they protect a late crop of fall greens, including turnip greens, lettuce, and beet greens. The kitchen garden is between the house and the Mississippi River. An adjacent one-acre field garden produces pumpkins and other livestock food.

The pine board fence, surrounding just the kitchen garden, protected the vegetables from foraging domestic animals such as young pigs and chickens. In the nineteenth century, wild animals like deer, rabbits, and groundhogs were not a principal threat to gardens, since extensive farming and killing for meat drove them away from settlements.

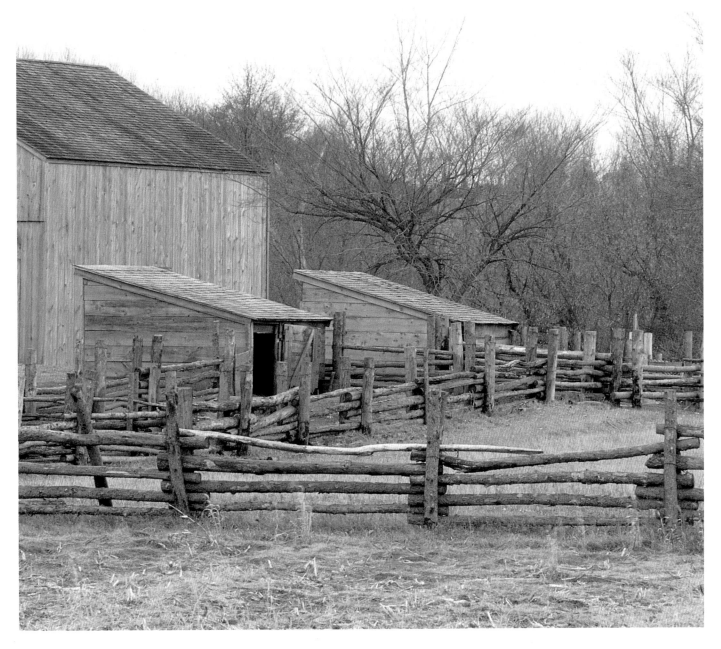

This view shows the back of the Kelley barn and sheep shed. All of the small outbuildings were reconstructed from an 1856 agricultural plan book, the same type of source that "book farmers" like Oliver Kelley relied on for advanced methods and scientific improvements.

The fencing is made of tamarack poles, which were readily available and required little extra work. Farmers logged tamarack, which grows in swamps, in the winter. The straight, slow-growing tree trunks were an ideal size for fencing and did not require the considerable additional labor of splitting.

Living History Farms in Urbandale, Iowa, includes this wonderfully restored turn-of-the-century progressive farm. The complex, which includes a modest farmhouse, barn, stable, and several smaller outbuildings, evidences the social and technological changes of the progressive farm movement, when American agriculture was transformed from small, labor-intensive but self-sufficient farms to larger, more efficient, and less personal operations.

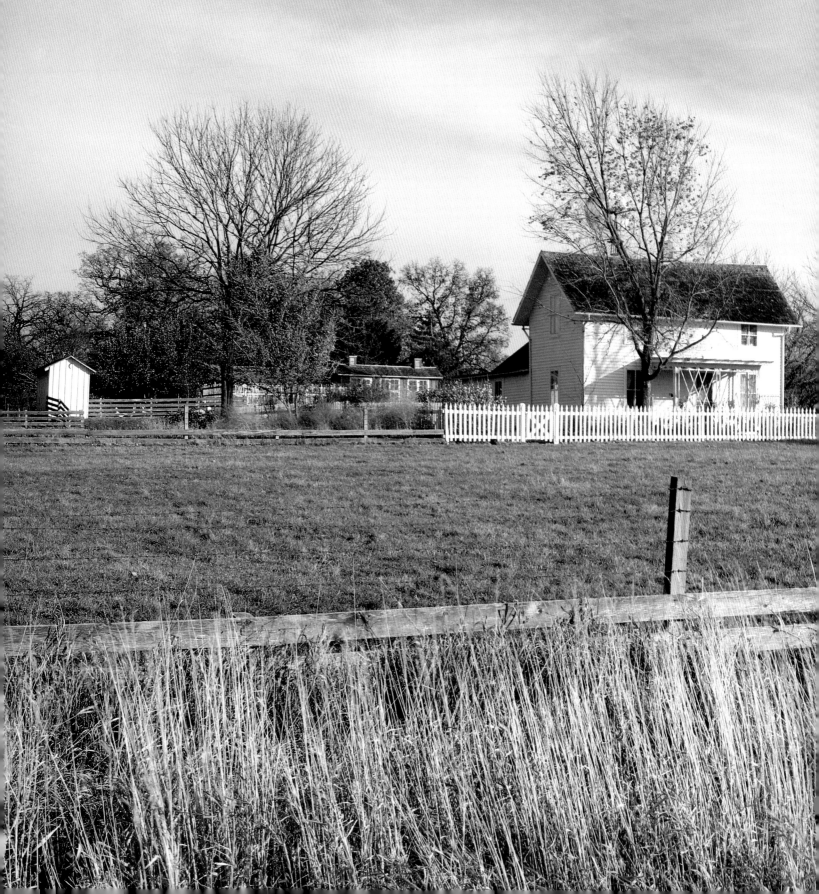

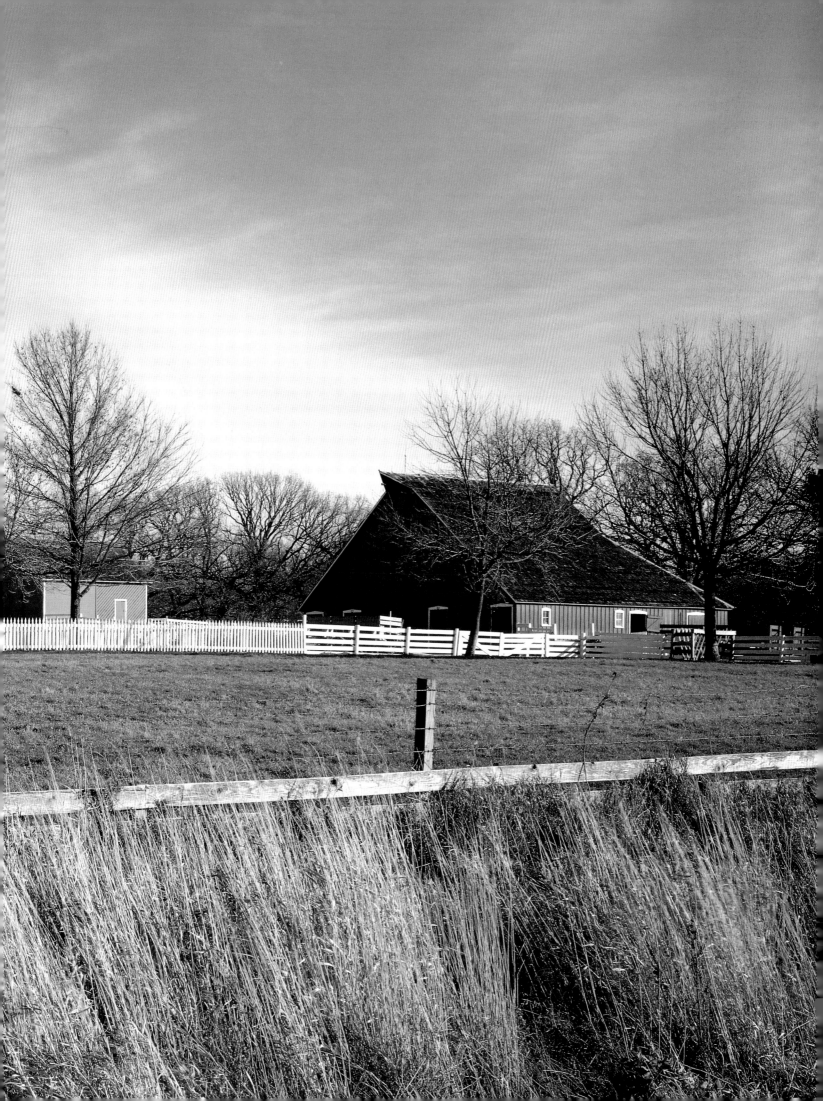

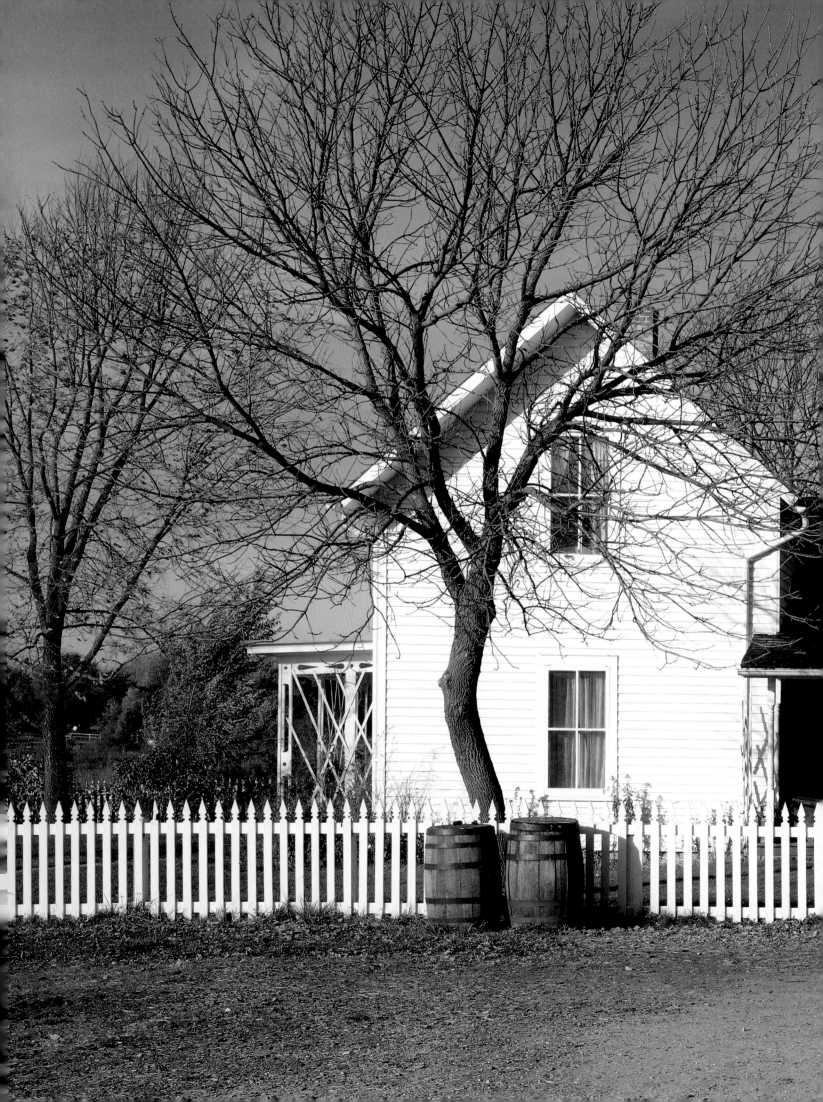

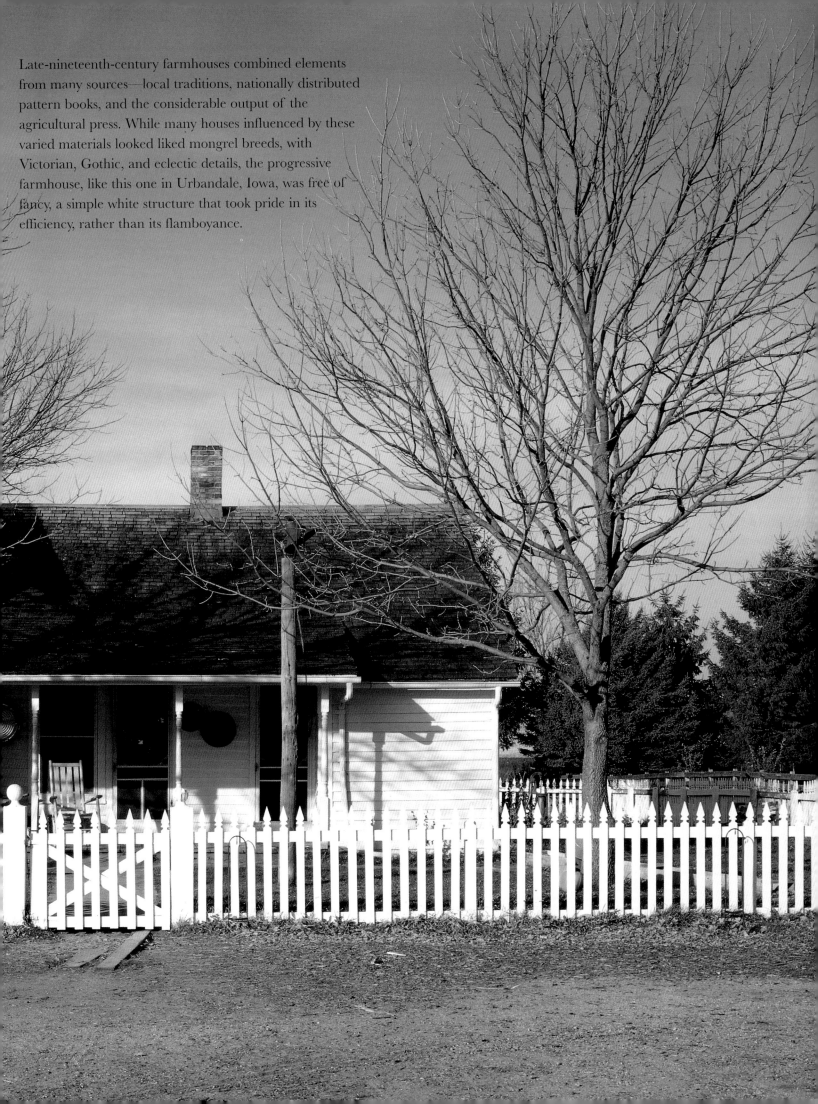

Late-nineteenth-century farmhouses combined elements from many sources—local traditions, nationally distributed pattern books, and the considerable output of the agricultural press. While many houses influenced by these varied materials looked liked mongrel breeds, with Victorian, Gothic, and eclectic details, the progressive farmhouse, like this one in Urbandale, Iowa, was free of fancy, a simple white structure that took pride in its efficiency, rather than its flamboyance.

The improvements on progressive farms were both large and small; here, the bottom of the porch post has been shortened and replaced with a metal L-plate to prevent rot.

opposite
The barn of the 1900 farm, seen from the farmhouse porch, has separate doors for different animals. Cows entered through the doors on the left, and horses used those at the right. The small porch gave the farm family a pleasant place to rest after the day's work, and also provided a commanding view of the farm's activities. The boardwalk was added later, after the farm was opened to the public.

below
Jutting out from the top edge of the barn is a small peak protecting the hay fork, a device for loading and unloading hay.

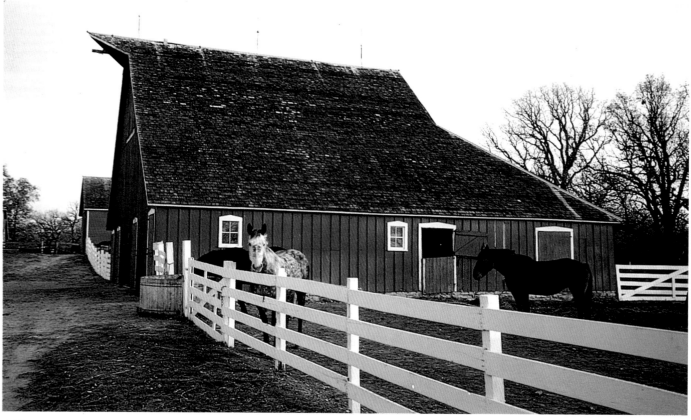

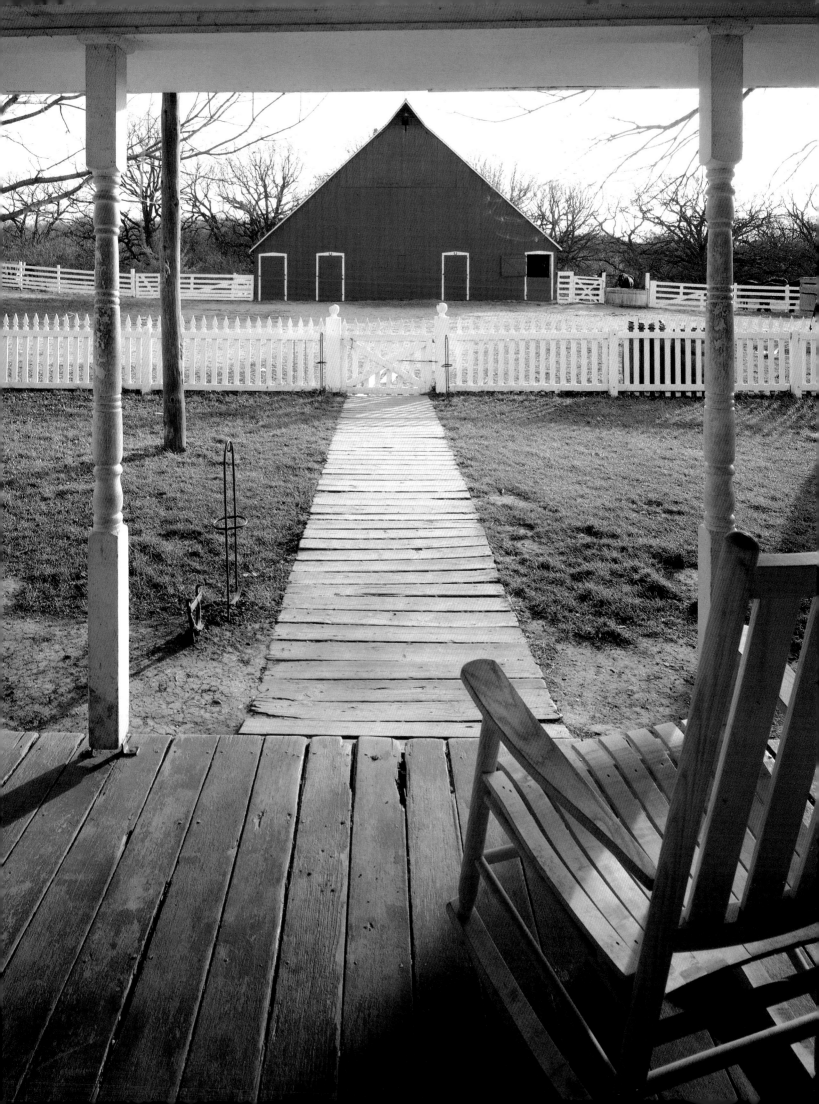

Women played a very large role in the development of the progressive farm. The major agricultural periodicals, such as the *American Agriculturalist*, the *Ohio Farmer*, and the *American Farmer*, published house and farm plans and helpful household tips provided by their readers, and women contributed a great number of farmhouse designs.

In addition to the general layout of the house, farm wives also focused on the kitchen, necessarily the room they spent most of their working hours in. At the 1900 farmhouse, the kitchen has been split in two; there is a main kitchen with the stove, and the back kitchen pictured here, where baked goods and some supplies were stored.

On the right-hand wall is a Hoosier cabinet, with a built-in flour dispenser, and at the back is a pie safe topped with several kerosene lanterns. The small saucers beneath the pie safe's legs are partially filled with water, preventing ants from reaching the baked goods inside. The tin panels are punched with a small awl to allow ventilation without admitting flying insects. In this part of Iowa, the sharp edges of the holes project outward, providing a greater deterrent against the insects.

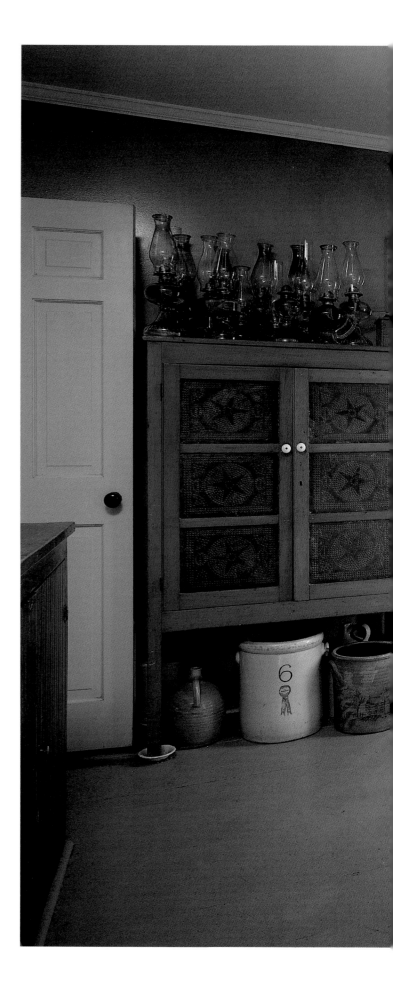

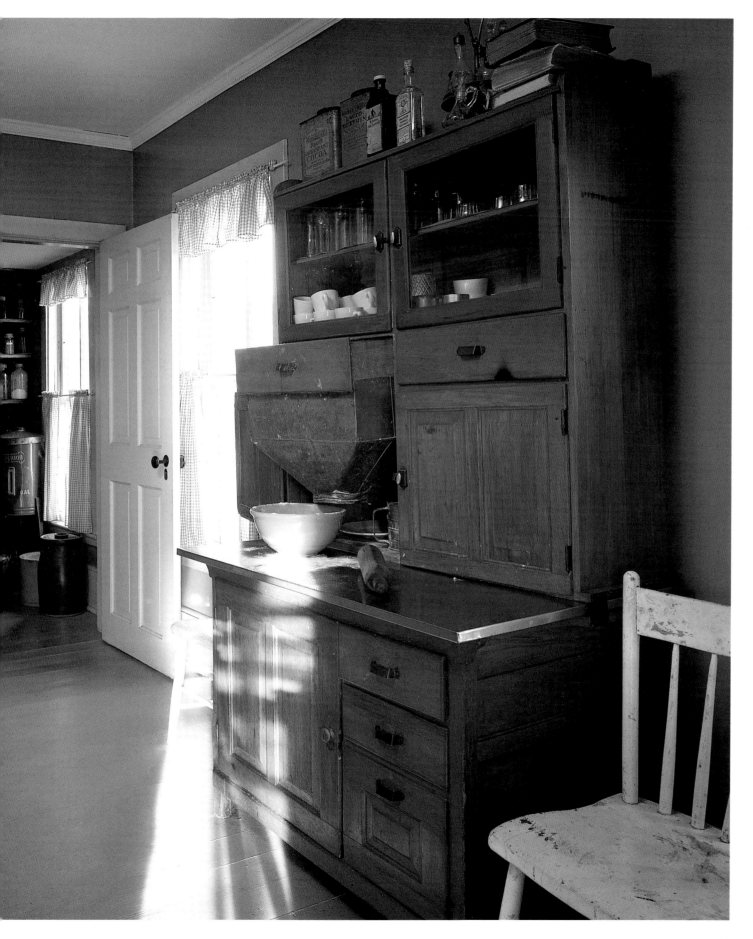

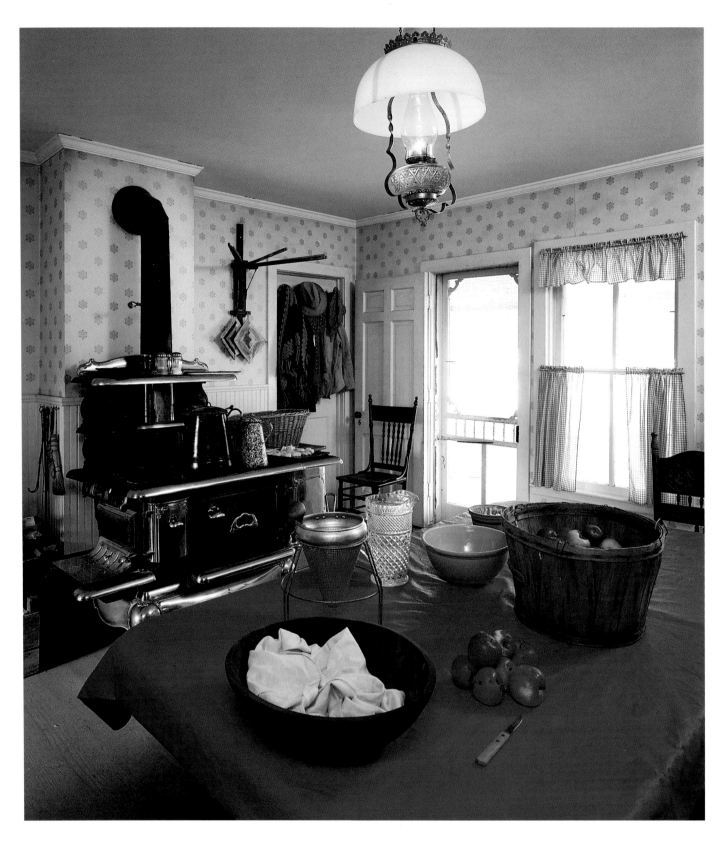

The main kitchen of the 1900 farm in Urbandale, Iowa, has a large, up-to-date cookstove, with plenty of burners and an energy-efficient oven door. On the oilcloth-covered table is a potato ricer, another labor-saving device introduced during this period; the kitchen also has an early screen door, a space-saving rack for drying towels over the cookstove, and a mail-ordered chair in the corner.

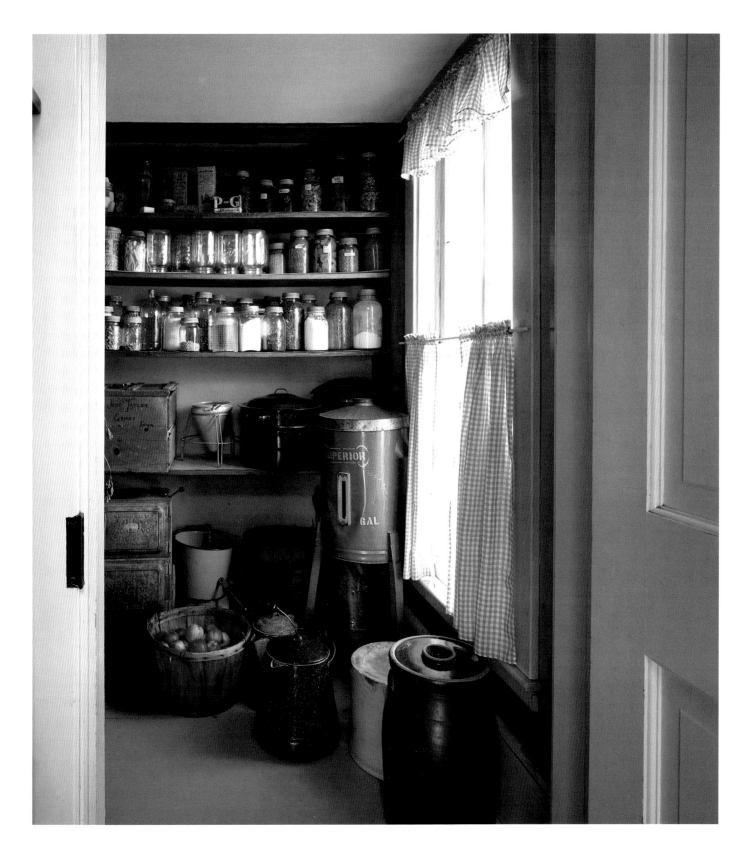

The pantry is well stocked with spices, grains, beans, and other dry goods. There are also new appliances, including a potato ricer on the bottom shelf and a mechanical creamer standing in the corner.

The two boxes under the bottom shelf hold a Conservo, used for canning. Also on the floor are an earthenware jar for pickles and a dasher churn for making butter.

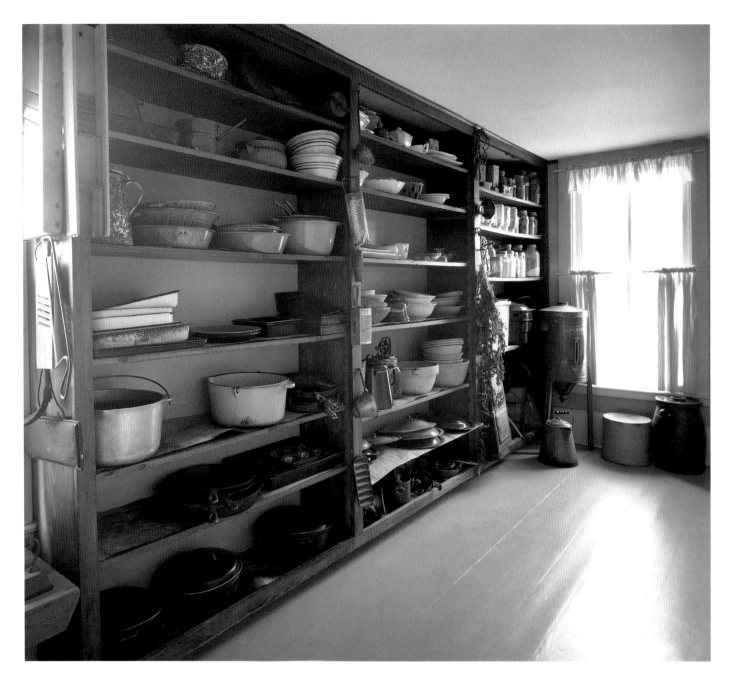

The long pantry outside the back kitchen contains all the tools of the farm wife's trade. Not only signs of prosperity, a well-stocked pantry and kitchen were integral to the progressive farm. Advances in farm technology encouraged individual farmers to specialize in certain products, like corn, potatoes, or dairy cows. Market gardens, traditionally tended by the farm wife and children, became less important as single crops began to dominate the farm economy.

At the same time, farmers took over the care and feeding of poultry and swine, further removing the farm wife from outdoor labor. The rigor and strength she had brought to her farm work was now focused on the kitchen, and it was organized in an efficient manner that contributed to its productivity. Mass-produced cookware and glass jars became widely available, helping to feed the farm's many mouths and enabling seasonal produce to be preserved.

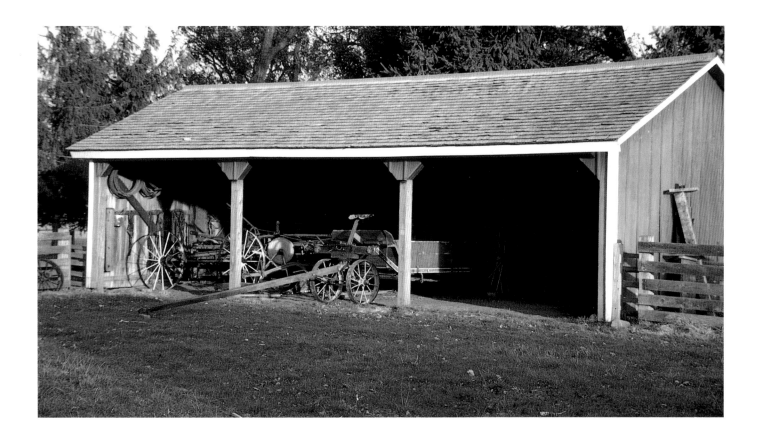

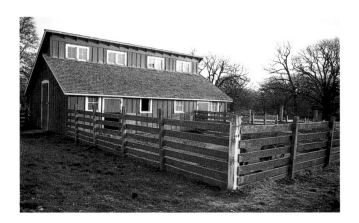

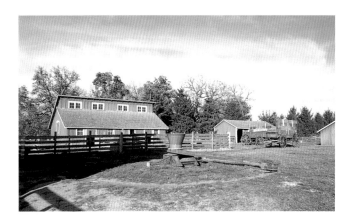

top and above

The outbuildings on the progressive farm were simple and efficient, and built at well-considered distances from the farmhouse and barn. The complex of farm buildings was usually placed at the center of the land, reducing travel between buildings and allowing the farmer to see all of his land from one position.

The long dirt driveway that ran from the road to the farmhouse first came to the wagon shed, where both farm equipment and the wagons were stored.

Pigs and the other livestock on the farm eat feed ground with the Burr Mill. A horse treads the twenty-foot, circular path around the mill, grinding grains or corn placed in the mill's hopper. Until about 1850, livestock were always fed whole grain; by the end of the century, some progressive farms were grinding their feed, which made livestock feeding practices more efficient, as there was less waste and digestion was improved.

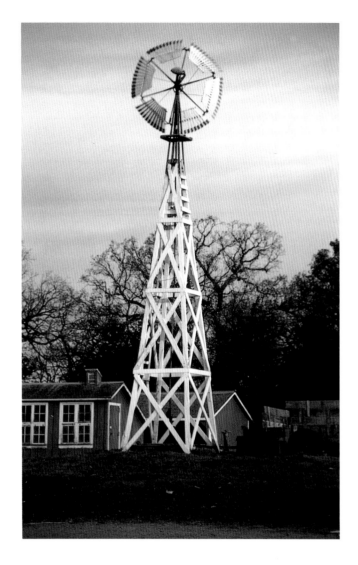

Windmills were typical of progressive farms, putting the natural resource of wind to its most efficient use. Unlike their heavy European predecessors, American windmills were light steel structures, using thin blades and a rudder that always turned it toward the wind. Here, the windmill powers the well pump.

This door leads to the milking area of the main barn at the 1900 farm. A multipurpose structure, it has areas for storing hay, a granary, horse stalls, a loafing shed, and the milking area. It is most active in the mornings, when the cows are milked, and also on rainy days, when repairs and cleaning are done.

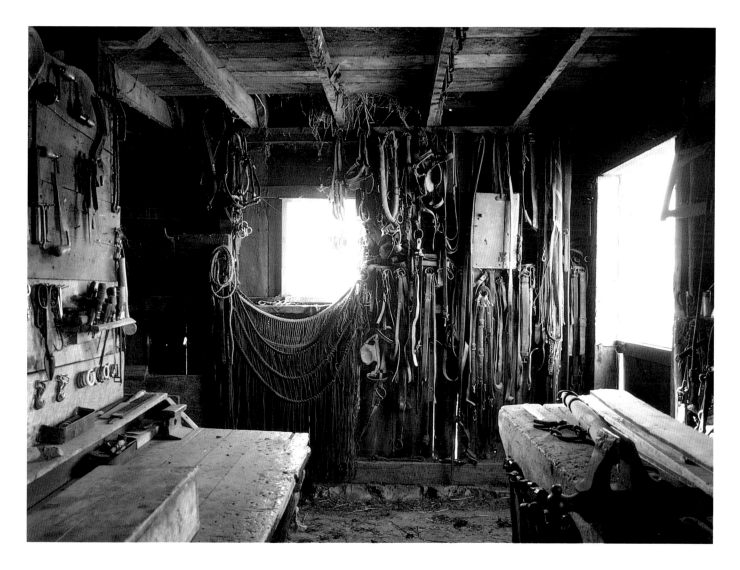

As the kitchen was the farm wife's domain, the progressive farmer's workshop was his outlet for invention and self-sufficiency. Farms became farther and farther from each other as the prairie was homesteaded, and a farmer who could shoe his own horses and fix a bridle was more productive.

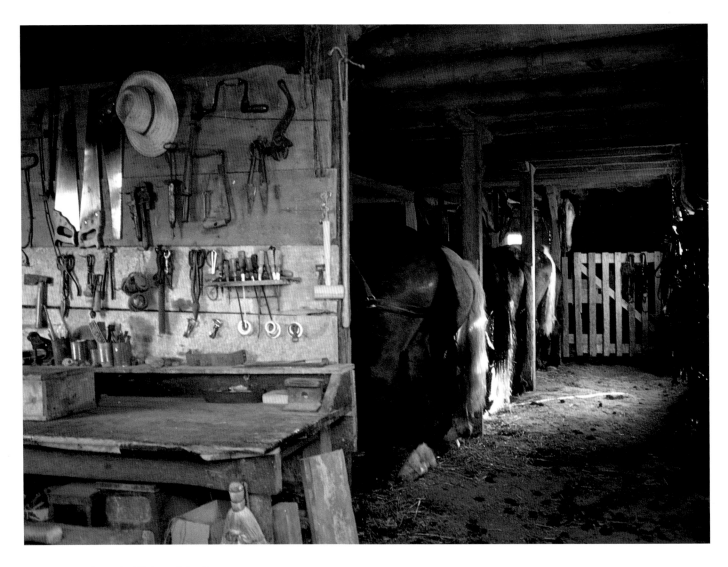

The 1900 farm in Urbandale, Iowa, was a prosperous one, with more than one team of horses. Hanging above the workshop bench are woodworking and farrier's tools. A great deal of maintenance is required to keep the harnesses and other hardware for the six Percheron draft horses. Other household items were repaired at the workshop bench, too, including shutters, shelving, pumps, and kitchen appliances. At the end of the row of horse stalls is a confinement pen, used for animal birthing.

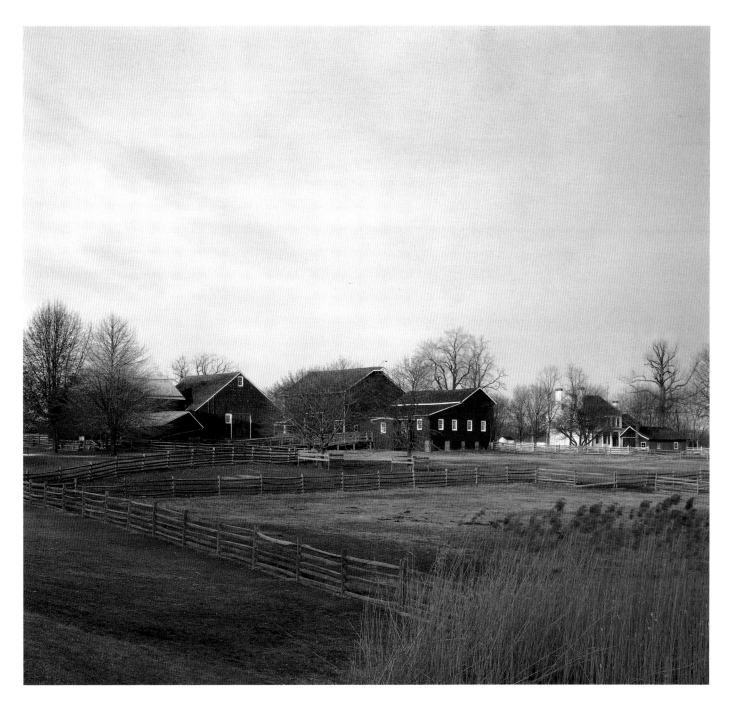

Longstreet Farm in Holmdel, New Jersey, is a handsomely preserved farmstead that was owned throughout the nineteenth century by the Longstreet family. It was one of the largest and most prosperous farms in its area, tracing its history to 1806, when Hendrick Longstreet combined several farms into one 495-acre spread. By the early twentieth century, the farm had become old-fashioned: tenant farmers raised grains, livestock, and potatoes, using horse power rather than more modern steam and gasoline equipment. The farm remained in the family until 1967, when it was purchased by Monmouth County, restored, and opened to the public.

In this view are the Old Cow House (1820–40), New Cow House and Shed (1858–61), carriage house, stable, and farmhouse, built in 1775 and modernized throughout the nineteenth century.

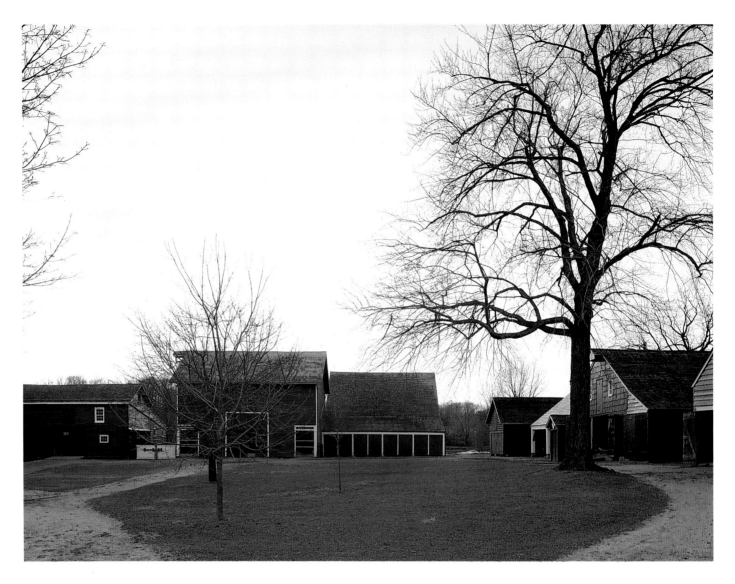

Longstreet Farm retains an impressive complement of farm buildings from the nineteenth century. The circular drive passes by, from left to right: carriage house, stable, Dutch barn, corn crib, wagon house, and cider house.

The carriage house was built by a family member in the 1890s to keep his carriages and light horses separate from the farm vehicles and animals owned by the tenant farmers.

The corn crib was built about 1900 to dry and store feed corn for the farm animals. It is raised on posts to keep out pests.

In the 1830s, an old cider house was converted into a wagon house to store more and different types of machinery. In the 1890s, a wagon house was converted by the addition of a cellar which provided cool, dark storage for potatoes, a cash crop for the tenant farmers.

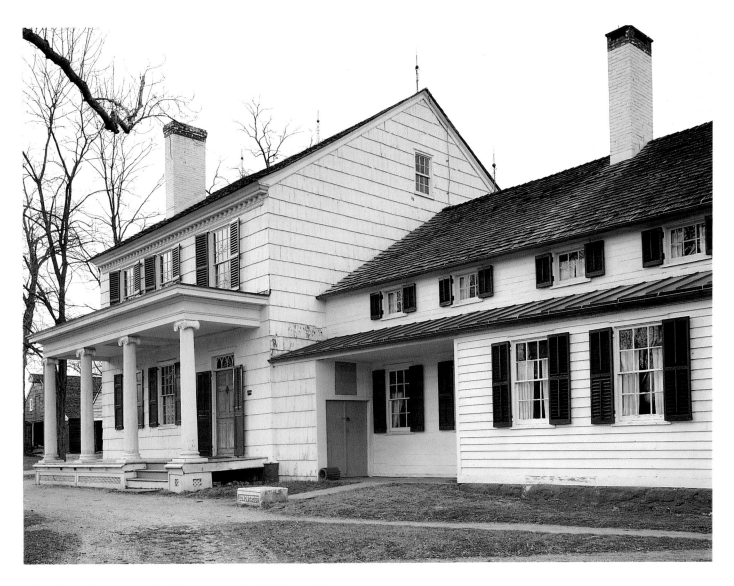

The farm house was the Longstreet family home from around the time of the American Revolution. The house was originally built in 1775 as a two-room cottage in the Dutch tradition. The large, two-story main section was added around 1800. Around 1840, the family added a larger kitchen on the east side and a Greek Revival porch to the front. Today the house has fourteen rooms furnished to taste of the 1890s, including front and back parlors, sitting room, maid's room, bedrooms, dining room, and kitchen.

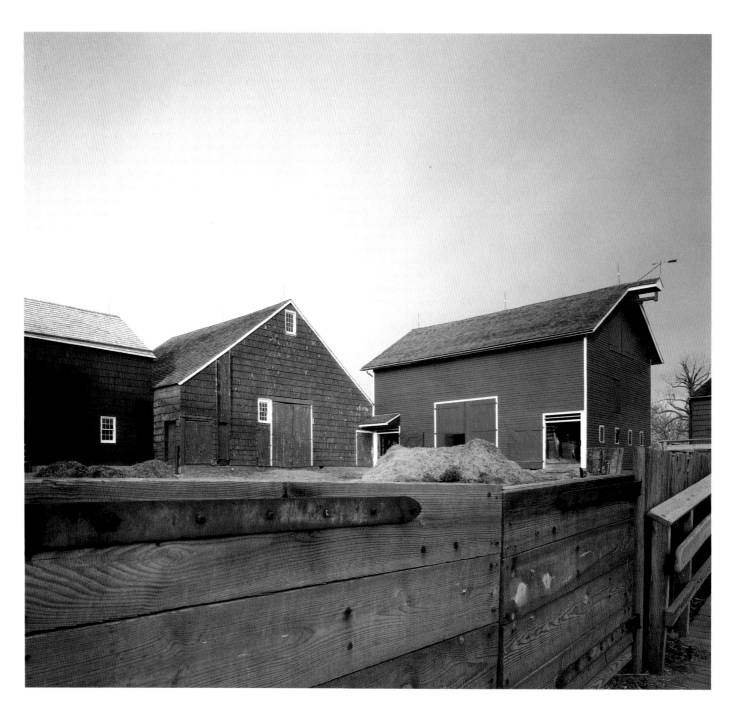

The Dutch barn, seen at the center of each photograph here, was built around 1800 and is pre-dated only by the farmhouse. It was originally used as an all-purpose building where the farmer kept horses, milk cows, equipment, hay, and grain. Farmers of Dutch descent in this area built similar barns as adaptations of buildings familiar to them in Holland. The barn's characteristic features include the steeply pitched roof and large double doors on the gable end.

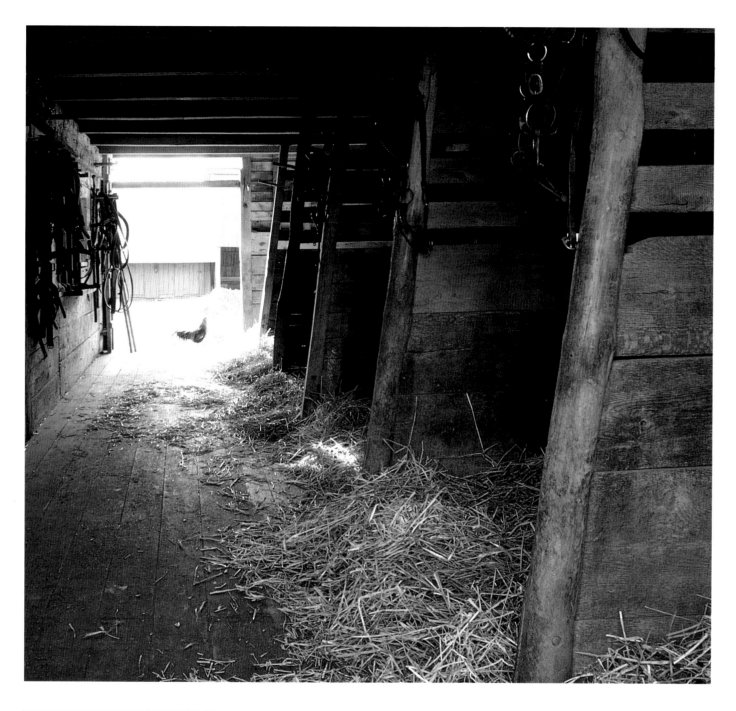

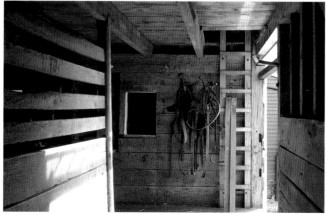

The stable, recently restored, housed four horses and four mules that did the heavy farm work. The mow above was for hay storage. Windows on the outside wall bring light into the stable interior; livestock were never kept in complete darkness when put away for the night. A harness for each horse hangs on the wall facing the stall openings.

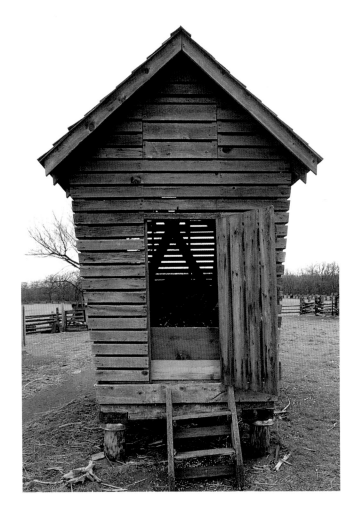

Cribs

The corn crib on the Kelley farm was reconstructed from mid-nineteenth-century plans published for farmers. In the first half of the nineteenth century, corn cribs were usually made of stacked logs. By the 1840s and 1850s, the availability and affordability of sawn lumber led to the development of the keystone-shaped corn crib. The walls are made of thin lath boards, with room between them for free ventilation in order to dry the corn well.

below left
The corn crib was built on elevated posts to help ventilate and dry the corn. The posts and the upside-down tin pans on top of them make it difficult for mice and rats to get into the crib. The steps to the door are portable, so they can be easily removed to eliminate another possible entrance for rodents.

opposite
These New Jersey corn cribs have walls slanted inward, which help ventilate and dry the corn by minimizing the amount of corn on the damper bottom levels and maximizing the amount at the top.

As long as sufficient space is left between the siding boards, corn cribs can be covered in almost any way; vertical, horizontal, and diagonal boards give corn cribs regional identities, while rarely deviating from the archetypal keystone shape.

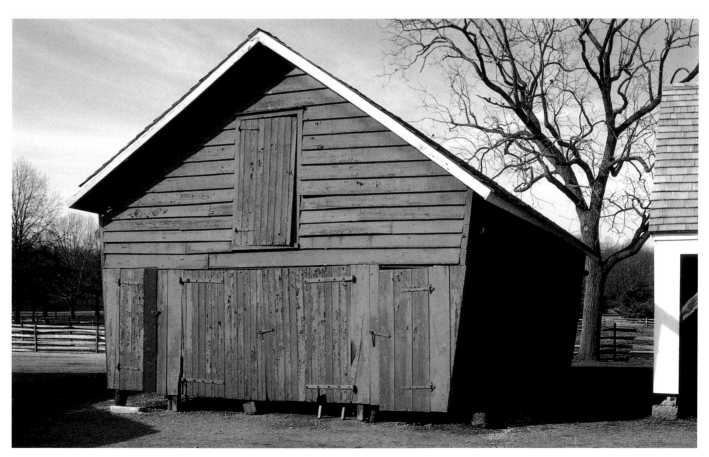

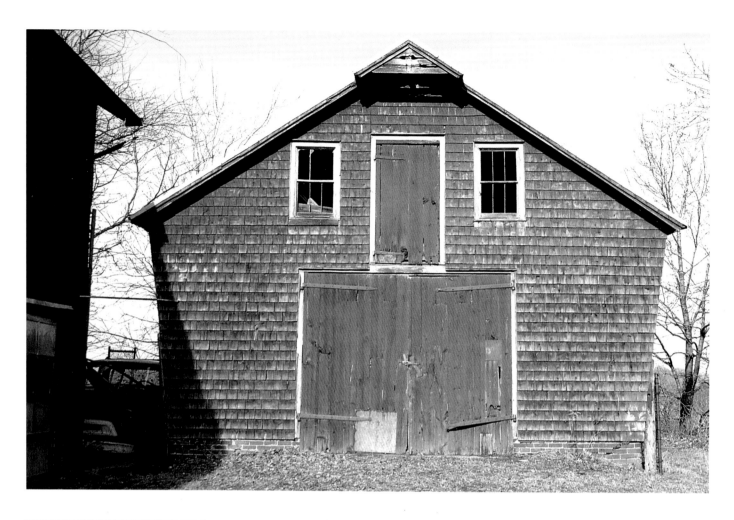

A hay loft sits on top of a large two-bay, drive-through corn crib in New Jersey.

left
The interior of the corn crib at the 1900 farm in Urbandale, Iowa, shows its diagonal cribbing. This type of cribbing was more labor-intensive during installation and used wood less efficiently than horizontal cribbing, but it provided extra bracing for the structure and shed water better.

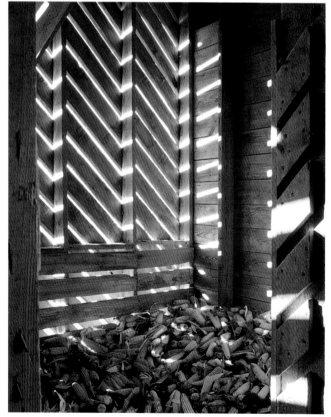

Wagon and Springhouses

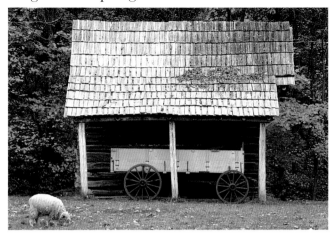

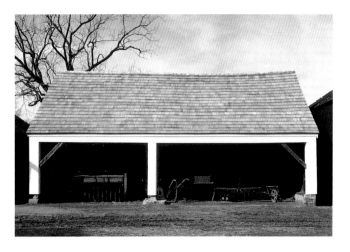

This open Tennessee field crib served as a shelter for the farm wagon and also for rainy day work space.

An old cider house was converted into this wagon shed on the Longstreet Farm in New Jersey.

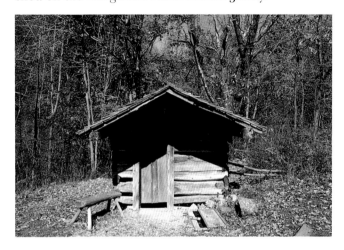

These springhouses in Virginia (at right) and Tennessee (below) are typical of the small structures built to cover the spring and also to provide cool storage for dairy products and perishable foods during the summer. Built with thick, insulating walls, they were ventilated to prevent mold and damp, and their interiors were often plastered and whitewashed.

A pump sits under the cantilevered roof of a New Jersey well house.

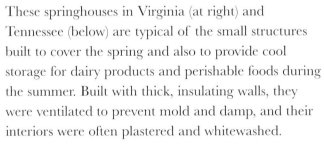

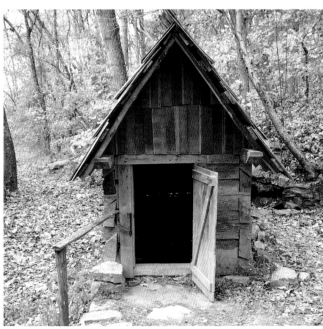

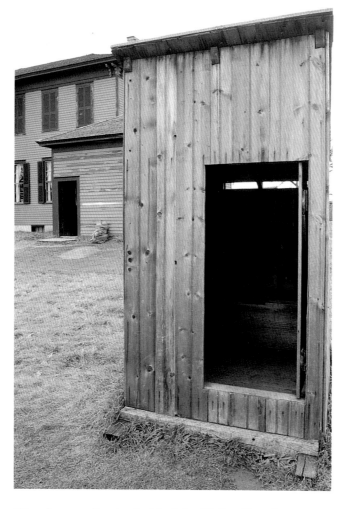

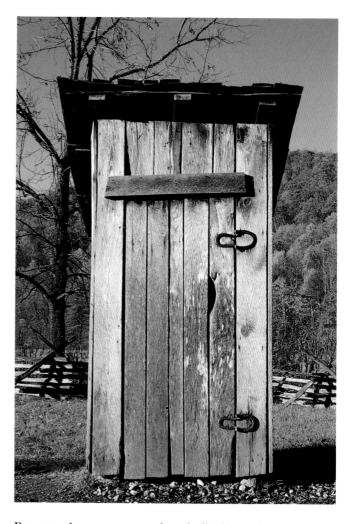

The slant-roof privy behind the Kelley Farmhouse has been reconstructed to its 1855 appearance. The two-holer has openings of different sizes for men and women and children.

Because they were moved periodically and not shown off to neighbors, privies were often not crafted with the same level of design and finish as farmhouses.

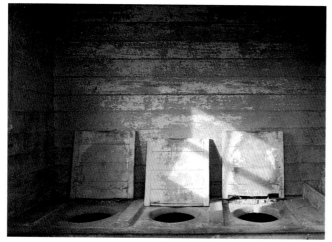

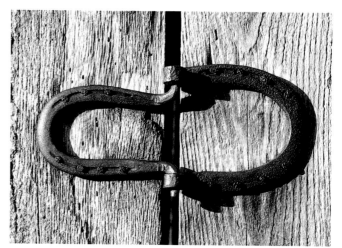

A three-hole privy in New Jersey. Privies were often decorated with pictures and pages cut out from magazines and newspapers. Most popular were puzzles, quotations, and pages from seed catalogs.

A horseshoe door hinge on this Appalachian privy represents an efficient reuse of iron. Door hinges of this type are often found in this region.

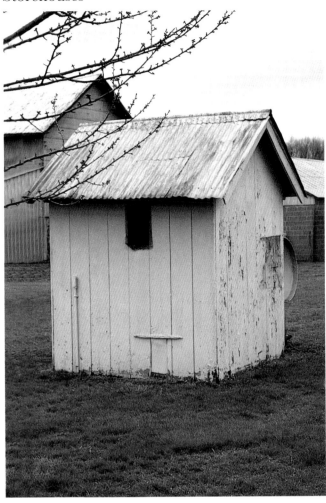

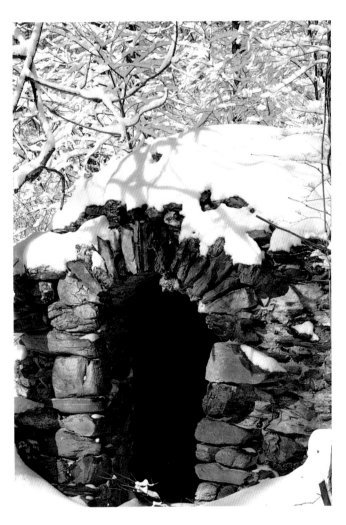

This smokehouse stands on a New Jersey farm. Fresh meat was smoked over a slow fire of green wood that was lit in the middle of the smokehouse floor; the smoke rose and exited through vents under the eaves.

A New England root cellar has an arched, unmortared entrance made of local stone.

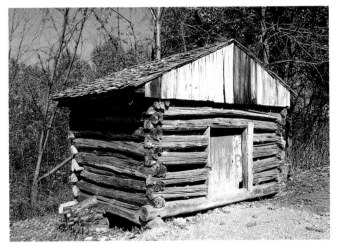

Smoked meat was stored in this small storehouse in the Blue Ridge Mountains of Virginia, with necessary ventilation for curing left between the rough-hewn log construction.

This seemingly isolated icehouse was located on a large Massachusetts farm. It was built on a slope, allowing for easy movement of large blocks of ice.

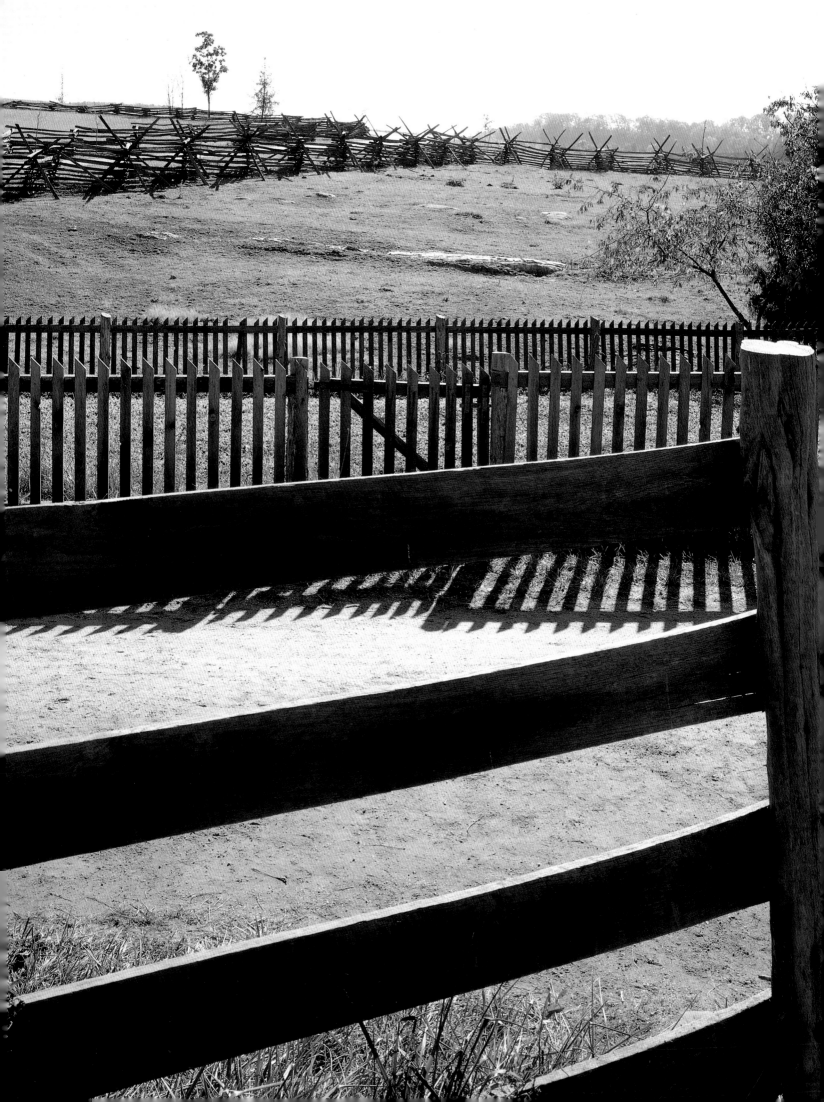

opposite

At the Botetourt County farm in the Valley of Virginia, neatly sawn board fencing encloses the house and barnyard. Tighter picket fencing protects the market gardens. More portable stake-and-rider fencing keeps animals out of the field crops of corn, wheat, and tobacco.

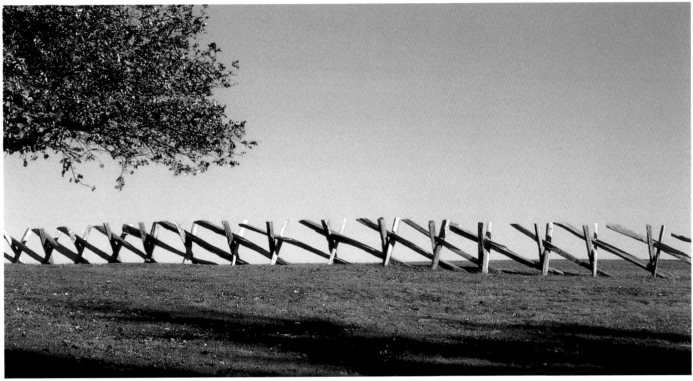

An Irish fence seems to step across the land. Although this type of fence used wood relatively economically, it was not widely seen.

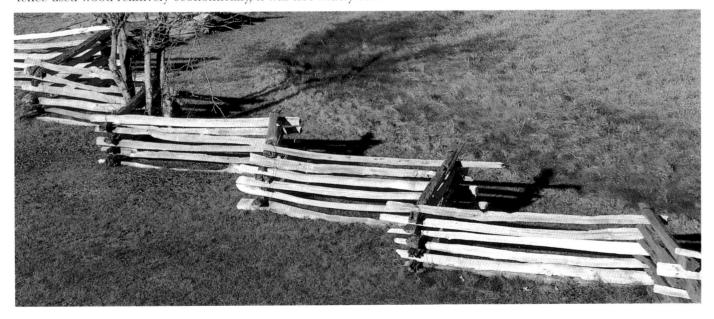

The rail fence is common throughout Appalachia, and is sometimes called a snake fence.

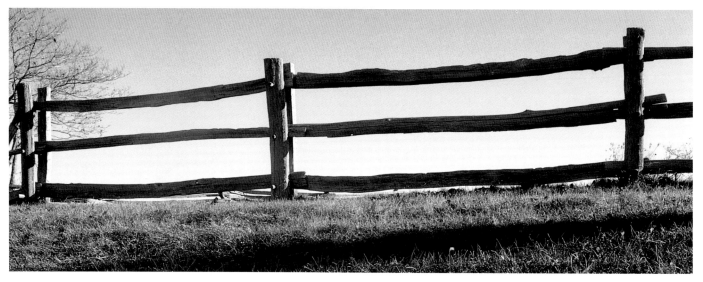

Post-and-rail fencing

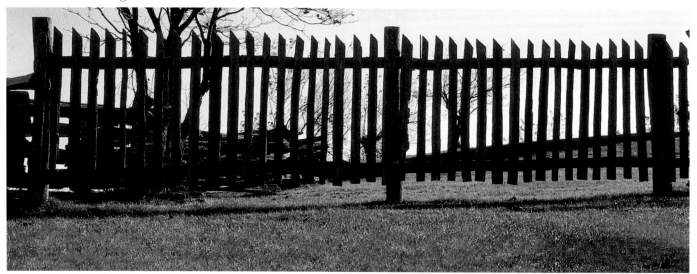

Paling fence

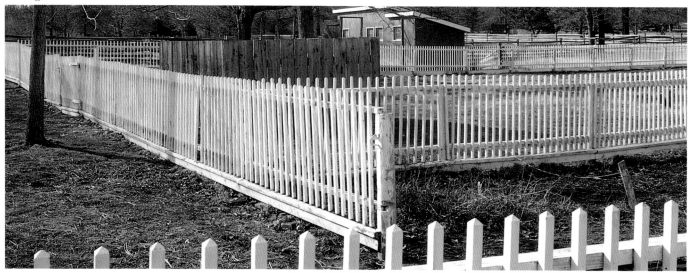

Picket fencing

Reconstruction

IN MANY CASES, the very things that make a farming region successful also bring about its decline. People are drawn to nature and to prosperity, and the fertile farmland of New Jersey and southeastern Pennsylvania offers both. Looking for a nice place to live, city dwellers have come to the country and wanted to stay.

Developers were quick to understand this. Since 1975, over a million acres of farmland in Pennsylvania alone has been developed. While there is nothing inherently harmful in wanting to live in a rural area, the pressures of development have done a great deal of damage to farming communities. As suburban developments are built in these areas, several things happen. The price of land rises, encouraging some farmers to sell their land to developers. Other farmers are not able to buy land for their sons to farm, causing at least part of the family to leave the area or to leave farming, or both. As fewer people work the land, the services they depend on—tractor dealers and repair shops, feed stores, livestock markets, creameries—begin to leave, making farming a more expensive proposition. And at some point, enough of the farming infrastructure leaves that farming becomes almost impossible.

Suburban-style developments also increase the load on sewer, transportation, and electrical facilities. Once one or two stretches of farmland have been developed into fifty or a hundred houses, new sewer lines must be laid and roads must be widened. Although these services benefit only the new homeowners, the tax revenue needed to build and maintain them is collected from every household, forcing farmers, who can usually ill afford it, to subsidize the very things that are driving them from their land. And once new sewers and wider roads exist, development becomes easier and more attractive.

Although the forces of real estate development are difficult to battle, American farms and farm buildings are being saved. In many cases, land remains in farming. While large businesses dominate large-scale farming, many family farms near cities have found new markets for fresh and specialty produce.

Farmland trusts, on national and state levels, work to ensure that some tracts of land remain in agriculture by transferring development rights from the landowner to these trusts. Money from these transfers allows farmers to upgrade equipment and to restore their buildings to working order.

But it is not always possible to preserve the land that historic farm buildings sit on. In these cases, they can be moved. Some preservationists object to moving historic buildings, and their objections are good ones. A moved building loses much of its history—its orientation to the land, its position in the landscape and the community, its relationship to the buildings that surround it.

However, a moved building is preferable to a destroyed one. Although farmhouses, barns, and outbuildings may be redundant on the landscape, they retain their simple dignity.

When a building is in danger and can be removed from its original site, the structure is photographed, measured and drawn, disassembled, and moved. As it is disassembled, the value of the building becomes more apparent. The layers of construction are removed, revealing parts of older buildings, fragments of original paint or wallpaper, and ephemeral traces of the people who lived there before, such as inscriptions behind plastered walls and woodwork and newspapers stuffed between floorboards for insulation.

What follows are some examples of how historic American farm buildings are being restored and moved. On their original and new sites, great care is paid to their accurate restoration and rebuilding, giving them the attention they need to remain living buildings for generations to come.

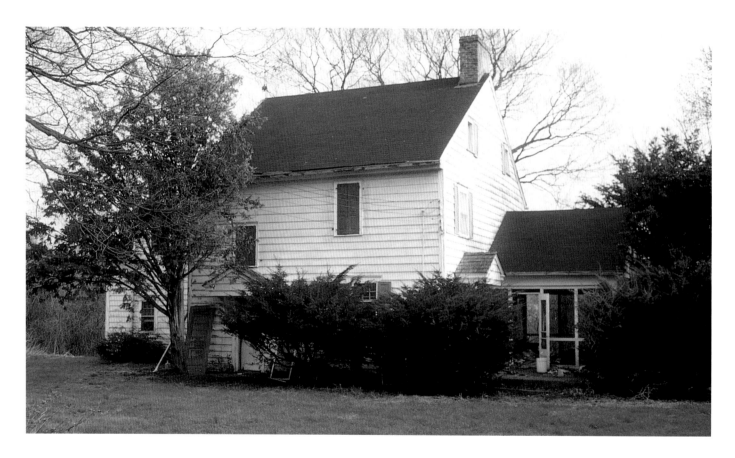

The Burroughs House had been abandoned about four or five years before it was relocated. A former resident of the house, who had thought that the building had been destroyed by fire, discovered that it was still standing but in jeopardy. He originally planned to move the structure to New England, but eventually another site was found, only a couple of miles from the original location. Although the house was moved from its original context, it has remained very much part of the local vernacular.

The original clean lines of the Georgian-style main house survive, although the windows and their placement on the back of the house are not original.

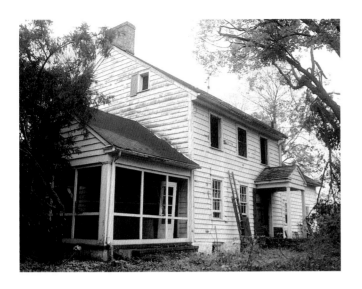 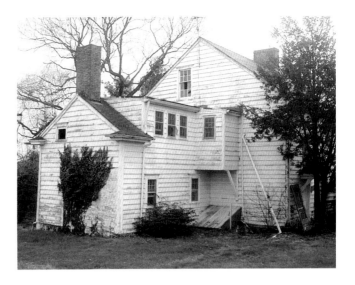

The Burroughs House before relocation. The second-floor windows are original twelve-over-eight sashes; the first floor's twelve-over-twelve sashes were replaced by six-over-six sashes in the twentieth century, reflecting contemporary tastes and modern glazing techniques. The attic window is original; as in most New Jersey houses from this period, the attic windows are placed only on the side walls.

Aside from sharing a roof angle, the screened porch was not particularly sympathetic to the design of the house and was not rebuilt on the new site.

The eastern wing of the Burroughs House is a late-eighteenth-century Dutch-style kitchen. The massive chimney base is exposed, typical of houses in the Mid-Atlantic. The chimney was rebuilt in the 1860s, a fact known from a dated brick found during disassembly. Only the small loft window on the gable end is original. The extended dormer on the second floor and the protruding overhang were added later, as was the heavy cornice; originally the rafter tails were visible.

Original details in the front parlor of the Burroughs
House include the shelving in the barrel-back
cupboard and the dog-eared architraves above it.
The dog-earing on the architraves, a sophisticated
decorative feature, is seen only in this room, reflecting
the parlor's status as the most important room of the
house.

The mantel shelf, the only original mantel surviving,
had already been removed when this photograph was
taken. The door at the left was probably added at the
same time as the porch, replacing an original closet.
The original flooring existed underneath another
layer added later but was not in good enough shape
to restore in the rebuilt house.

This wonderful bathroom at the Burroughs House shows the understated exuberance of pre–World War II interior design. The bathroom was added around the turn of the century, and refurbished later. Although it is not original to the house, its location was preserved when the house was rebuilt.

The addition of modern amenities such as indoor plumbing and electricity often produced considerable changes in farmhouses. Although their timber frame construction allowed room for routing pipes and wires, the additional space needed for a bathroom often caused wholesale rearrangement of the floor plan and spilled outside the original boundaries of the house.

As disassembly began, the house's clapboarding was removed, revealing the sheathing boards and some of the frame underneath. The clapboarding was not original, so the positioning of the nail holes on the corner posts was measured and analyzed, revealing how the boards had originally fit. This arrangement was used in reconstruction.

Although the exposed chimney base of the kitchen fireplace is plainly visible, the traces of an original beehive bake oven are not. It is not known when the bake oven was removed, but it was undoubtedly some time ago, perhaps in the mid-nineteenth century, when cast-iron cookstoves became widely available.

To the left of the chimney base is the ghost of a window that was probably added when the staircase to the second floor was removed. The second-floor window is original, as are some of the sheathing boards. The large opening at the right is part of a hallway added later, which bore no relationship to the original floor plan of the house.

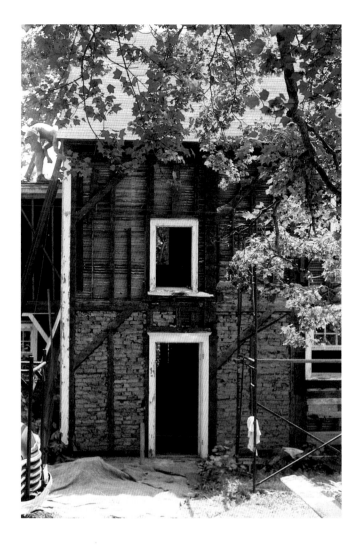

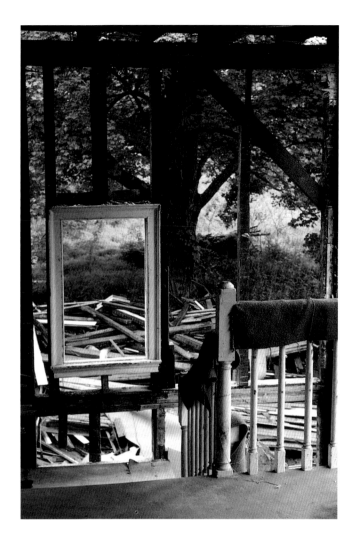

In this view of the rear of the main section of the Burroughs House, only the windows on the back of the second floor and in the attic are original.

Windows on the back of the house, facing north, were generally smaller than the south-facing ones, reflecting a consciousness of the position of the sun over the course of the seasons. On the second floor, the major timbers and braces are visible. English houses like this used lots of wind braces, which greatly increased their stability and life expectancy.

After the sheathing was removed, the timber frame, interior lath, and nogging were revealed. It was at this point that much of the evidence of the original structure and later changes became clear. Below the ganged, or doubled, kitchen windows, for example, the brick nogging had been interrupted with new sheathing. The absence of structural changes around the other openings testified to their age.

The exterior walls, as well as the interior walls supporting the summer beams, of eighteenth-century farmhouses often have unfired brick used as nogging, which serves as insulation and gives the structure more rigidity. In this house, shingle lath was placed over the unfired brick before it was plastered, further indication that the Burroughs House was of a higher quality than most homes of the period.

149

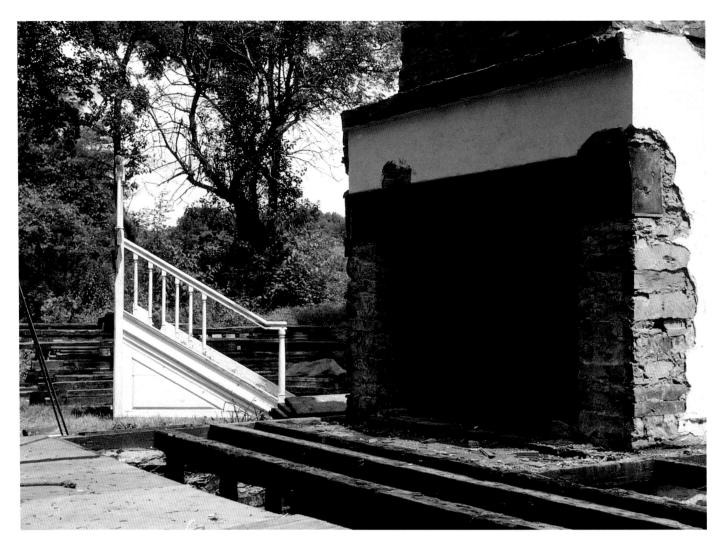

Because the stonework of this fireplace would be visible in the reconstructed house, the stones were numbered, documented, disassembled, and moved. The other fireplaces in the house had always been plastered over, and in some cases relined with firebrick, and did not warrant such intricate and accurate reconstruction.

In the background is the lower section of the original staircase from the main section of the house, taken out in three pieces. The ornamentation on the side of the lower staircase panel was probably made by a local carpenter, although his work was up-to-date for the period, probably learned from a Philadelphia craftsman.

After the nogging was removed, the sturdy timber frame was carefully marked for disassembly, moving, and reconstruction. The horizontal beam, a girt, is supported in two ways—it is pegged into the post with a tenon and it is shouldered so it sits on the post itself.

150

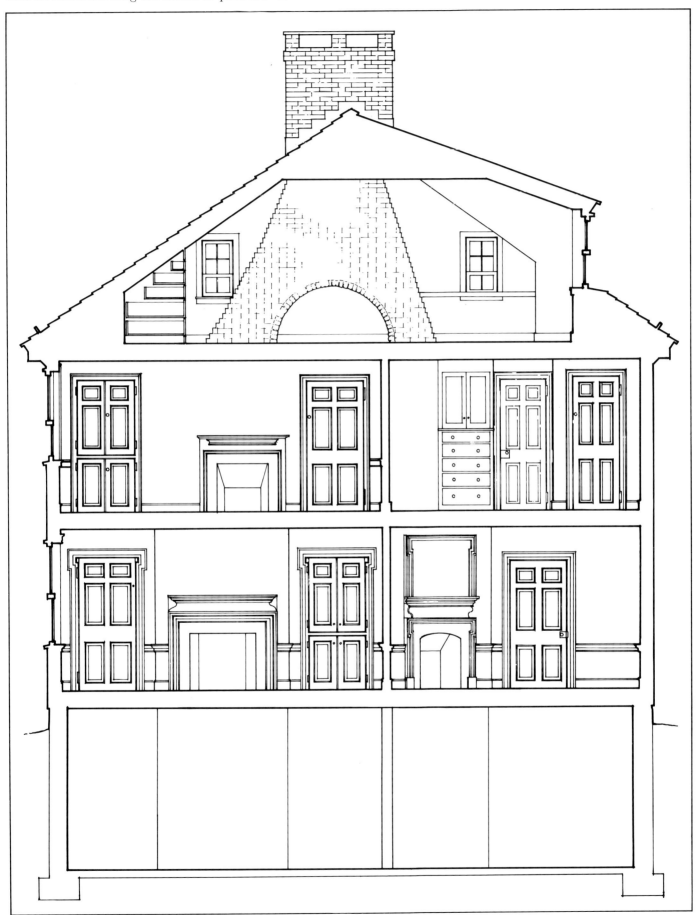

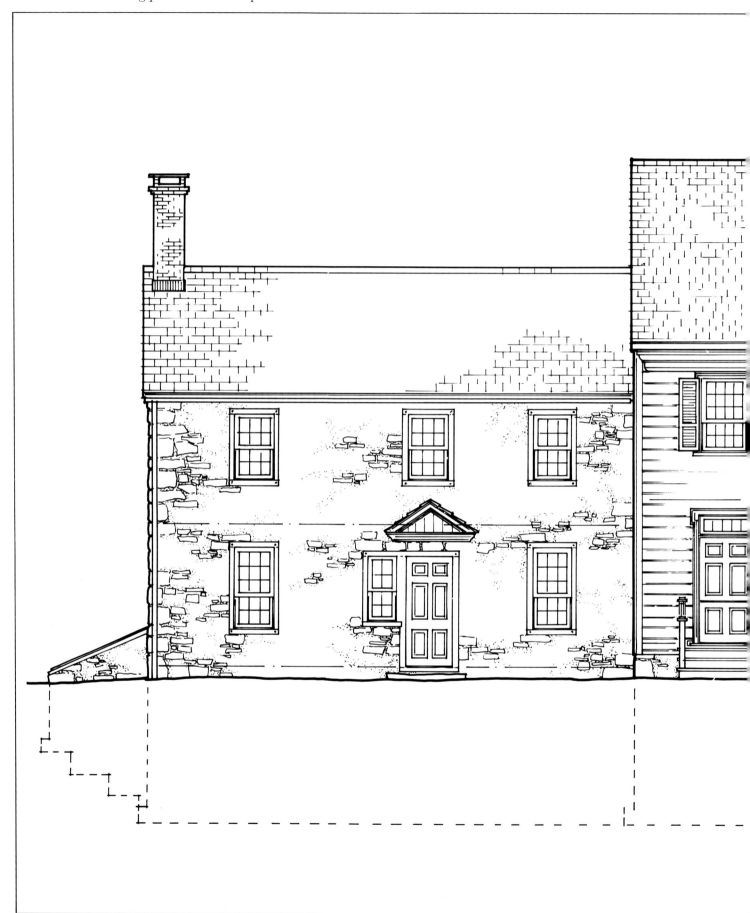

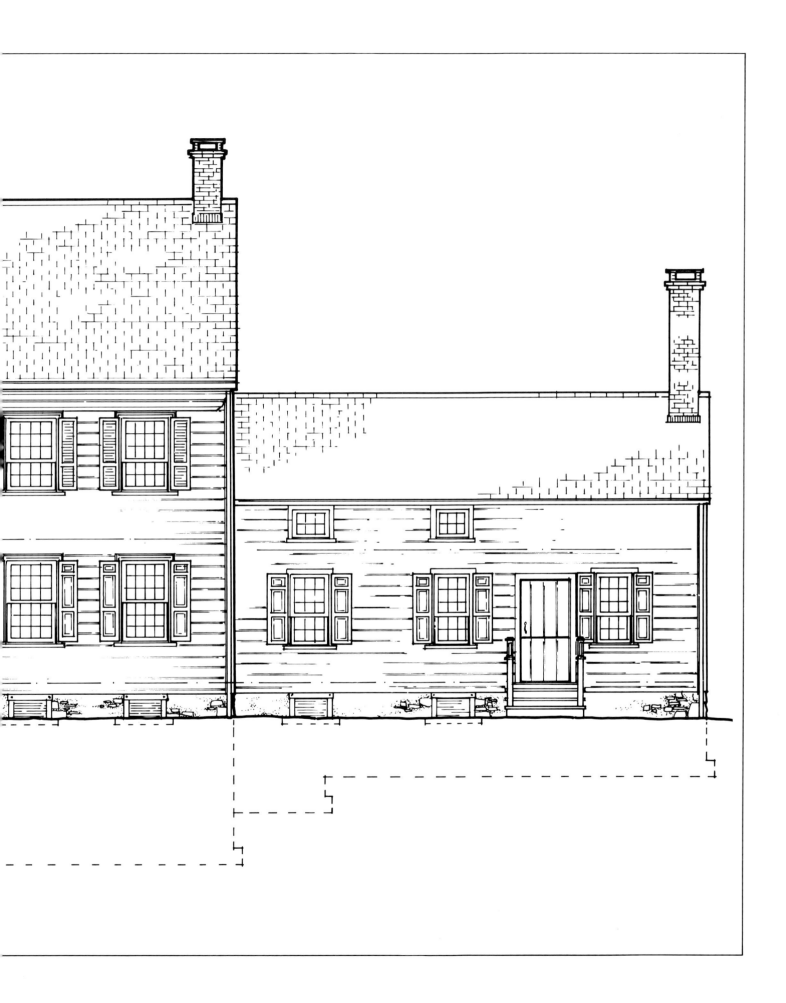

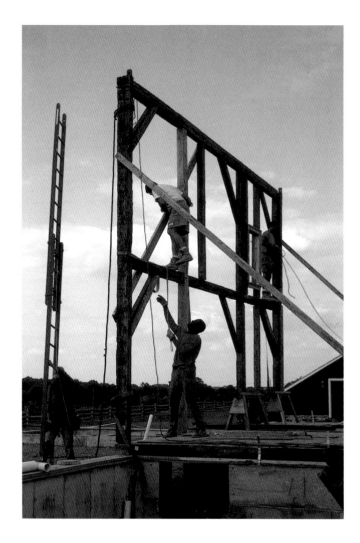

On the new site, the rafter sets for the Dutch wing were laid out and their measurements checked. The rafters were originally held together with only a peg; for added stability a collar was nailed on before they were raised. The truck is a 1948 Chevrolet.

The first bent is raised on the new site of the Burroughs House. This is the rear wall section of the main house. Once the front and back walls are in place, tie beams are run between them and studs and braces are erected.

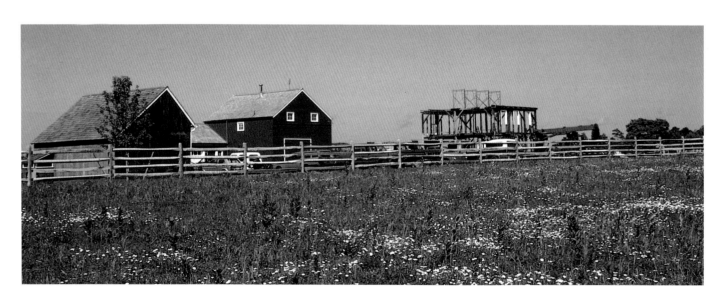

opposite page bottom

The second floor of the main section is partially raised in this overall view of the Burroughs House's new site. At left are a wagon house and a wood shed, which came from Bucks County, Pennsylvania, about fifteen miles from this site. The wagon house is reused as a garden and tractor shed.

Careful drawings were also made of the smaller buildings surrounding the Burroughs House.

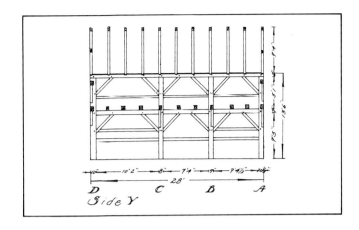

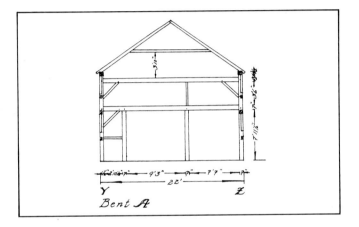

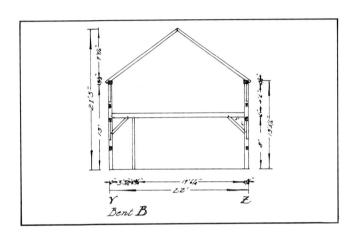

The soil and the lay of the land of the new site were well-suited for the pond the new owner wanted to install on the property. Natural springs that were discovered when the foundation of the new house was being laid are channeled down to the pond, and the rain gutters also drain into it.

With the house almost completed, the arrangement of the buildings took shape. At the left is an addition to the wagon house built to resemble a 1930s or 1940s garage; next to it is the wagon house, and next to that are the three connected sections of the Burroughs House.

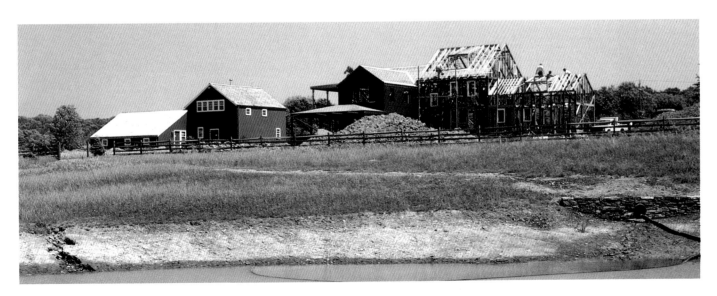

Site plan

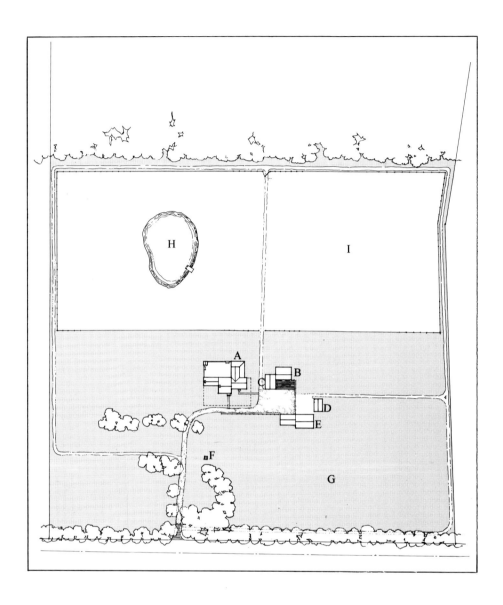

The new owner of the Burroughs House wanted more living space than the original structure offered. At the right of the main section of the house is a stone wing that is entirely new, built to resemble an early-nineteenth-century Delaware Valley stone house.

One of the disadvantages of moving older farm structures is that they lose their natural context, the trees and shrubs that had grown around them for decades. However, this situation gives us a better sense of the way these buildings looked when they were built in the eighteenth century, when the land was freshly cleared.

In this view, the cladding of the main section and the Dutch wing is almost finished, and the stone on the stone wing is virtually completed. In order to differentiate between the styles of the two original sections, the exposure of their clapboarding is slightly different, as are their cornices. Based on architectural evidence in both the Burroughs House and a similar house a few miles away that was almost undoubtedly built by the same carpenters, the main section has a substantial cornice with a crown molding and bed molding. The Dutch wing has no cornice; its rafter

tails are visible, although slightly obscured by a simple gutter. The stone wing has a simple cornice, as would have been used in the early nineteenth century.

A brick chimney on a stone house might seem incongruous, but it is in fact typical of Delaware Valley houses. Stones would have had to be very thin to be usable in a chimney, so brick was the preferred material. When a stone house does have a stone chimney it is often something that has been added or renovated later without following historical precedent.

left
The exposed chimney bases of the main section and the Dutch wing were completed by the time this photograph was taken. The use and form of chimney bases varied considerably by region; in this area of New Jersey, the bases were generally exposed to the level of the second-story floor, although in some cases they are only as high as the firebox. In New England, chimneys are right in the middle of the house; further south, in Delaware and Maryland, they are often exposed for their full two-story heigh, while in Virginia and points further south, the entire chimney is outside the house's frame.

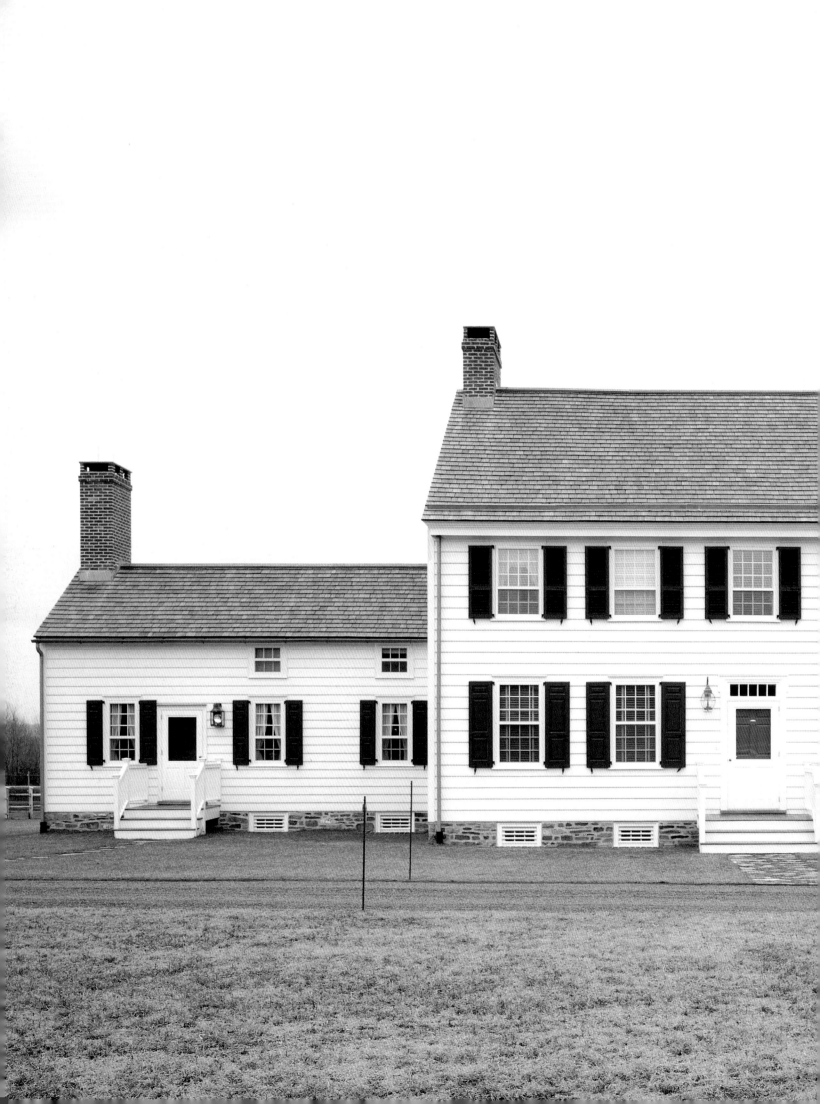

The owner wanted to expand the house from about 3,000 square feet to about 5,000 square feet. The stone wing at right is a new addition, loosely based on historical precedent. The orientation of the original buildings was also changed, with the Dutch wing moved to the left of the main house to complement the new site. The shutters, the transom over the front door, and the cellar windows were not found on the original house, but all are based on historical and regional precedents.

The stone veneer on the new wing is ten inches thick, much thicker than most veneers. The stone came from digging the foundation for the house in its new location, from the house's original foundation, and from a farmhouse that used to be on this property. All of the colors and types are indigenous to this property and region. The biggest stones are quoin stones, which define the corners. Between them, there are a lot of horizontal stones, with a few larger ones mixed in, which is typical of early houses. In later years, when quarrying became widespread, larger stones were used throughout.

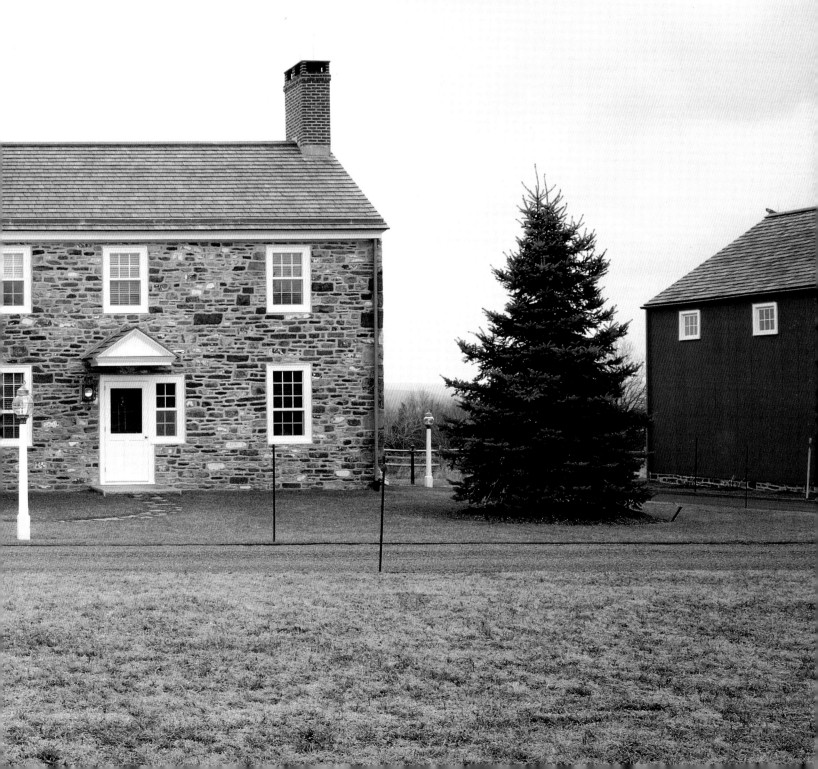

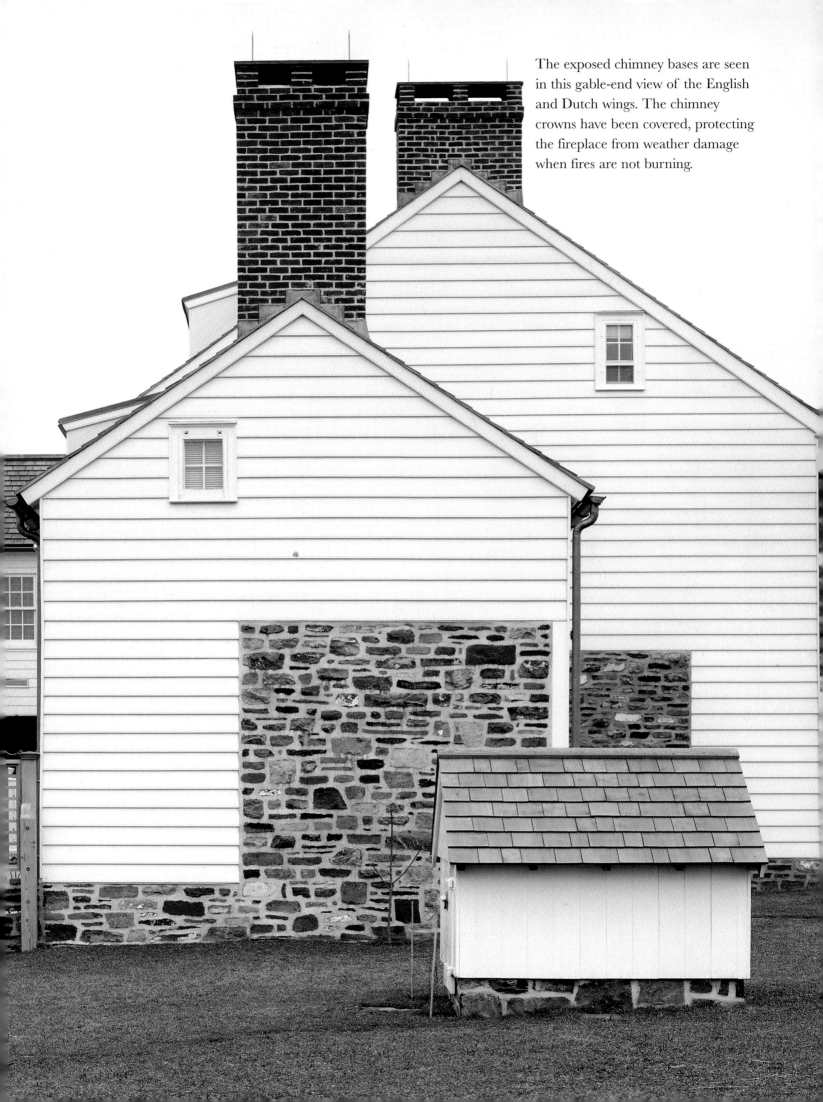

The exposed chimney bases are seen in this gable-end view of the English and Dutch wings. The chimney crowns have been covered, protecting the fireplace from weather damage when fires are not burning.

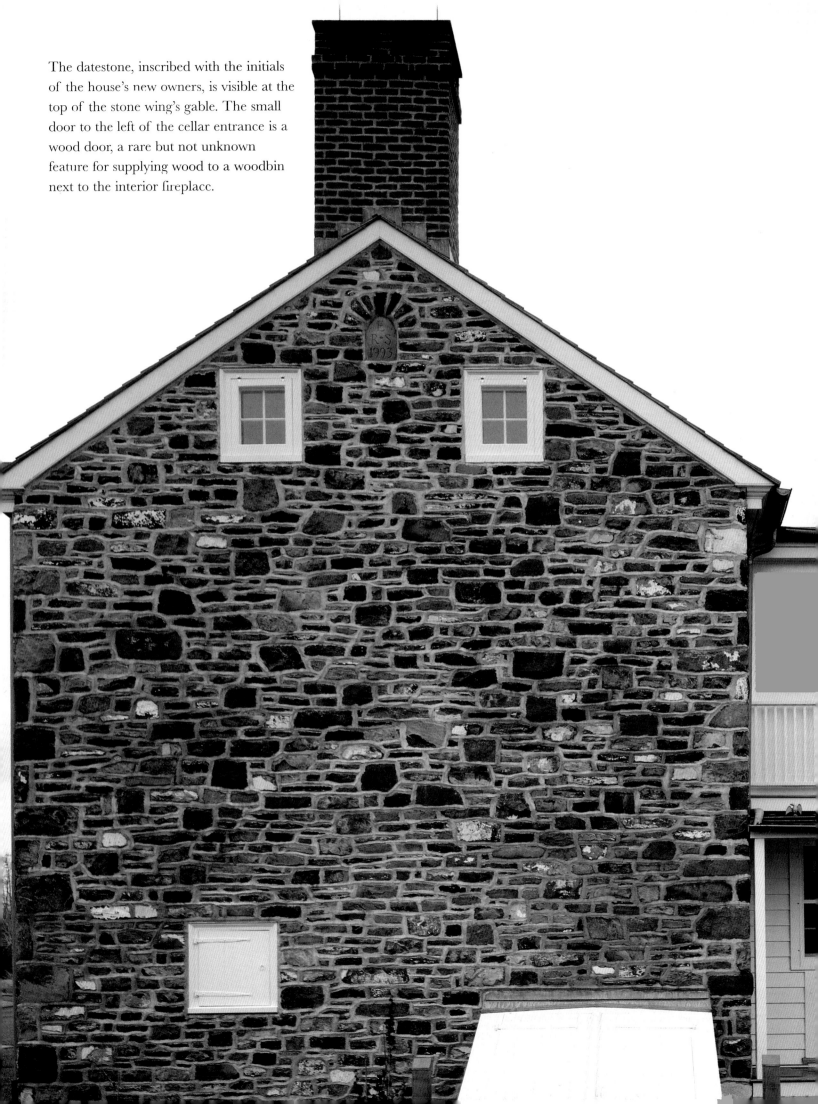

The datestone, inscribed with the initials of the house's new owners, is visible at the top of the stone wing's gable. The small door to the left of the cellar entrance is a wood door, a rare but not unknown feature for supplying wood to a woodbin next to the interior fireplace.

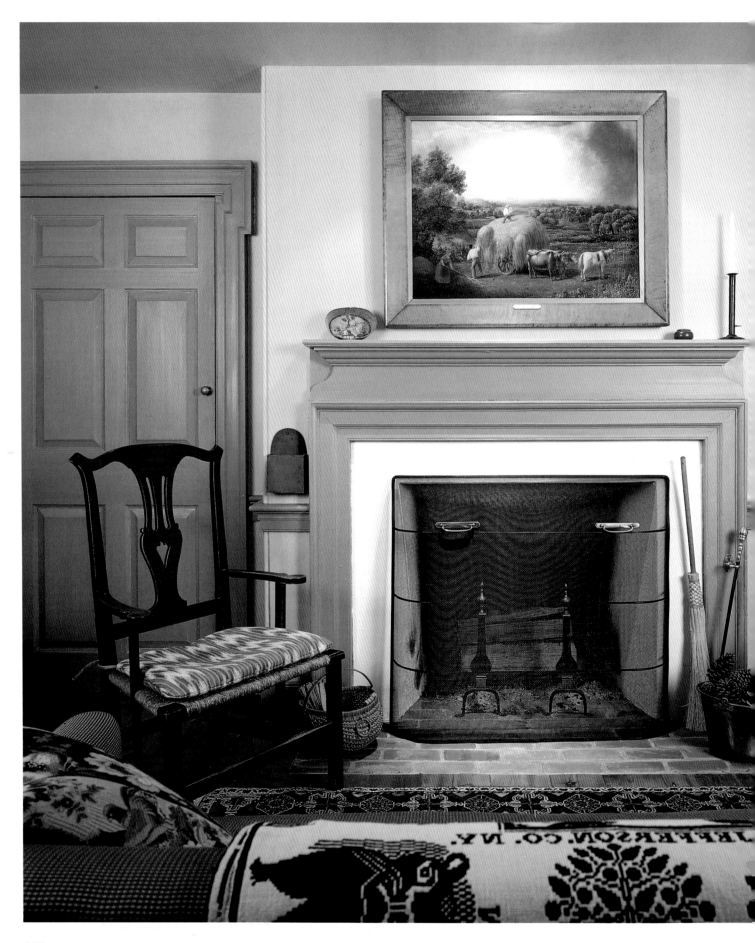

The unrestored parlor at its original site.

The parlor in the main section of the house was restored to its original layout, with a closet to the left of the fireplace where an exterior door had been added. One of the carpenters on the project made new dog-eared architraves to match those surviving above the cupboard. As was often the case in well-kept farmhouses, the fireplace brick was not meant to be exposed and was covered with a coat of mortar and whitewash to reflect light into the room. The floorboards are not original, but are early yellow pine.

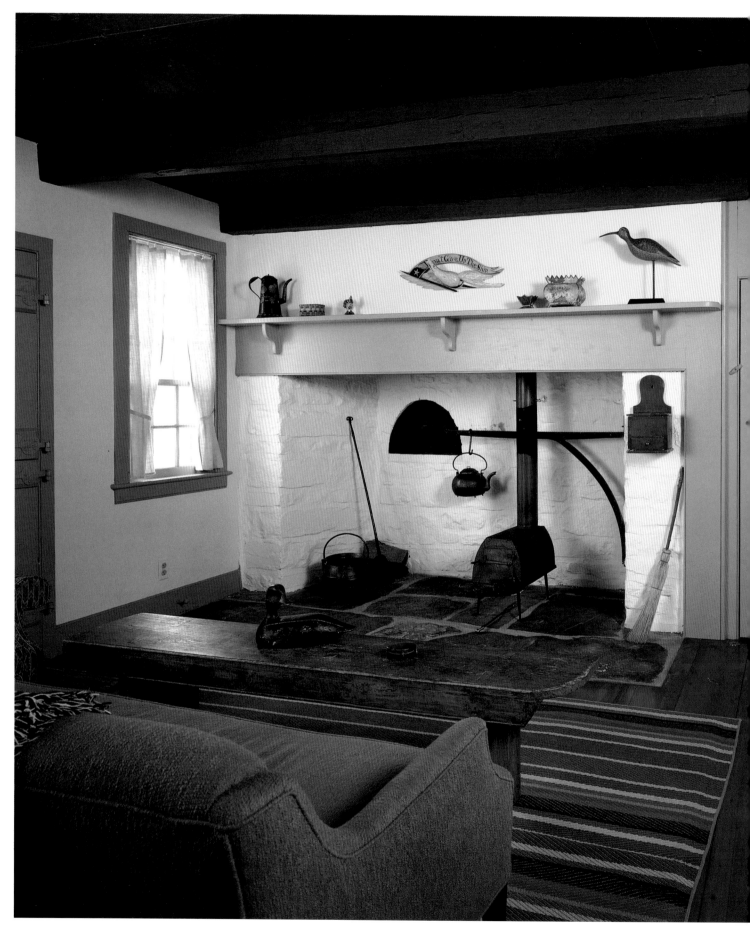

All the stones of the large cooking fireplace in the Dutch wing have been put back into their original locations and whitewashed, as was the practice when the building was a working kitchen. Around the early to mid-nineteenth century, cookstoves and heating stoves replaced open fires and were inserted into the fireplace, as the owner has done here. The mantel shelf was constructed from evidence found in the walls of the original structure. The window next to the fireplace is also typical of working kitchens, bringing light into houses that were considerably darker than modern Americans are accustomed to.

The staircase to the right of the fireplace had been removed when the original house was found, but enough regional precedent existed to believe that it was constructed in this manner. The second-floor loft would have been used by farm laborers and was not directly connected to the main house. The floor joists are exposed, as they were in Dutch houses. At the far left is the Dutch door, part of which comes from an original Dutch door from another property.

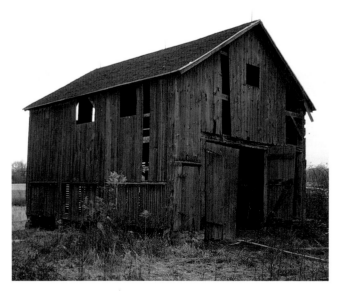

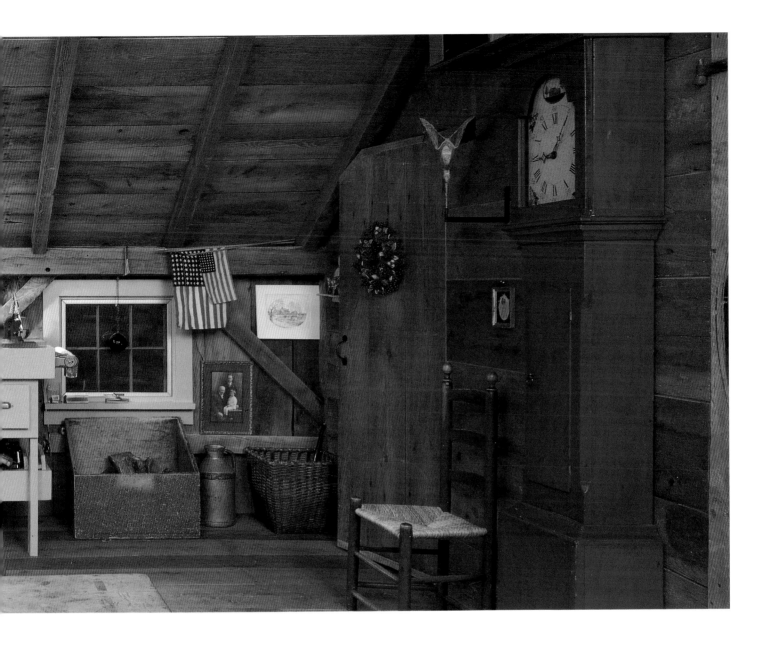

The interior of the office/studio/workshop space on the second floor of the wagon house, shown above. Its flooring, wall sheathing, and ceiling sheathing are all boards reused from earlier buildings. The boards and the frame itself have been washed to restore some of their rich color.

At left are the unrestored and restored exteriors of the wagon house.

The restored wood shed at right has a pigeon cote in the gable and is reused in part as a tractor shed and a storage area for garden equipment.

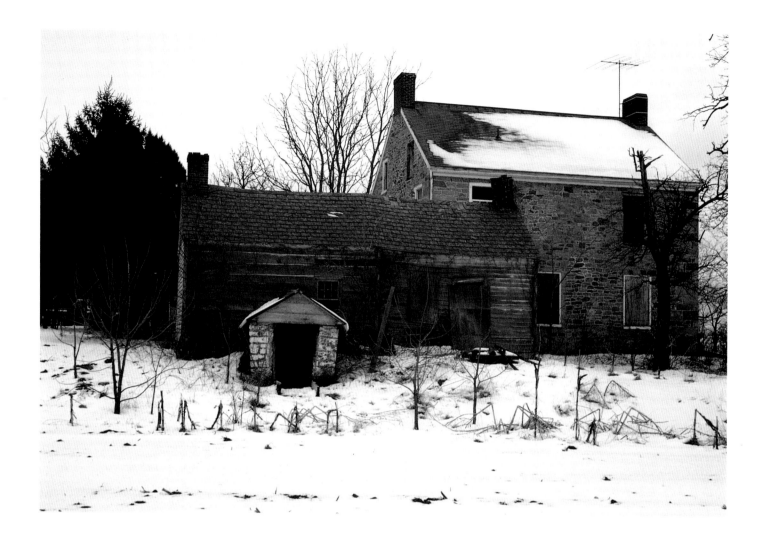

This stone house and log house in Nazareth, Pennsylvania, were scheduled for immediate demolition to make way for a shopping center when a large storm blanketed the area with several inches of snow. The log house was measured and removed in the four-day demolition delay. The time and expense of documenting and disassembling the stone house were too great, so only the log house was saved.

The log house was built in the early nineteenth century and was originally the property's main farmhouse. Later in the century, the stone house was constructed and the log house became a detached summer kitchen. At an even later date, a wing was added to the stone house and the log house was extended, connecting the two buildings.

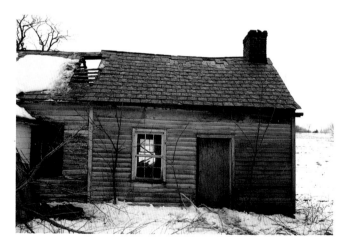

The later addition to the log house was a timber-frame structure that did not stand up to the years as well as the original, as evidenced by the damaged roof and sagging clapboarding.

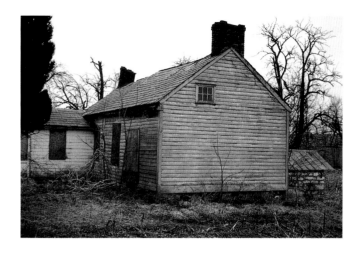

The log house originally had an exposed chimney base and a protruding beehive bake oven, which was removed at some point in the nineteenth century. After the oven was removed, the gable wall was reclapboarded, covering the chimney base.

Slate is indigenous to eastern Pennsylvania and was used for many purposes, including roof shingles, siding, and fence posts. One side of the log house's roof overlaps the other by about two or three inches, on the side where the weather came from.

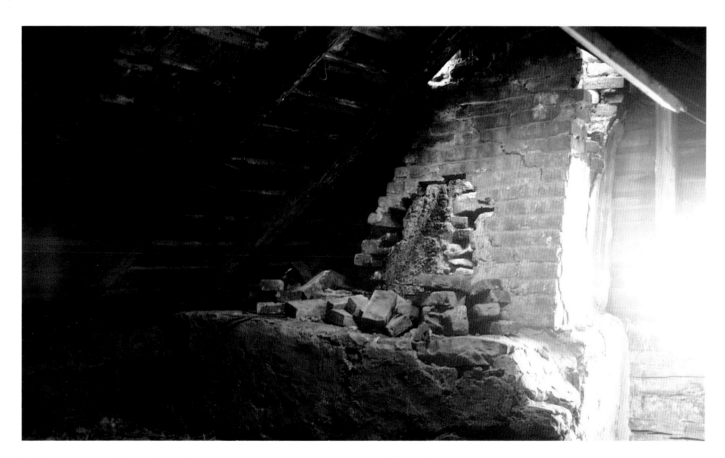

Inside the second-floor loft of the log house, the chimney had failed. The decay of often long-abandoned structures makes accurate documentation and reassembly a difficult task.

The brickwork steps to the centered chimney from the fireplace, which is obviously off-center. While the logs in the lower section of the building were joined by notches, the rafter logs were joined by tenons.

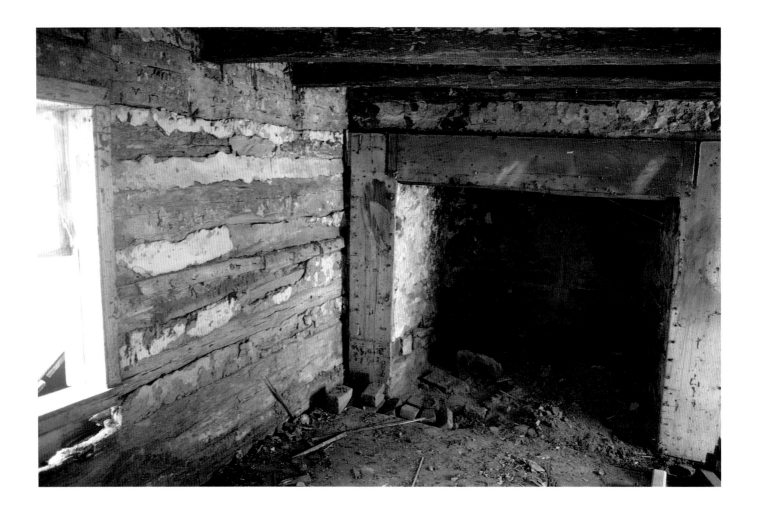

The interior of the summer kitchen shows its exposed log walls and floor joists and the massive stone fireplace. At the back right of the fireplace, the profile of the beehive oven is visible, and on the outside is an original wood fireplace surround. Many nineteenth-century fireplaces had doors on them, and although some evidence was found that this fireplace once had them, it was impossible to determine if they were original, so they were not incorporated in the reconstruction.

left
The door, which opens to a closet, and the staircase, which ascends to the second-floor loft, are original to the log house. The closet served as a small pantry, rather than for the residents' wardrobe, which was very limited and would have been stored in chests and on wall pegs. The second-floor loft was for sleeping; after the living areas were removed to the stone house, it was probably used as a storage area.

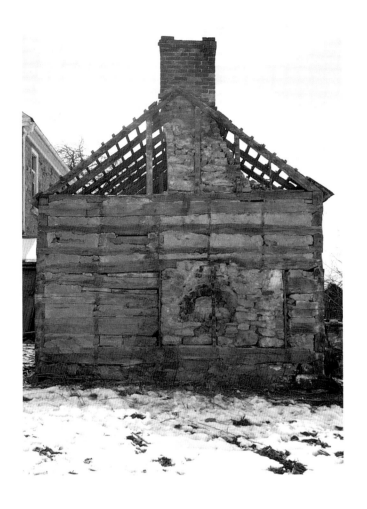

In the first stage of disassembly, the slate roof shingles and the clapboarding were removed. The log construction, nogging, chimney base, and the arch of the beehive oven are visible, as is evidence that the chimney base was originally exposed.

Disassembly of the log house has been completed, and the logs are stacked to the left of the foundation. At their right is the winder staircase, which was removed in one piece. With the logs removed around the fireplace, the protrusion of the former beehive oven is visible, providing evidence of its original size. The location of stones and brick in the fireplace and oven were recorded at this point so they could be reconstructed correctly on the new site.

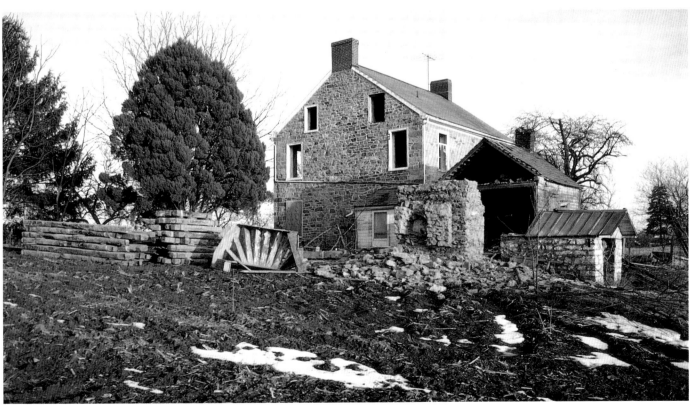

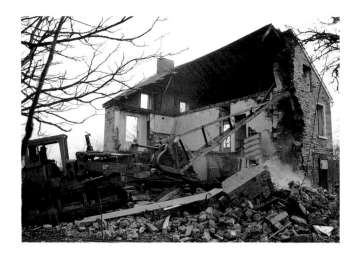

After four days of disassembling the log house, contractors arrived to demolish the remaining buildings. The stone house, which could not be moved, was summarily bulldozed to provide a site for a shopping complex, which was never built.

The lowest timbers on three sides of the structure had rotted so badly that they had to be replaced. Because the entire house stands on these timbers, the newly hewn replacements had to be made very accurately. The necessary haste of the disassembly made this difficult to ensure, but they did prove to fit correctly.

The timbers of the log house and a barn that was also saved are loaded onto a truck and taken to a storage facility.

With the log frame complete, window surrounds are inserted. The log house's new site is in view of the Atlantic Ocean.

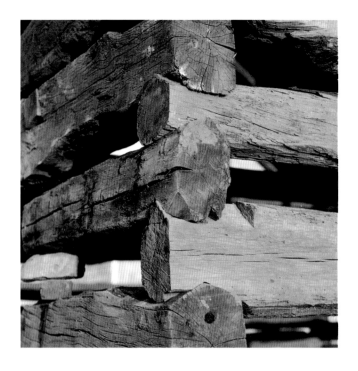

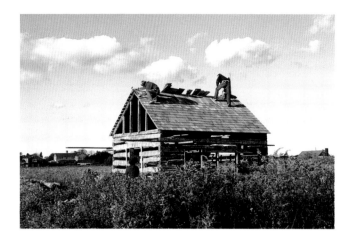

Although the log house had a slate shingle roof on its original site, eastern Long Island farm buildings were historically roofed with wood shingles, so these were used for the log house.

The corners of the log house were joined with V-notches, the most common method of making corners on eastern Pennsylvania houses. Horizontal log construction was first introduced in prehistoric times in central and northern Europe; until the settlement of America, these structures had logs left round and overhanging, rather than squared, at the corners. The Pennsylvania German settlers of the late seventeenth and early eighteenth centuries used roughly squared timbers, and made their corners flush and square, producing a tight wall.

above and below

After the roof is finished, the relationship between the log house and its new surroundings begins to take shape. Behind it is a barn from Marlboro Township in Monmouth County, New Jersey, reclad in shingle to reflect local precedent. Its shape and roof angle complement the log house well, reflecting a similar architectural background.

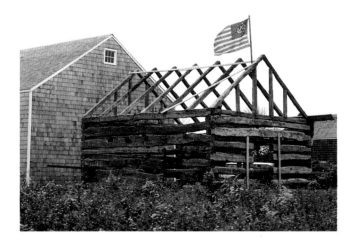

The American flag is flown to celebrate the raising of the last set of rafters.

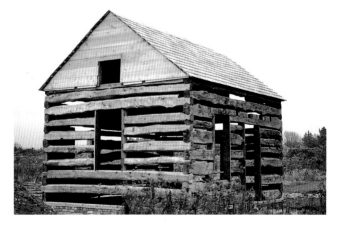

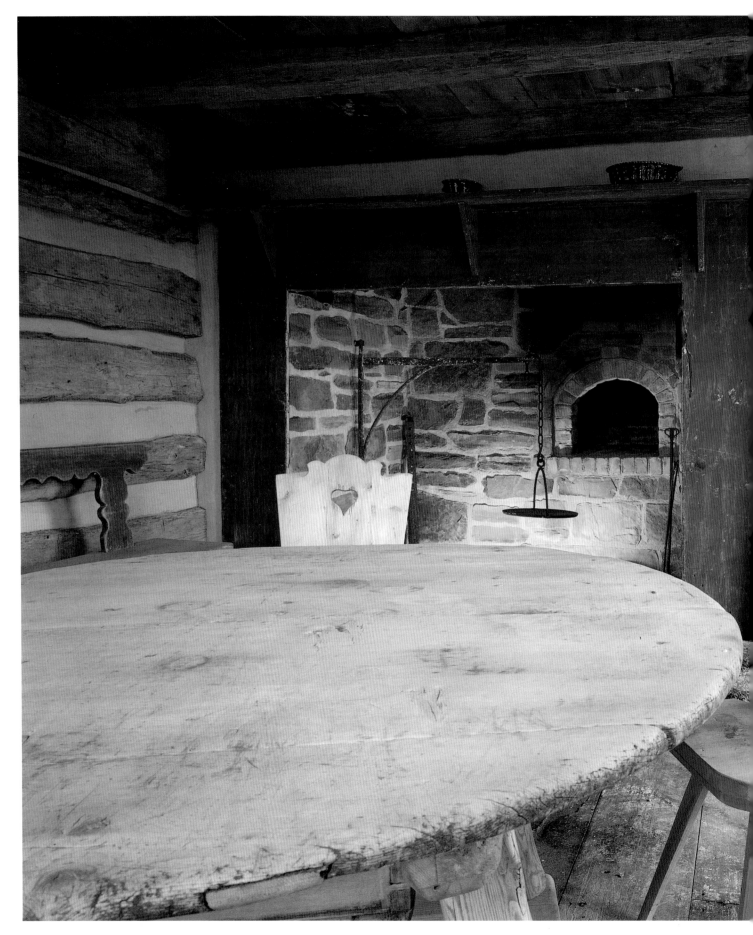

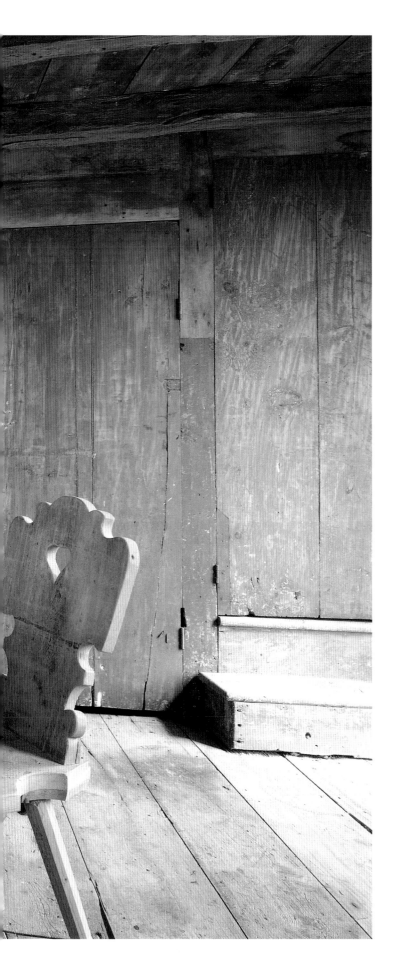

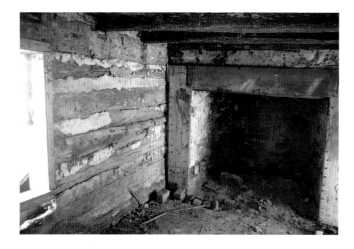

Interior of Nazareth log house showing bricks from the collapsed chimney.

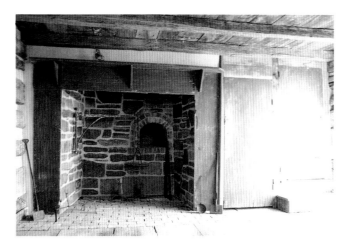

The log house as reoccupied serves as a summer dining room on the estate. The early furniture is from Germanic sources or influences, and may be similar to the furniture used by the house's original builder and occupants.

The Nazareth log house stands restored on its new site; behind it is the barn from Marlboro Township, New Jersey. Although the interior of the building was restored to its original state, the exterior was adapted to reflect local styles and materials and to fit into its estate setting. Farm structures in eastern Long Island were typically clad in cedar shingle with a fairly long exposure, a method that was used here and on the surrounding buildings.

To reflect the local conditions, brick was used for the exposed chimney base and the base of the beehive oven and for the visible portion of the foundation. Although the beehive oven had been removed many years before, the adjacent farm in Pennsylvania did have one, from which the dimensions were taken for this reproduction.

The geometry of the log house stands in strong contrast to the flat Long Island landscape. The profile of the beehive oven is especially pleasing, a curved exception to the straightforward materials and lines of the small building.

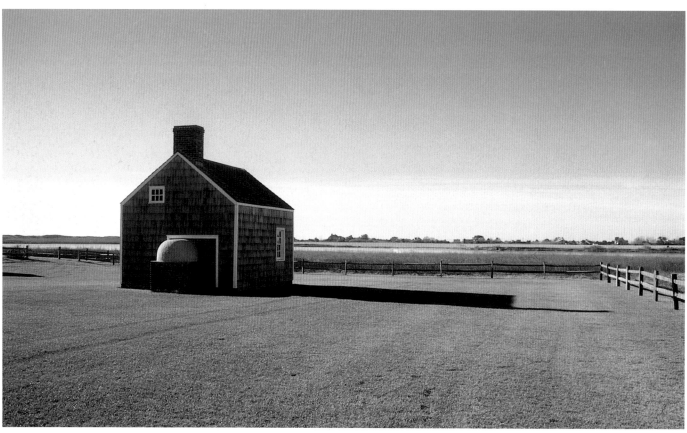

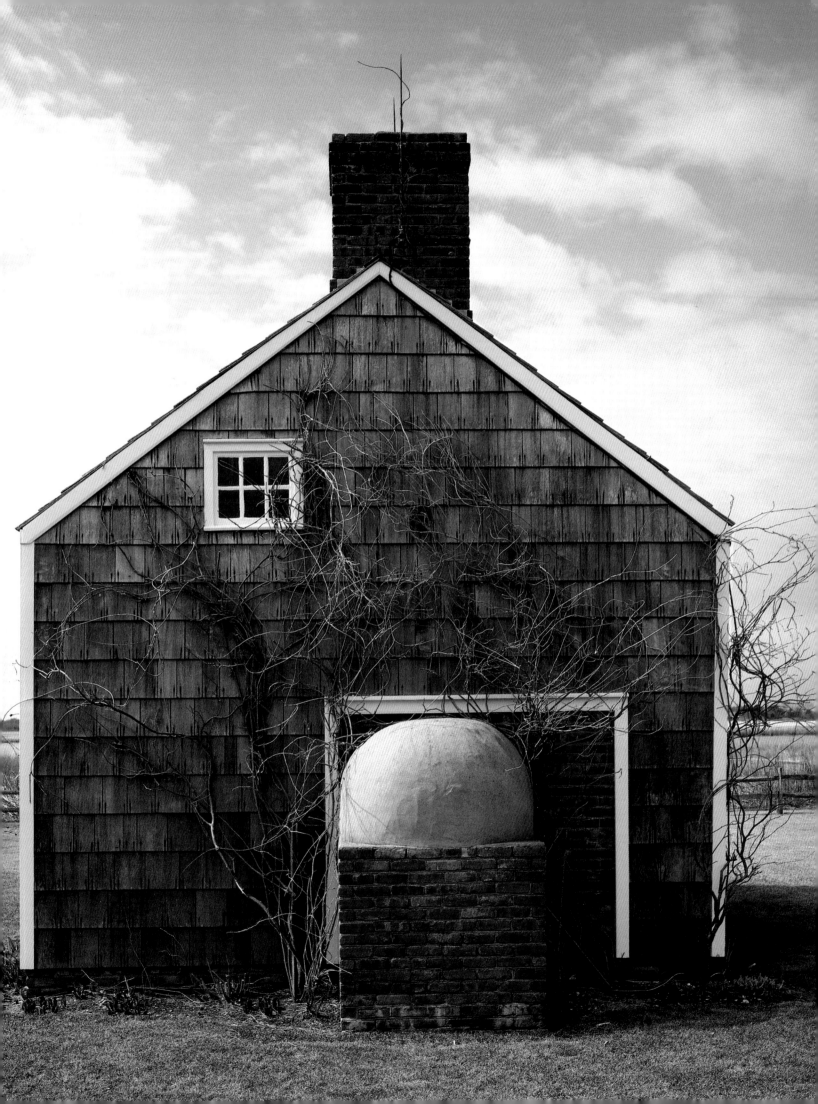

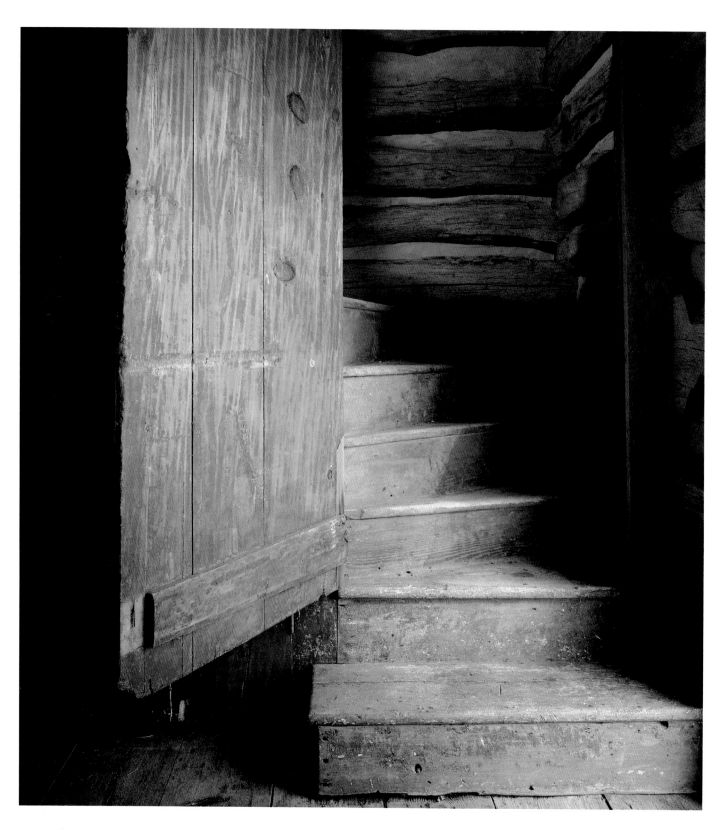

The distressed surfaces of the staircase and doors
were left in their original state when the log house was
reconstructed, providing a forceful reminder of the
structure's previous condition.

The log house is visible between two outbuildings on the estate, the eighteenth-century barn, on the right, and a wagon shed based on typical forms in eastern Pennsylvania.

The small door in the corner of the barn was used by livestock, while the larger double doors were used for grains and hay. The use of barns for both animals and grains is typical of Dutch farms; English farms almost always separated the two.

Wagon sheds like this are found near meetinghouses throughout New England, Pennsylvania, New Jersey, and New York. One side was open to admit vehicles, usually the side away from the prevailing winds. The curved edge here is based on a wagon shed in Bucks County, Pennsylvania.

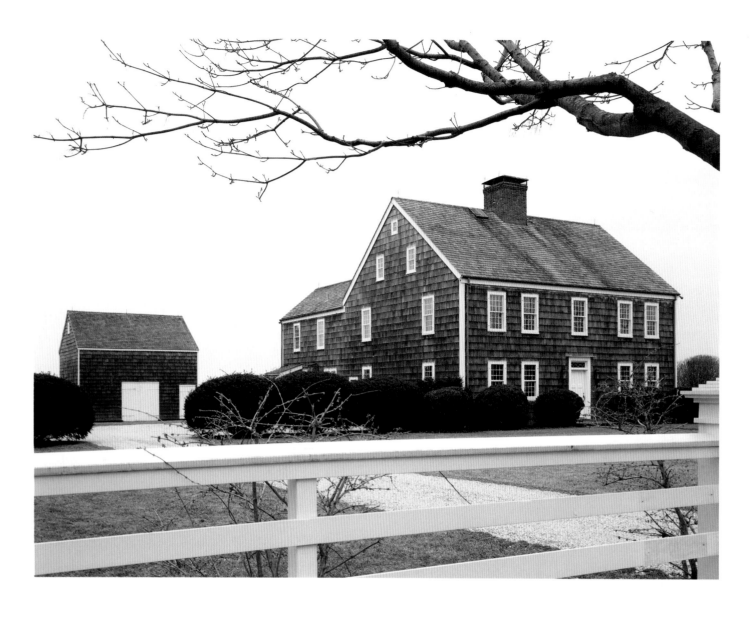

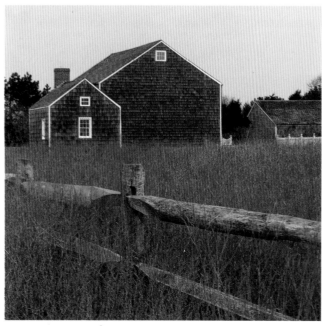

This five-bay English-framed farmhouse was moved from Sagaponack, Long Island, about a mile from its present site. It dates from 1780 and is indigenous to eastern Long Island, an area settled by colonists from Connecticut and elsewhere in New England. Reflecting this influence, it is more typical of a New England house, with a large central chimney and a modified two-over-two interior plan, than one from the mainland of New York.

Although the log house traveled almost 250 miles, and the Marlboro barn about 150, after being reclad with shingles and given white framing on their corner posts and gables, they fit into their new landscape quite gracefully.

The dining room of the farmhouse is furnished with early American furniture from the owners' collection. The large fireplace reflects the New England origin of the house, as does the general style of ornament and furnishing. The ceiling molding was probably added in the nineteenth century.

The front door of the farmhouse opens to a small entrance hall, with the dining room and parlor accessible on either side and a staircase leading to the chambers above. The configuration of the entrance hall and staircase in New England houses was often so tight that a secondary door, called a coffin door, was added in the back. As the name suggests, this door was used to carry out the deceased, as it was almost impossible to maneuver a coffin out the front door.

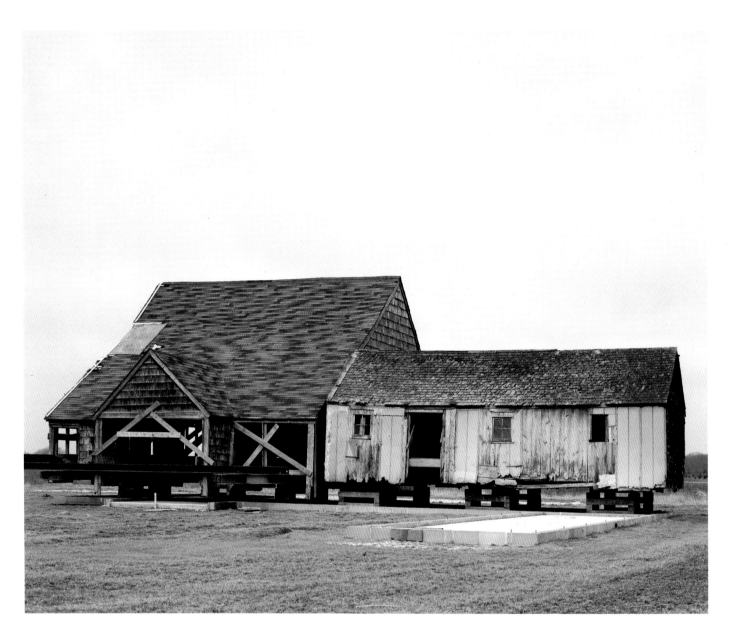

This mid-eighteenth-century barn awaiting
restoration is indigenous to eastern Long Island. Due
to recent zoning conflicts, it was removed from a site
about five hundred feet away, which was in fact
its second site, since it had already been moved across
the road several years before. The addition on the
right was made very early in the barn's life; the gable
end coming off the front of the barn was a slightly
later addition. These projecting gables were called
porches in the nineteenth century and are typical of
many buildings in both the northeastern United
States and in England.

This small summer kitchen in eastern Pennsylvania was disassembled and moved to an estate in Connecticut. This view shows the building as it was found, in an advanced state of decay. The chimney had collapsed into itself, and the rafters had been removed some time previously, so the original roof was never seen or documented.

During disassembly, a small opening in the masonry above the fireplace was discovered. It contained a clay pipe bowl that had never been smoked; it may have originally had a wood stem that decayed over the years. The meaning of the pipe bowl, which had been concealed since the structure was built in the 1840s or 1850s, is not known, but it is speculated that it served as a talisman to encourage the chimney to draw well.

The exterior sheathing that remained was stripped, revealing the sturdy timber frame and nogging, which was a mixture of mud and small scraps of wood.

A winder staircase ascended to a second-floor loft; a small pantry was incorporated underneath.

The marked timbers of the summer kitchen were brought to their new site and laid out for reassembly.

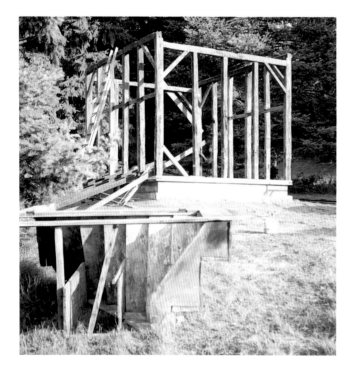

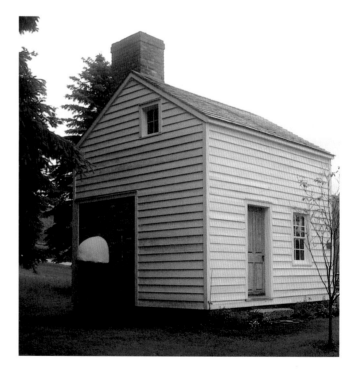

The bents that comprise the gable walls were reconstructed and raised, and then the slightly longer side walls were filled in with studs and braced. The staircase lies complete in the foreground. The summer kitchen sits on a raised earthen platform surrounded by an unmortared stone wall. The frame was covered in clapboarding and the roof with shingles, following local examples. The second-floor window, which was no longer extant at the original site, was based on historical precedent.

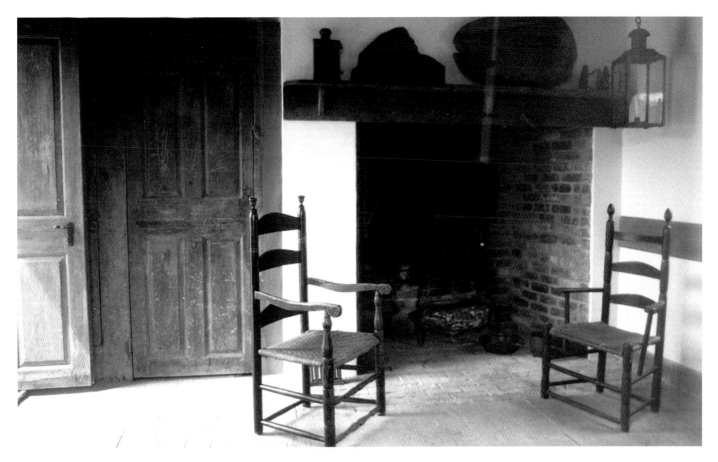

The restored interior of the summer kitchen shows the attractive simplicity of the building. The distressed wood doors have raised panels, the mantel shelf has nicely turned supports, and wide chair-rail lines the room, acting as both decorative accent and protection for the plaster.

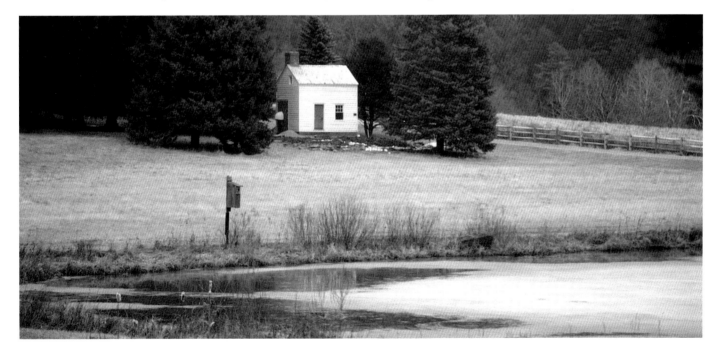

The building is now a garden folly on a large estate, incongruous but appealing in the wooded landscape.

A progression of barns and outbuildings leads up a small hillock to the Merino Hill estate house in Monmouth County, New Jersey. Set in the middle of otherwise flat land, the large house and its tall shade trees can be seen from a great distance.

The property was purchased about 1770 by the Wright family from Philadelphia, and the farm has descended in the family since, one of very few farms to have such an unbroken lineage. The stately house was built in 1810, and it and the Wright family have been prominent in the region for almost two centuries.

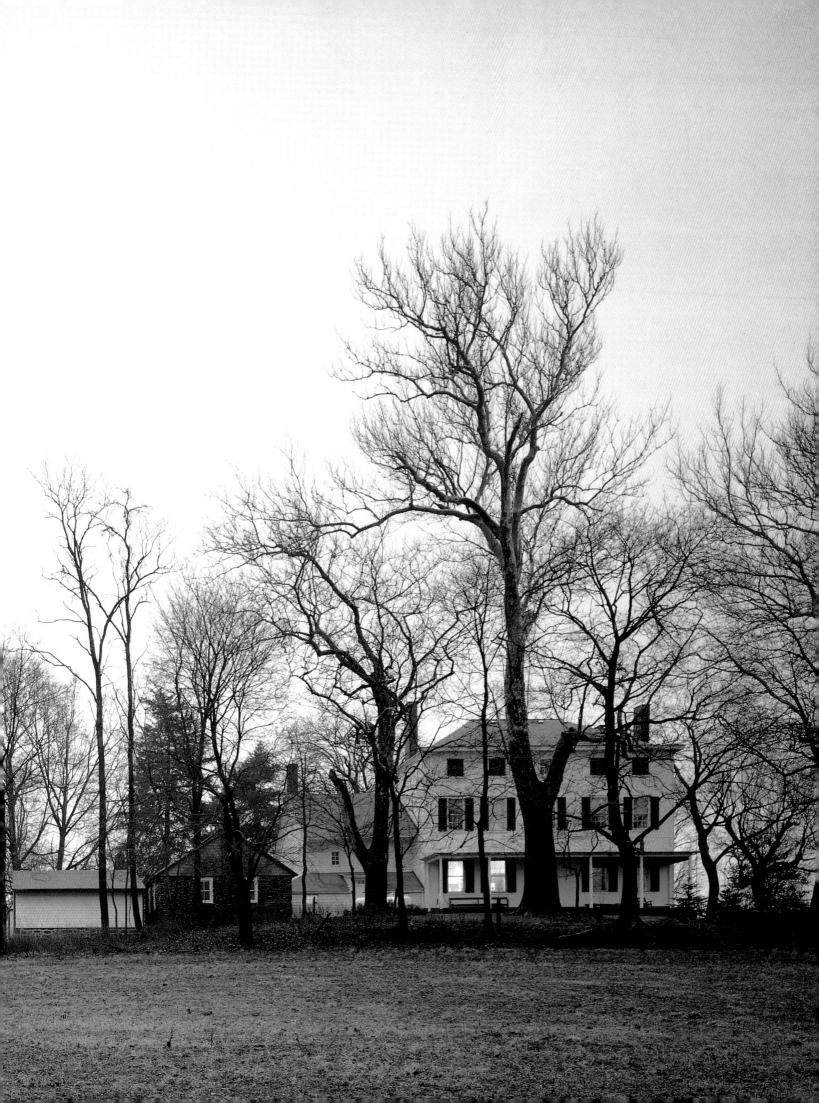

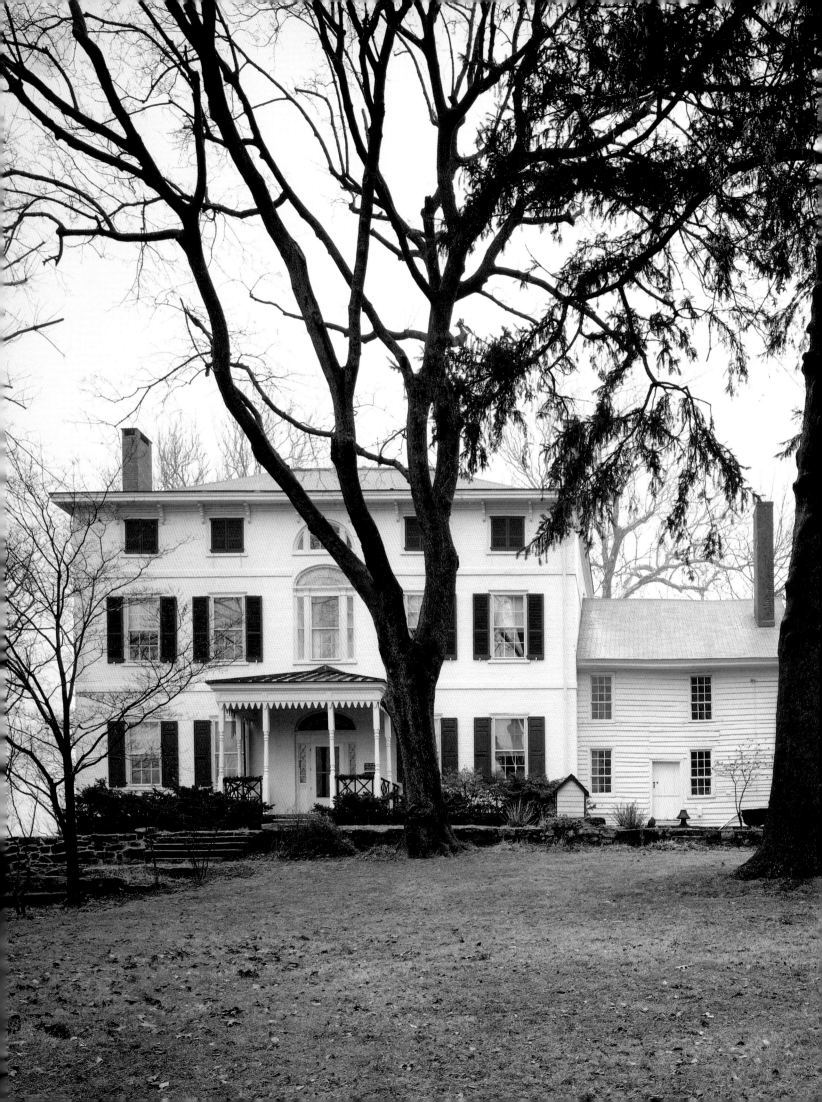

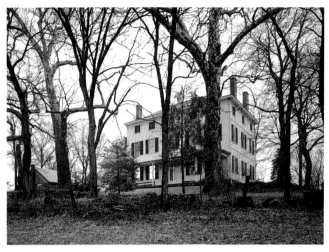

The jewel of Merino Hill is the Federal-style two-and-a-half-story house. Built in 1810, it is a beautifully designed and well-preserved reminder of the family's considerable wealth and status.

The form is unusual for New Jersey and for a working farm; two-and-a-half-story houses were found mainly in the more urban areas of Providence, Rhode Island; Boston; and Portsmouth, New Hampshire. Notable elements of the design include the large Palladian window on the second floor, the semicircular window on the top floor, and the fanlight above the front door. The low hipped roof contributes to the clean lines and light effect of the house, as do the stone belt courses between the floors. The sloped portico was added later in the nineteenth century.

The land around the main house at Merino Hill has been terraced, supported by low stone walls, and serves as an outdoor living and gathering area. Scattered throughout are European marble busts, which were used as payment for Merino sheep bought from the farm by a nineteenth-century area resident, Joseph Bonaparte, the brother of Napoleon III and the exiled king of Italy.

The view of the rear of the house, above, shows its commanding presence at the top of the hill. The large shade trees surrounding the house date from its construction.

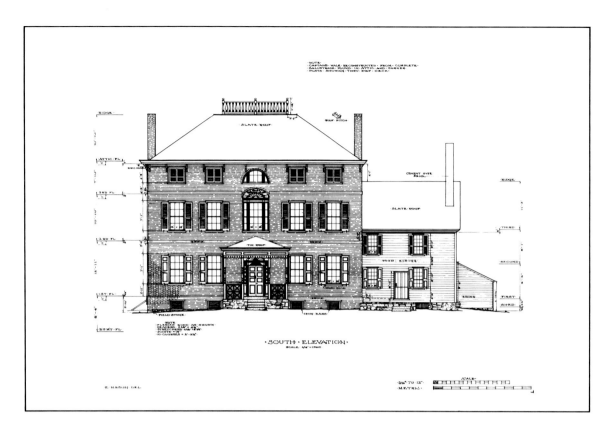

South elevation

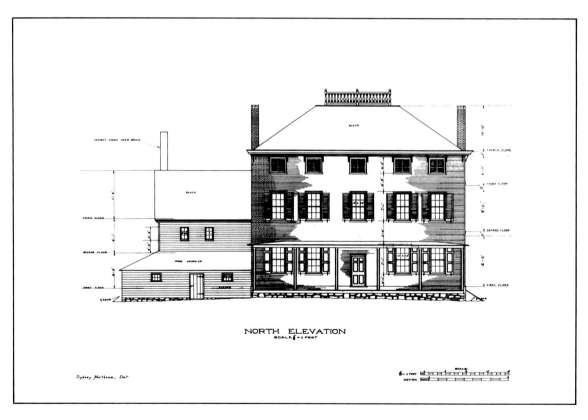

North elevation

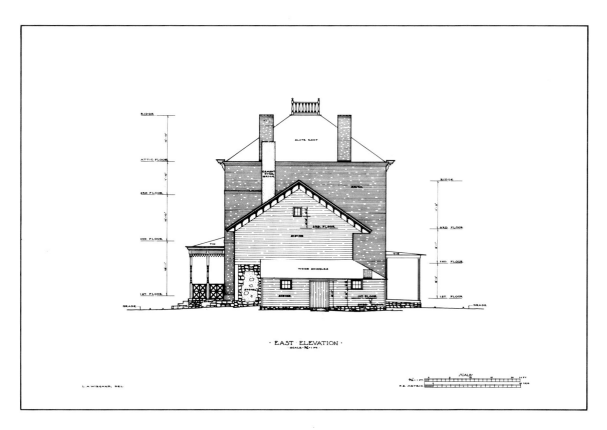

East elevation

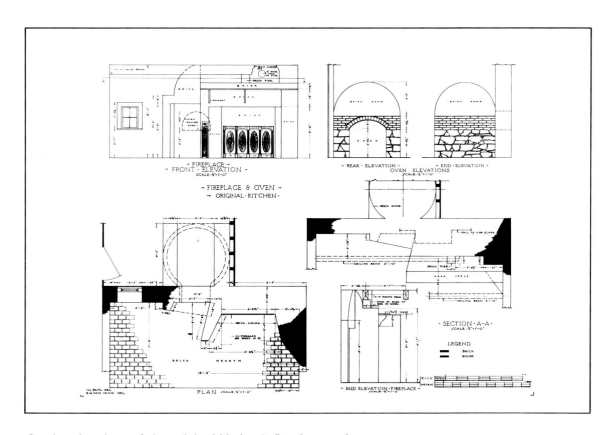

Section drawings of the original kitchen's fireplace and oven

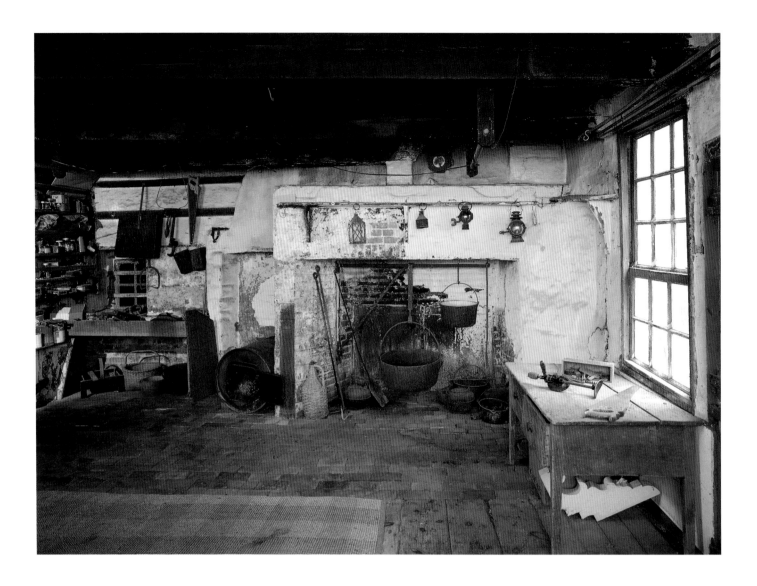

The original kitchen wing provides a wonderful view of an unrestored eighteenth- and nineteenth-century kitchen. Because the Wright family has lived on the property for so many years, the material trappings of farm living have accumulated and often stayed in their original places over many decades. The unbroken occupancy has also contributed to the lack of major modifications to the house, although a masonry jamb to the left of this fireplace indicates that there was once an even larger hearth here.

Huge floor joists support the second floor, and original wooden hinges are visible on the door at the right. The kitchen wing's windows have smaller panes of glass than the main house, reflecting the advances in glass-making in the decades between the two sections' construction.

These fireplace inserts were cast at the Philadelphia foundry of S. C. Wright, the great-great-grandfather of the house's current owners. The oval and linear fluting is typical of Federal-style decoration.

Fireplace inserts became popular in the early nineteenth century; they both protected the brick and reflected more heat into the room. In some areas of New Jersey, several houses in a row along the major roads have the same inserts, evidence of an early traveling sales force.

Front elevation of fireplace. All drawings of Merino Hill are from the Historic American Buildings Survey, 1943. The farm has long been regarded as one of the most important vernacular buildings in America, and it is unique for being almost completely unchanged.

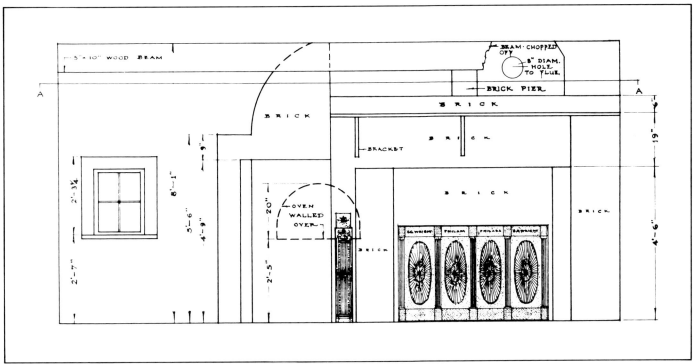

One of the most charming buildings at Merino Hill is this small structure, called the storehouse. It was built in 1835 of an iron-rich stone found on the property, and its ironwork, probably from the Wright foundry, provides unexpected ornamentation. The Federal-style doorway and pediment were probably moved from a nearby house undergoing renovation.

This view shows the new pointing at right, as well as some older lime mortar above the ironwork.

The gable ends of the storehouse have more ornamental ironwork, and additional narrow, small-paned windows with bars behind them. Until the mid-nineteenth century, there was a very limited supply of lime for use in cement, so most stone was laid up with mud and then pointed with lime mortar, which was derived mainly from oyster shells. When the pointing falls out after many years of service, the underlying mud is exposed, and total deterioration of the mortar is swift.

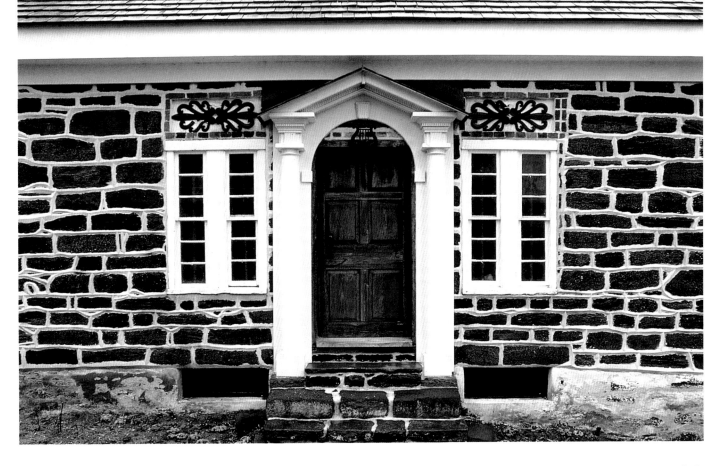

The repointing complete, the storehouse was reroofed and its peculiar windows and entrance restored. Small stones were used to fill in the sometimes large gaps in the stonework, as beside the right window.

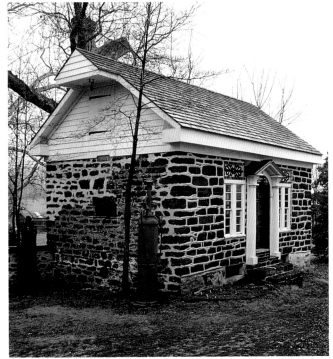

The small projection at the top of the gable contains a pulley used to lift objects up to the level of the attic.

Side elevation of storehouse

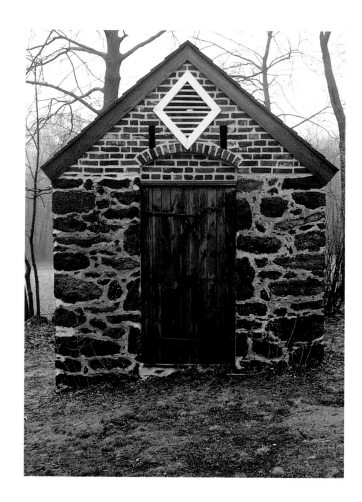

Befitting such a well-appointed farm, the smokehouse at Merino Hill was somewhat larger and more sophisticated than most. It was constructed of local stone and topped with brick and a simple peaked roof. The utilitarian nature of the structure is reflected by the battened door, which is much more primitive than any on the farm's other buildings.

The smokehouse, which had not been used since the turn of the century, had fallen into serious disrepair. When funds became available in 1991 through a farmland trust in New Jersey, it was restored.

The restored smokehouse has a louvered flue opening at the top of the gable, providing the draft needed to draw the smoke from the fire, which burned in the middle of the smokehouse floor.

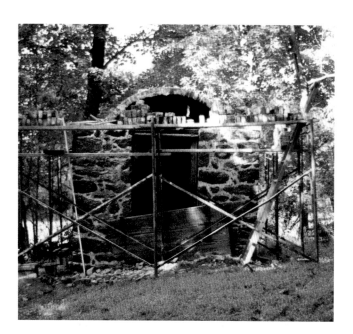

After the removal of the roof and upper brickwork, the smokehouse's arched interior vault became visible. By nature simple structures, most smokehouses made do with flat ceilings, although arched ceilings were thought to produce better results.

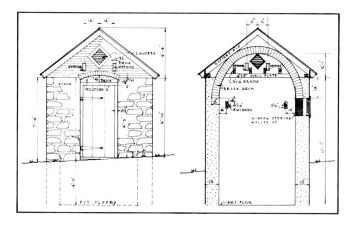

Two end elevations of smokehouse

196

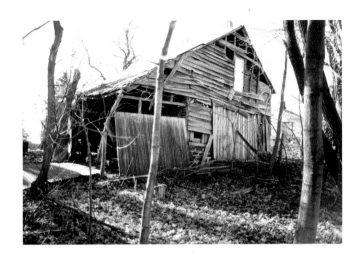

After many years of neglect, a severe storm in November 1988 accelerated the decay of the upper wagon house at Merino Hill. Through the partially collapsed clapboarding, the basic saltbox shape of the main section is clear, as is the simple construction of the lean-to on its side.

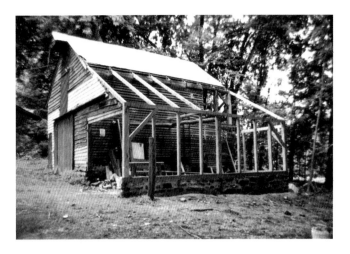

The timber frame of the lean-to is simple, with regularly placed, minimally braced studs supporting a rafter plate and single rafters. The wagon house received new wood shingles, and fresh clapboarding was applied to the lean-to and a few decayed or missing areas on the main structure.

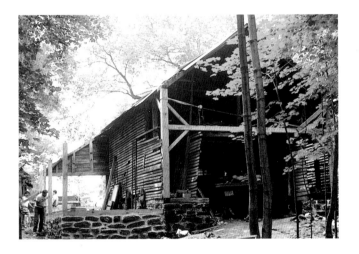

A new tie beam, corner posts, and braces were fitted into the existing structure. With the rear wall absent, the left corn crib is visible, one of a pair running the length of both sides of the wagon house's main section. The interior walls of the cribs are canted inward to keep more of the corn at a higher, drier level; the lath walls allow sufficient ventilation to dry the ears of corn.

Each opening to the wagon house served a different purpose. In the left corner is a door to one of the corn cribs; the main wagon doors are at center; and doors for a second wagon are at the right. As in many wagon houses, the second floor was used as a granary. The projecting hood at the top of the gable contains a hay hook that allows grain to be lifted to the level of the second story, and then into the upper door.

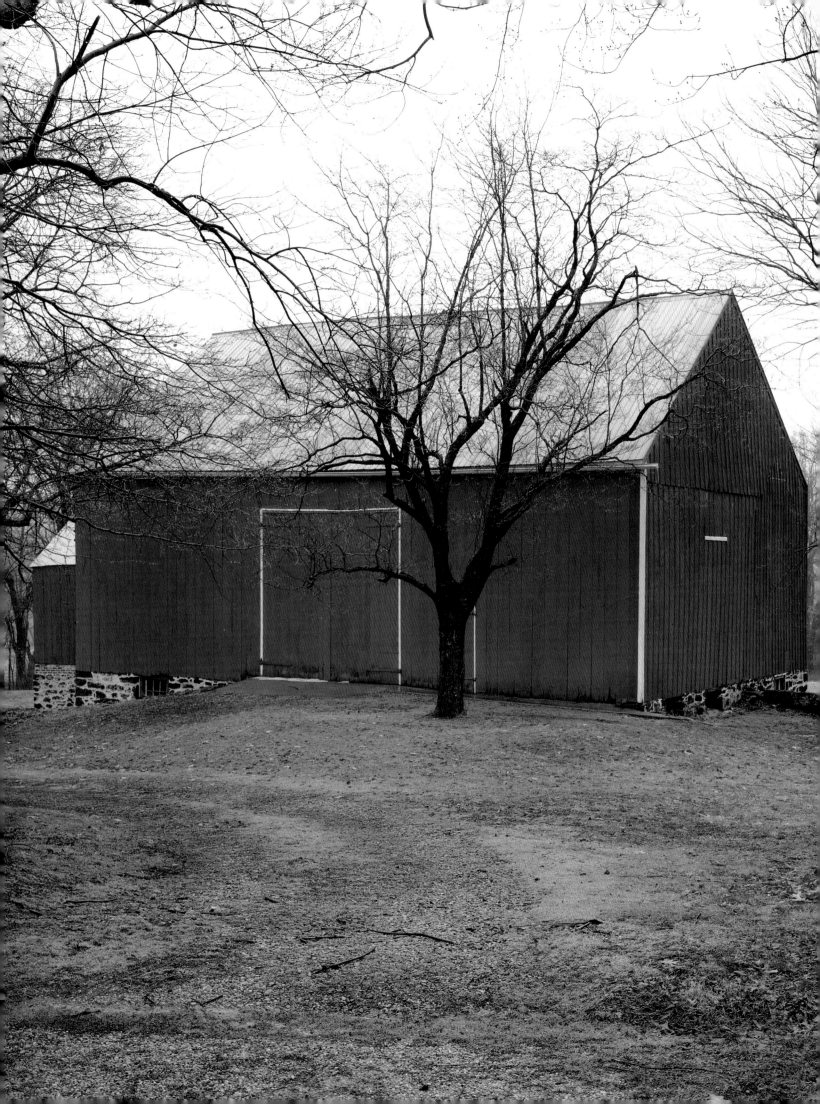

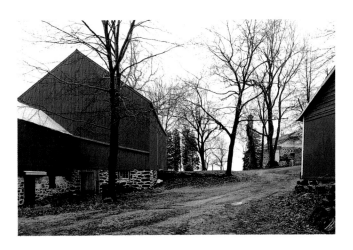

The largest structure at Merino Hill is this New Jersey bank barn. The main wagon entry side was in good condition, but the other side, where the threshing door and stable entrances were, was considerably decayed.

In 1990, Merino Hill and its 165 acres were put into a permanent land trust, ensuring that the land would be used only for agricultural purposes. In the face of continuous and strong pressure from developers, many thousands of acres of fertile farmland are converted to residential and commercial uses every year. Through land trust programs like the New Jersey Farm Preservation Act and the American Farmland Trust, farm owners transfer their development rights to an agricultural trust, providing money to continue their operations and to keep the land and historic buildings intact.

The mid-nineteenth-century New Jersey bank barn was also restored. This type of barn was more common farther west, in southern Pennsylvania, but the hill on this property made it appropriate in eastern New Jersey.

What remained of the original vertical clapboarding was replaced after new wall posts were inserted. A huge, thirty-six-foot tie beam lies on the first floor of the barn, soon to be raised in the interior.

Much of the lime mortar and mud in the lower stone wall had decayed, and some of the original stones had been lost. As in the small storehouse, the wall was repointed and local stone was used to fill the gaps. The diamond-shaped window is a feature rarely seen in barns.

German barns were used for both the storage and the processing of grain crops and for housing animals. Several doors at ground level lead to stables and pens; the threshing door above opens over the feeding lot.

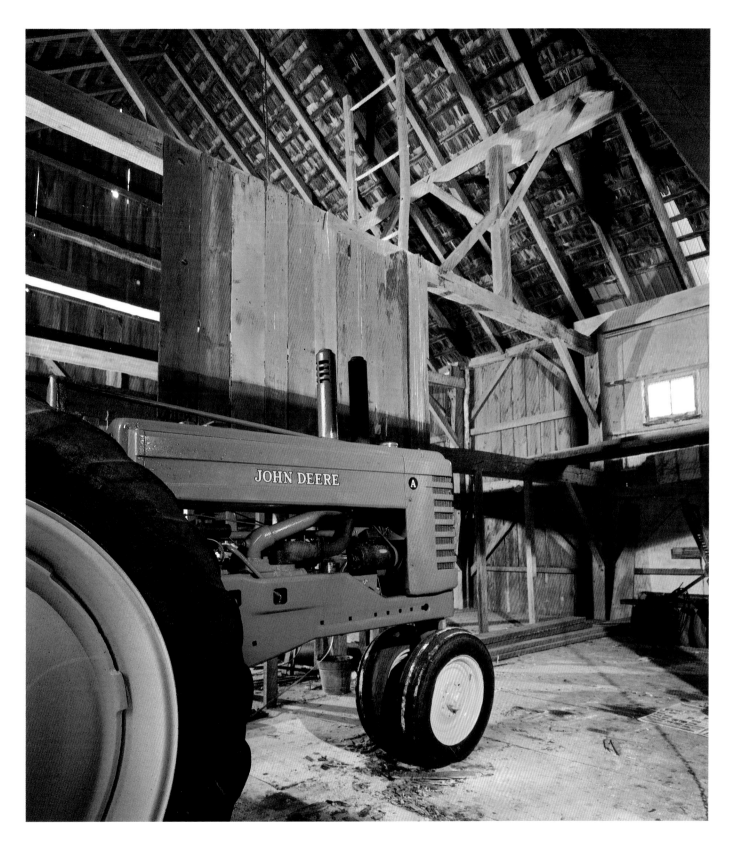

The interior of the restored barn shows some of the complexities of such a large structure. The wide roof is supported by heavy rafters and purlins, which in turn are supported by struts and braces. The vertical boards in the middle of the floor surround a hay mow, a large well for storing hay.

A New Life for Farm Buildings

MANY OF THE STRUCTURES that appear in this book are faithfully preserved and carefully researched historic buildings. They were restored and protected to interpret history, to give people, especially non-farmers, a sense of what farm life was like, what working hard in a simple environment could produce. They have done that job well, but they have also had an unintended effect: they have created a great interest in saving farm buildings.

What does it mean to save a farm building? After all, they were not made to be monuments. As family farms grew, alterations and additions were made to the farmhouses, small barns were replaced with large barns, and outbuildings were moved around. And older buildings have always been sources of timber for new ones.

To save a farm building it is not necessary to preserve it perfectly. When one thinks about saving one, it is necessary to think about what a farm or a farm building can be. Could the farm become a workshop? Can a barn become an artist's studio? Would a complex of farm buildings work as a school? As a retreat? Could the farm work as an organic farm, or an orchard? Or a combination of these things?

A farm, of course, can be any of these things. In England, an oast house has in fact been converted into a framing shop. And there has been a movement back into farming, as people have realized that a small farm, with a mix of crops and using modern transportation and agricultural techniques, can supply food to more mouths than it did at any time in the past.

The Industrial Age pulled people away from the farm, as the amount of labor necessary to work the land was reduced and the amount of work available in the cities was reaching ever higher levels. Now, the age of communications and computers is providing an opportunity to return to rural living. With a well-equipped home office, work can take place virtually anywhere. And while an occasional trip into the city may be necessary, it may not.

The benefits of such an arrangement are not measured simply in time and money. People who live in reused farm buildings in rural areas find them good places to raise children, with relatively uncrowded schools and a healthy environment.

But unless something is done to protect these historic structures, somebody, somewhere, will find a reason to demolish them. In America, the American Farmland Trust and similar state trusts work to keep farmland in agriculture. Individuals, ranging from first-time home buyers with an appreciation for history to wealthy patrons of vernacular architecture who collect these buildings, can save them.

In Europe, the older traditions of rural life have meant that farm buildings must be saved in spite of many restrictions. Great effort is required to comply with local laws and zoning limitations, which go back many years and vary from area to area. Anyone who intends to live in a converted farm building must discover what the laws require regarding wall covering and insulation, ceiling height, sewage disposal, fire-prevention, water quality, ventilation, natural light, and many details of construction. Conversion plans must be submitted to county committees, which invariably lengthens the process. But many buildings have been converted with great success.

Just as farmers adapt old buildings to new purposes, it is possible to adapt and reuse farm buildings and houses in an intelligent and productive way. Following are some examples of farm buildings and houses that have new lives in landscapes that cannot support their old uses.

All that good, straight timber may be part of the salvation of these structures. The well-joined timber frame has always had enough integrity to be rebuilt. Indeed, the Roman numerals that mark old timbers can still serve a useful purpose, although the terrain may have changed.

The oast house is a perfect example of a building that has developed along purely functional lines. The structures were used to dry hops; their cowls and vertical shape provided the maximum amount of draft to distribute the heat generated by the charcoal kiln. Today, working oast houses use heat generated by oil, gas, or electricity, and the traditional shape and cowl no longer make practical sense.

Oast houses dot the countryside of southern England, especially in Kent and Sussex. Until recently, most were abandoned and derelict, seeming to defy adaptation. But in recent years, the appeal of these striking buildings has been great, and most have been purchased and converted to private dwellings. With the addition of some windows, this pair of oast houses in East Sussex now serves as a country estate.

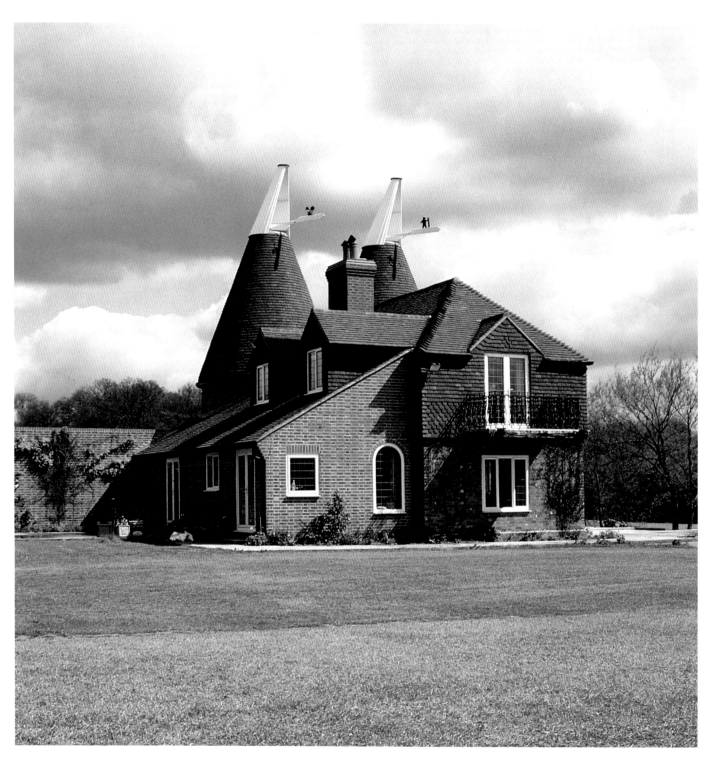

The owners of this restored pair of oast houses stumbled across them, considerably decayed, while walking through the country. The oast houses stood on seven acres of land, although there was no access road, electricity, or water supply. A mile-long road and a small bridge had to be built before they could start restoration, and a generator, water tank, and water processing plant were all needed to make the property livable. Good timber in England had been largely depleted by the seventeenth century, so brick construction became common; the owners of these oast houses were fortunate to have a source of good bricks in the ruins of a contemporary Tudor farmhouse that had burned down several years before.

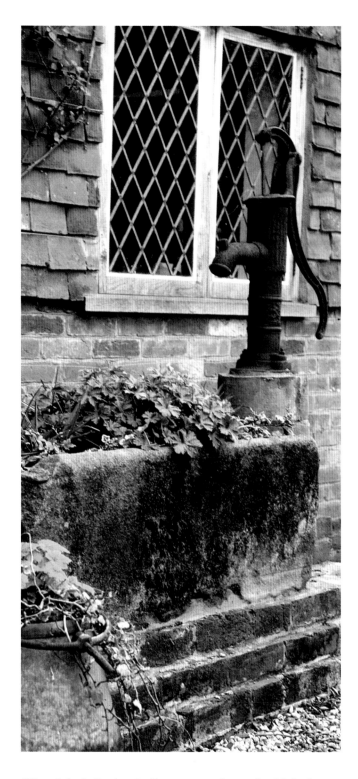

Clay tiles began to replace the less durable wattle-and-daub cladding in the seventeenth century. By the following century, brick at the ground level and clay tile above became standard building practice in southeastern England. Although the tile exterior made buildings appear to be of solid masonry construction, timber-frame construction remains beneath the elegant tiles.

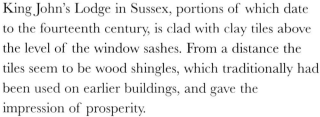

King John's Lodge in Sussex, portions of which date to the fourteenth century, is clad with clay tiles above the level of the window sashes. From a distance the tiles seem to be wood shingles, which traditionally had been used on earlier buildings, and gave the impression of prosperity.

opposite
The original timbers are exposed at the top of the stairs in the round oast house. A dramatic spiral staircase of carved wood descends to the main floor.

Book cases have been built into the rounded wall of one oast house. The curved space at the bottom of the staircase forms a small library, made more intimate by exposed wood and subdued light.

A guest bedroom occupies the upper portion of one of the oast houses. Visitors enjoy the echo of the room and the sound of the wind as it passes through the roof space above. In 1987, a rare hurricane hit the region, damaging the cowl-tipped roofs of the oast houses, the buildings most vulnerable to wind.

The wagon porch of this converted seventeenth-century barn in Kent contains an open staircase to the second-floor loft. Vertical windows have been inserted into the large door frame to admit light into the main living areas, and all the original framing has been retained.

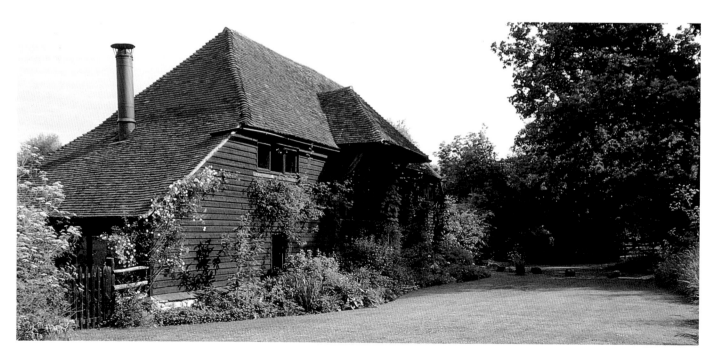

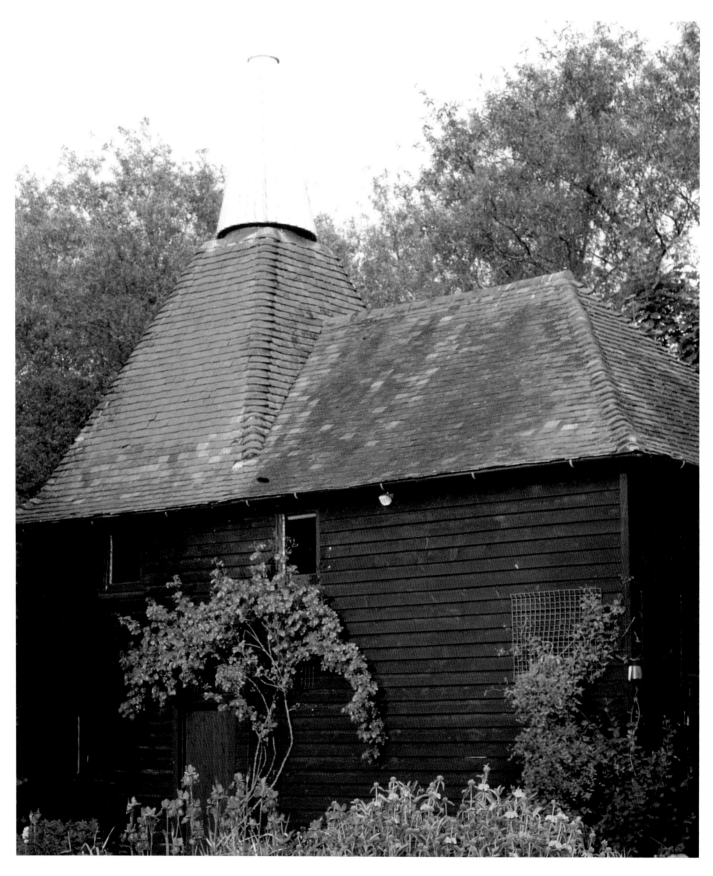

preceding page
On the same property was a damaged small oast house.

With a restored cowl and new tiles, the structurally sound building was made into a guest cottage.

212

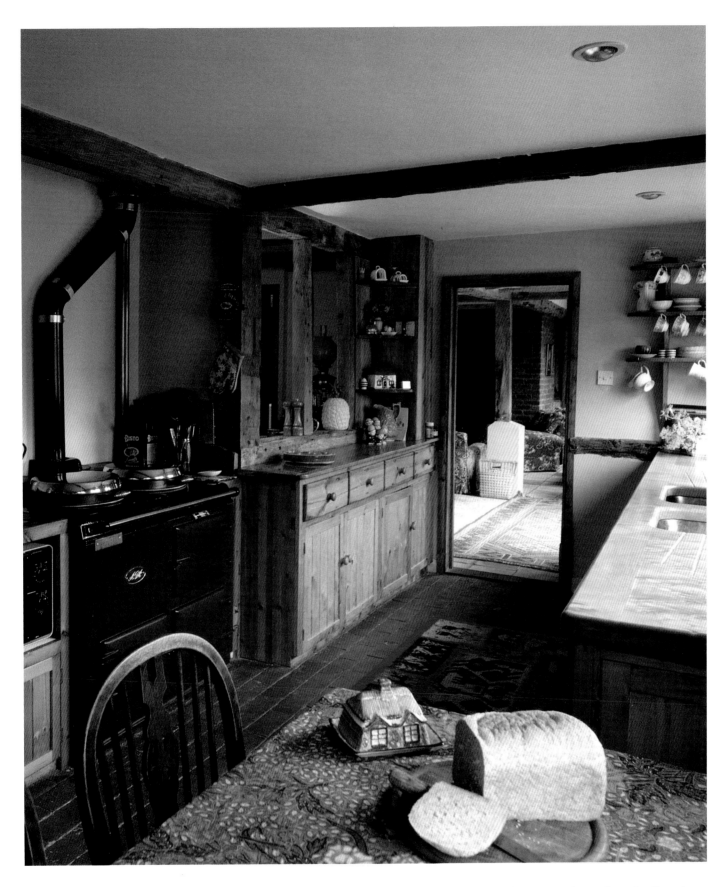

The kitchen of the converted barn contains an Aga, a clean-burning, solid-fuel stove. Extremely efficient for cooking and for heating water, it needs to be lit only once a day for all its tasks.

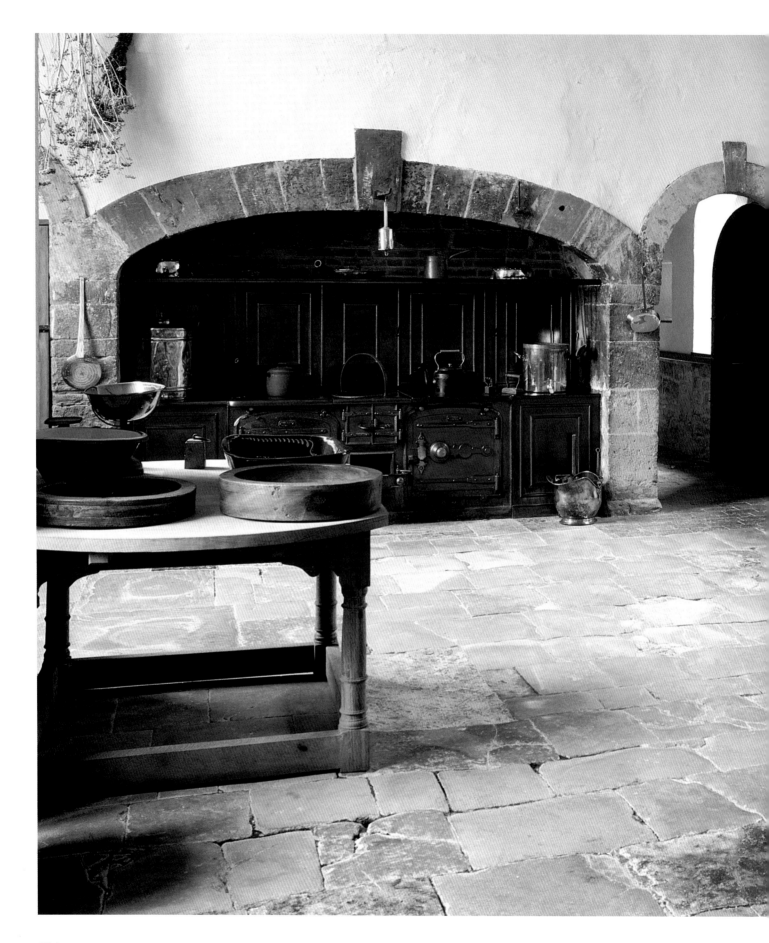

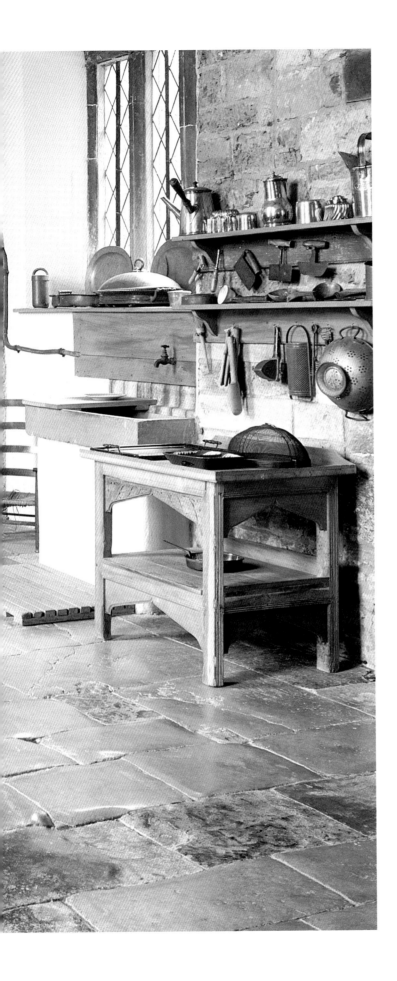

This grand kitchen is in a large farmhouse in northern Britain. Home to a family of great means, the kitchen has high ceilings and a wonderful sense of space and peace, at least when there is not any cooking going on. During meal preparation when the land was a working farm, the kitchen was a bustling place, as food for the family and the hired hands, who could number at least a dozen, was cooked.

All the kitchen surfaces are scrubbed clean and are ready for work. The floor is made of large pieces of stone, the trestle tables of aged whitened pine or oak, and the walls are whitewashed stone. Copper cookware gleams in the afternoon sun. Shiny surfaces required a great deal of labor; maintenance, cleaning, and polishing would would have taken many hours of the day.

A double range has been inserted into the large original hearth; above it is a hot plate shelf, which uses the heat of the stove to keep food warm.

This large but informal Irish farmhouse kitchen is cleaned and decorated in preparation for a *ceili*, an informal gathering on no particular occasion.

Henry Glassie describes such a gathering in *Passing the Time*: "*Ceilis* are not planned. They happen. At night you sit to rest and perhaps a neighbor or two will lift the latch and join you at the hearth.... The kitchen is clean and sparkling, but empty without its content. Its content is human action. People enter, crowding within to cook and eat and tell their stories."

Chickens stroll through the airy kitchen, watched over by the farm dog and cat. They are put away at night, to protect them from foxes, but the daytime is safe enough. The insects they are looking for as they roam around the farmyard and kitchen are good for their eggs and makes their meat more flavorful.

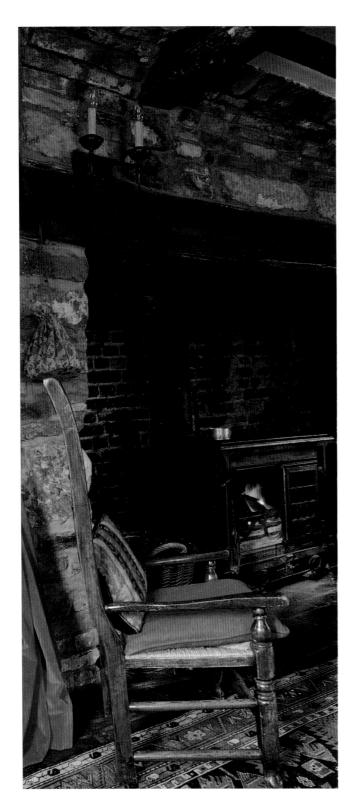

An iron stove burns in a large fireplace in a converted medieval building. However attractive a large hearth may be, it is much easier and more efficient to use a stove—much of the heat from a fire is wasted as it rises up the chimney.

This enormous vaulted kitchen had been turned into a cow shed. From an original sketch, it was converted back into a kitchen, and its original splendor and proportions were restored. The great height of the ceiling allows linens to dry above the stove.

This large country kitchen in an English farmhouse also uses an Aga stove. The Aga is a perfect rural appliance, powered by solid fuel and working all day with only minimal care. It sits in the original kitchen hearth, with tile added behind it for easy cleaning.

A fourteenth-century house in southeastern England awaits the arrival of a thatcher to repair the roof on the left half of the house. Only a small proportion of farm buildings in England still have thatched roofs, but the number is slowly increasing. Their use declined in England over many years, mainly because of the relatively large amount of maintenance they require. But thatch has many advantages over modern roofing materials. A thatched roof is thicker, keeping the building warm in winter and cool in summer, and frost cannot permeate it. In many cases it is cheaper, too, because the material—flax, rye, or oat straw—can be grown rather than bought.

Early American settlers covered their homes with thatch, as they did in Europe, but the practice was soon abandoned. The drier climate made thatched roofs more likely to catch fire, and the abundance of wood made shingle roofs economically feasible.

opposite
This ninety-foot-long terrace of oast houses in Kent was converted into a private house and framing workshop in the late 1980s. It had been used for its original purpose—drying hops—until 1970, so the structure had not fallen into serious decay, although maintenance had been poor. The number of roof lines would have seemed challenging to most potential owners, with the necessary repair and maintenance of the cowls, but the conversion has proven to be a success, producing a comfortable and attractive place for living and working.

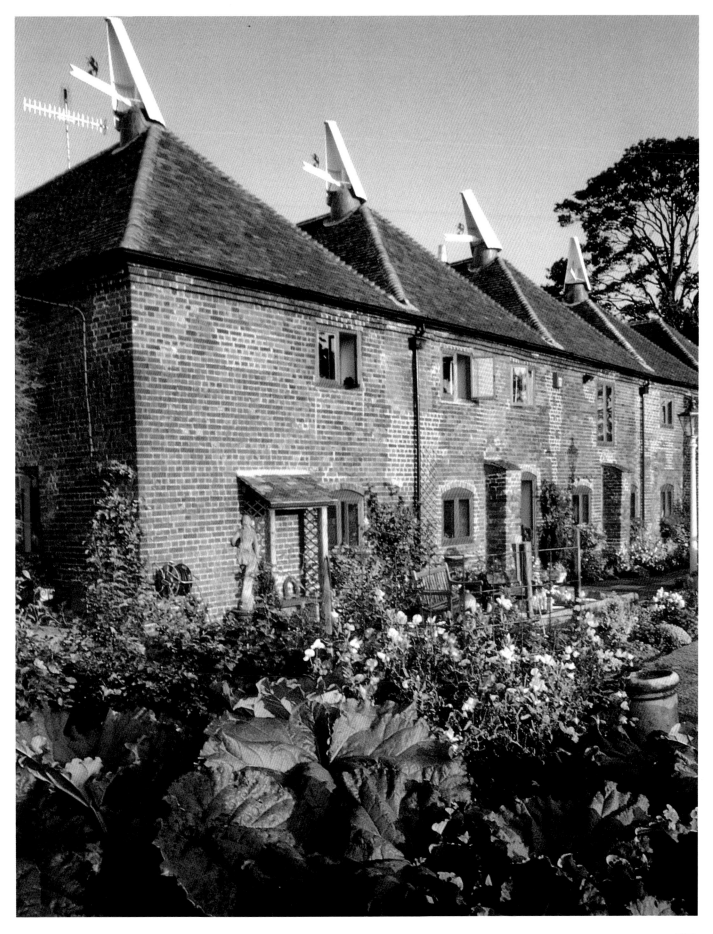

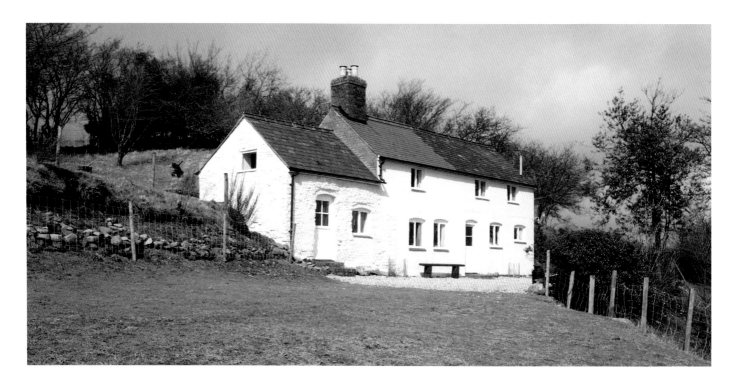

This Welsh farmhouse has been restored. The small
addition on the left, now integrated into the facade of
the main building, was probably a wood shed.

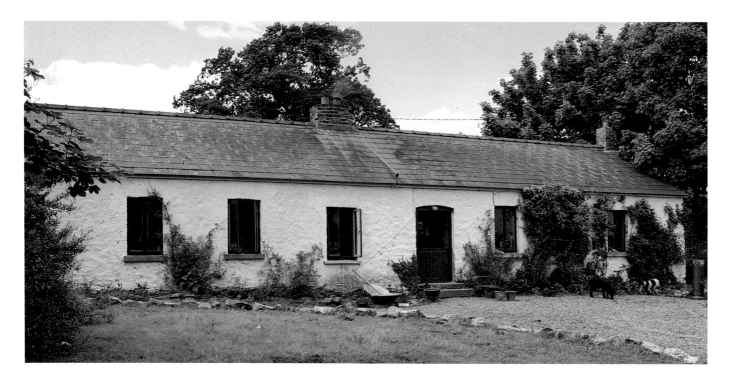

This single-story, stable-like building in England has
been converted to residential use. Slate replaced
thatch in some areas in the nineteenth century,
providing a long-lasting and fire-resistant roof.

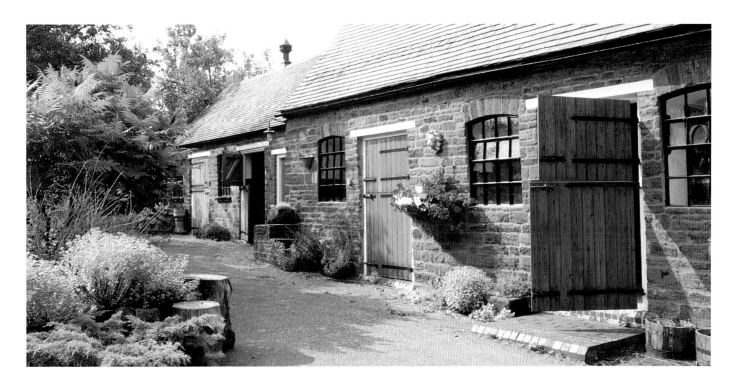

In converting this Kent stable to residential use, much of the original structure was left unchanged. For instance, the old loose box, or stall, divides the laundry area from the rest of the kitchen.

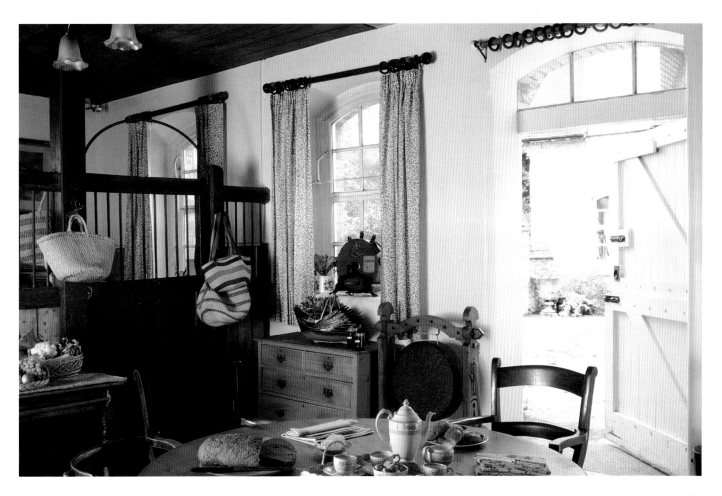

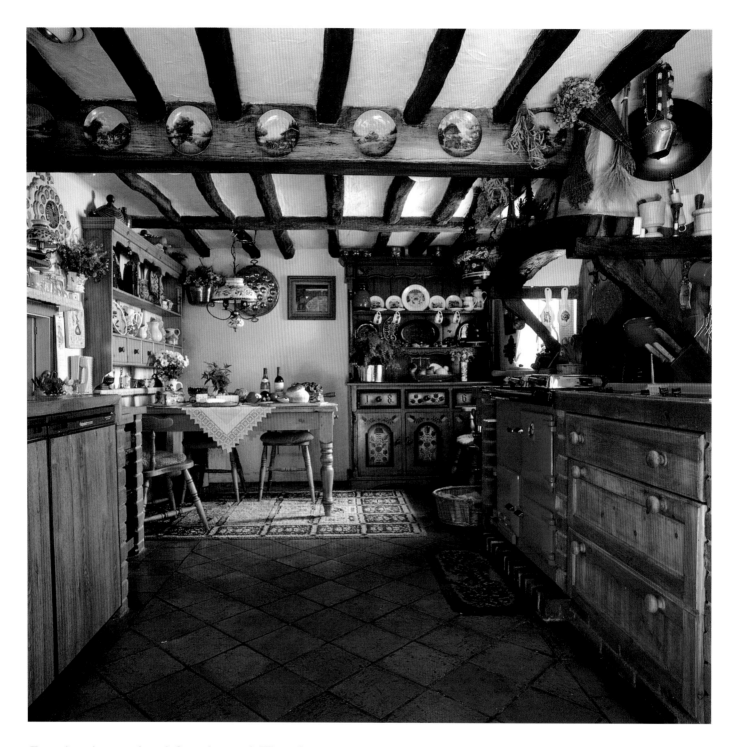

Farm interiors are best left uncluttered. There is a
temptation in converted farm buildings and country
public houses to cover the aged, darkened beams with
pottery, crockery, or horse brasses. In historic rural
structures, the walls, timber framing, and ceilings
were often quite bare. The exposed evidence of their
simple construction is a large part of their appeal
and beauty.

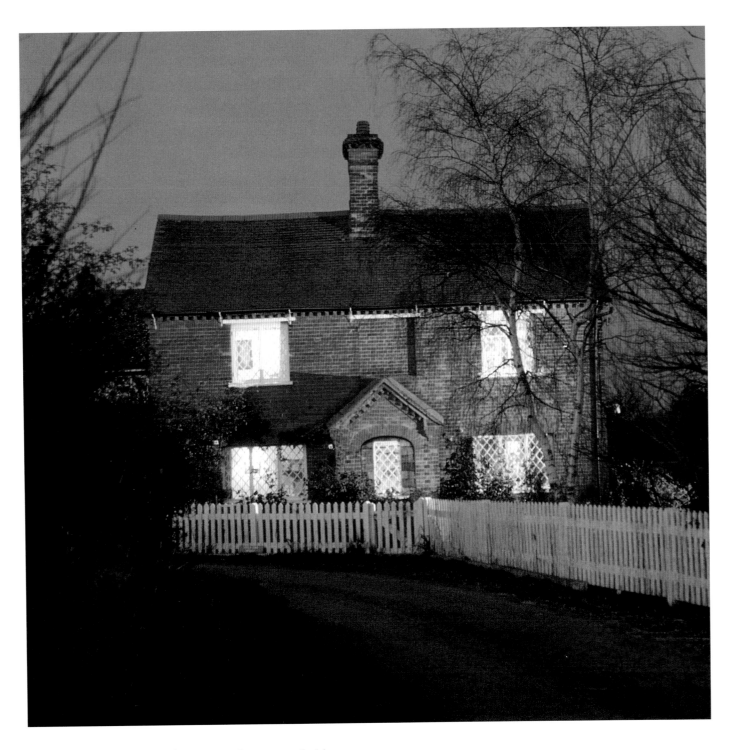

This small restored farmhouse stands surrounded by shade trees on its land in England. The window above the entrance seems to be bricked over, but in fact it never existed. One nineteenth-century tax was based on the number of windows in a house, so many builders left out one or more. In anticipation of the repeal of the tax, the window bay was built, but it never received a window.

opposite
In the nineteenth century, cast-iron cooking ranges and stoves were inserted into farmhouse fireplaces throughout America and Europe. In smaller houses and cottages, cooking was usually done in the parlor, and the new ranges made this more efficient and less dirty, as the ash and smoke of the fire was carried out in the stovepipe.

Although these nuisances were reduced, the range required a new set of cleaning chores. The flue had to be swept, grease had to be scraped from the plates, and the bright steelwork had to be polished. But the range was the pride of the farm family. It was used for a wide range of duties, from cooking to boiling water to heating the house, and it was the coziest place in the home to gather around.

Although these farmhouses have been converted into modern dwellings, the appearance of a well-used and well-kept stove area has been retained.

A black-leaded stove built into an original fireplace in southeastern England.

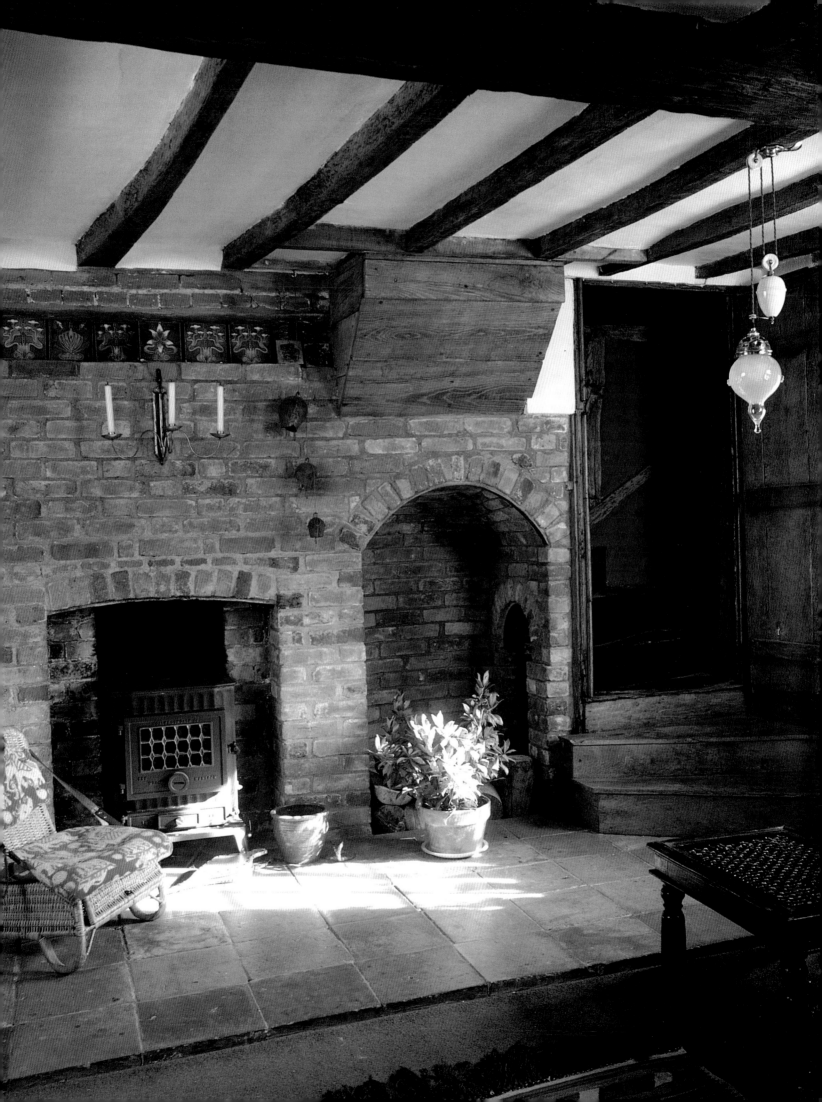

This ice house in the Hudson River valley has been converted to be part of a residential complex. The structure and its interior have not been significantly altered.

Ice houses were found on almost every American farm in the nineteenth century. Purely functional buildings, their design was simple and focused on one thing: insulation. Most were freestanding, and they were often built on sandy or gravelly soil over an excavated pit lined with stone or mortar.

Wood-frame ice houses had plank walls filled with packing, usually sawdust or straw. The building was filled with large blocks of ice, with sawdust beneath, between, and on top of them. A ventilator at the top of the ice house let collected vapor escape; when it was properly sealed, it stayed cool enough to preserve ice year-round.

The inner door to the ice house was usually several planks stacked on top of each other. A layer of straw was then placed between these planks and the outer door. When ice was retrieved, only the planks down to the level of the ice were removed, preserving as much of the insulation as possible. This insulated door worked well, although the time-consuming process of replenishing the insulation was necessary each time ice was needed.

This ice house is particularly large, and would have held well over one hundred tons of ice.

opposite
Natural light comes in through the roof ventilator and windows, which were added later.

With the addition of a floating spiral staircase, which does not interfere with any of the original structure of the ice house, the conversion was complete. The staircase allows access to a gallery area. The building is now used for entertaining.

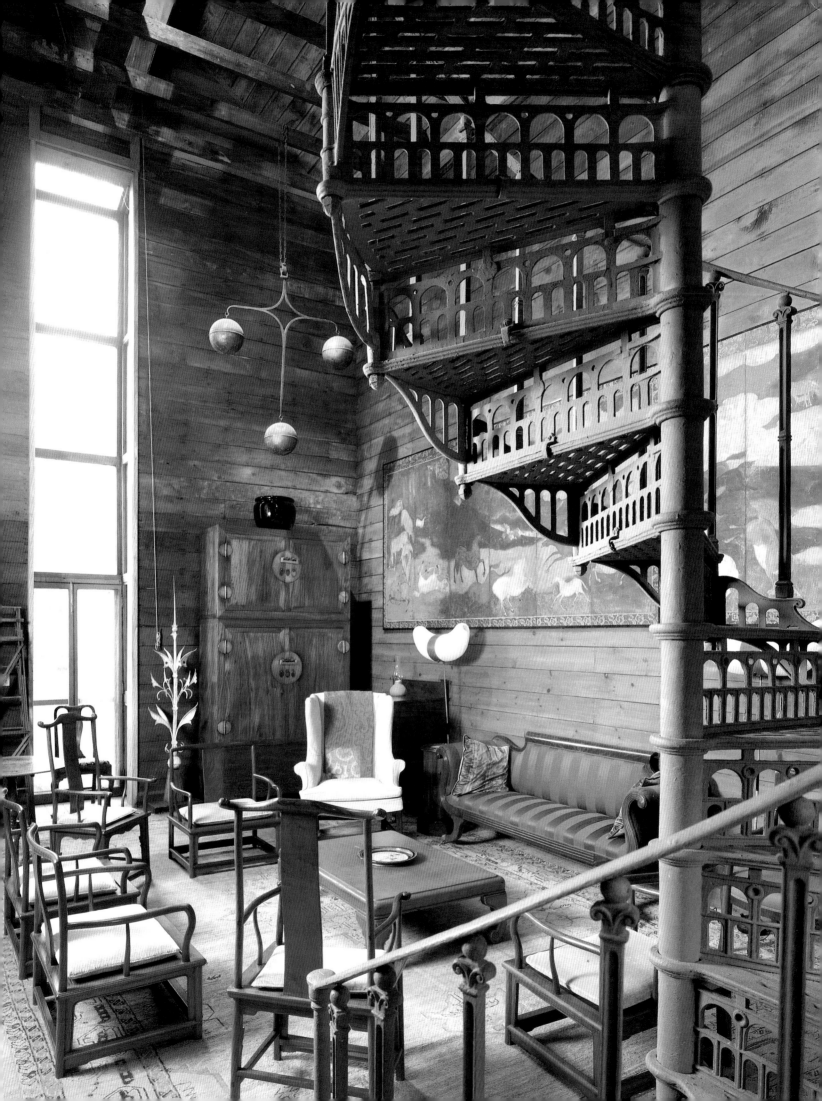

This English-style house was built in 1738 by Susanna Wright. Although its layout and proportions are English, some of the house's details are the work of local German craftsmen, including the herringbone-pattern of the entrance hall bricks. The hall's details and furnishings reflect the simplicity and dignity of Wright's Quaker beliefs.

As a young woman, Wright purchased a hundred acres of land on the east bank of the Susequehanna River in Pennsylvania. Soon after, she was joined by her father and brothers, who bought similar acreage on the opposite bank. River crossings between the family members were frequent, and eventually led to the establishment of Wright's Ferry, for which Wright's house is named.

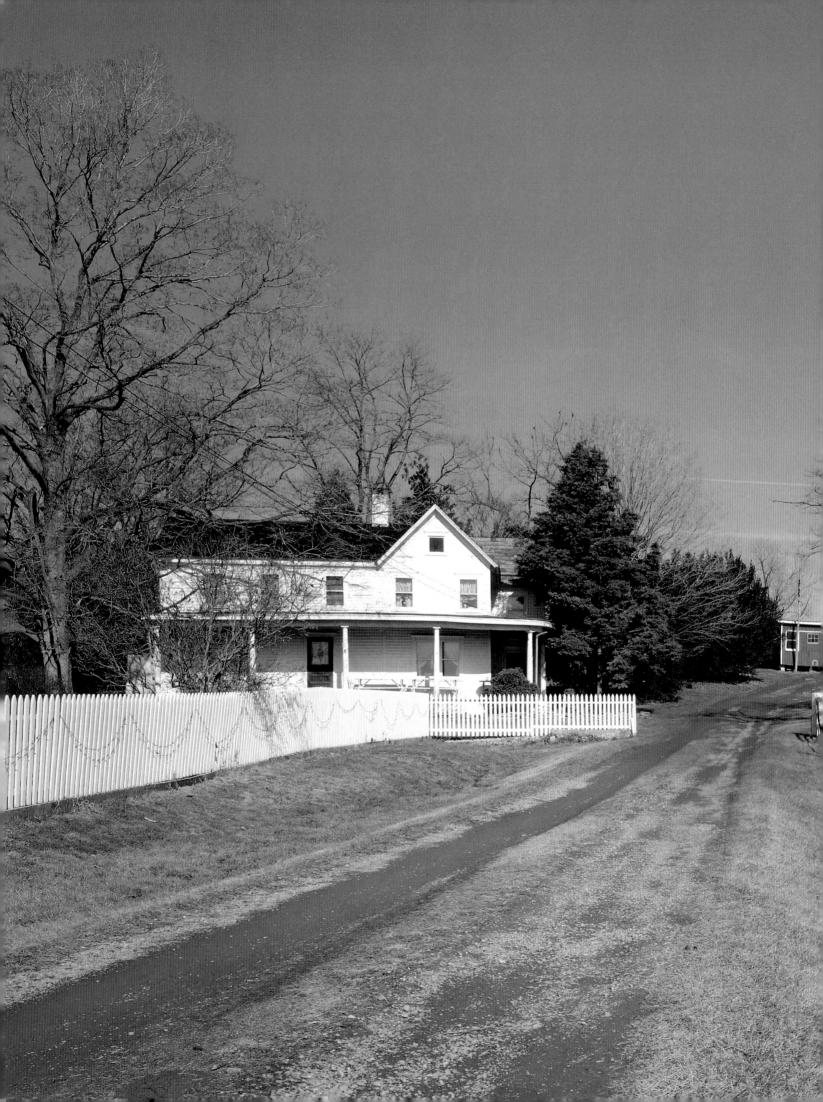

A road leading to a farm was regarded, by the farmer, as a great boon. But as traffic increased between farms, roads became paved and public. These roads eventually became the main thoroughfares, and often bisected the farm, producing the modern farm landscape of a barn on one side of the road and a farmhouse on the other.

On this family farm in New Jersey, which has remained unchanged and unconverted for several generations, the road never became developed, providing a glimpse of a traffic-free rural landscape.

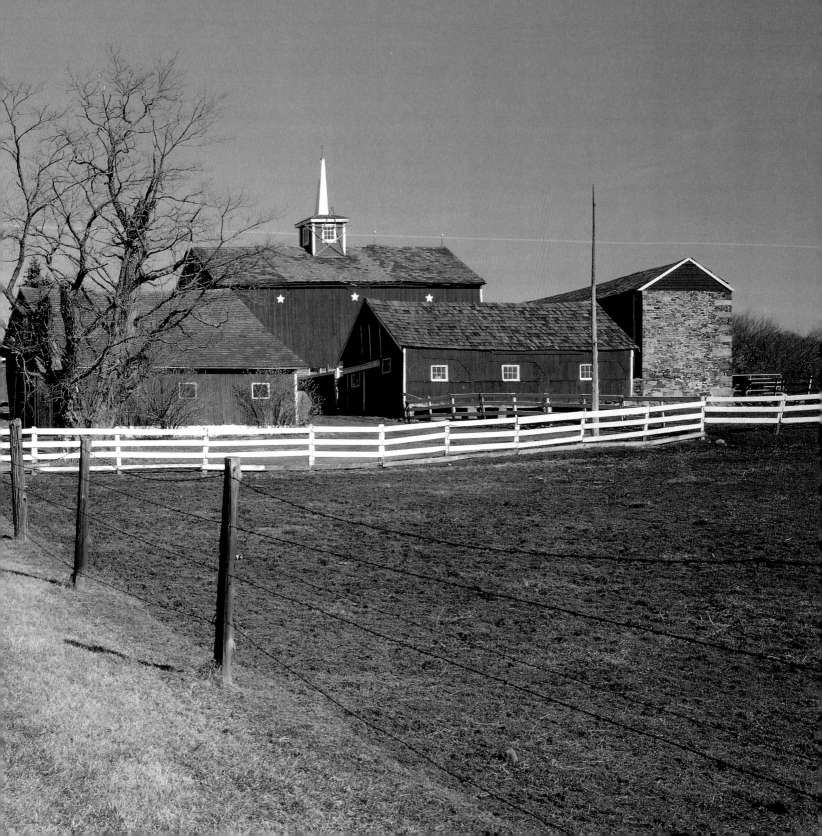

Glossary

ANCHOR BEAM In Dutch barns, a massive horizontal member that ties together arcade posts to form a rigid H-shaped bent, which spans the threshing floor.

BACK HOUSE A building in a connected farm complex located between the kitchen and the barn. It may also refer to a privy or outhouse.

BALLOON FRAME A type of timber framing introduced in the mid-nineteenth century, in which the studs are continuous from sill to plate.

BASILICA PLAN A building plan in which a dominant nave is flanked by two or more side aisles. Dating back to Roman meeting halls, the form was adapted for early Christian churches. Later it was used in aisled barns in England and Dutch barns in the Netherlands and North America.

BENT The basic unit of assembly in a timber frame, in which vertical posts are joined with one or more tie beams and often stiffened with paired braces.

BRACE A diagonal timber, straight or curved, that is mortised into two timbers set at right angles to each other, to provide strength and rigidity.

CANTILEVER BARN In the upland South, a barn form in which a second-floor loft projects beyond a log crib on the ground floor.

CHAMBER A bedroom, usually on the second floor.

CORN CRIB A building for storing corn, usually constructed with slatted boards for ventilation and inwardly slanted walls for weather protection, set on stilts to deter rodents.

ELL A building that extends from the farmhouse, usually forming an L shape.

ENGLISH or YANKEE BARN A simple three-bay barn plan with a side entrance. Common in England and known elsewhere in Europe, this plan was used for most early American barns.

FACHWERK The exposed heavy timber framing of central European construction.

GAMBREL ROOF A roof that has a lower, steeper slope and an upper, gentler one on each side.

JERKINHEAD ROOF An English roof form in which the upper portion of the gable slopes back to the ridge, forming a partial hip.

LATHING Thin, narrow strips of wood nailed to internal walls and ceilings.

LONG HOUSE or LOS HOES A connected structure in France, Germany, or the Low Countries that contains living space at one end and space for livestock at the other.

NEW ENGLAND BARN Introduced in the nineteenth century, a popular barn plan in which the entrance is in the gable end.

NOGGING Any material, including stone, brick, or wattle and daub, used to fill spaces between studs.

OAST HOUSE A special structure built to house the kiln for drying hops.

PENNSYLVANIA BARN A two-story barn with a forebay, built into a slope. The dominant barn form in southeastern Pennsylvania, the Pennsylvania barn can also be found in the Midwest and Canada.

PORCH A roofed entrance to a barn or other structure.

PRINCIPAL RAFTERS Large, diagonal timbers at each bent that support the purlins, which in turn carry either secondary rafters or roof boards.

PURLIN A horizontal timber running parallel to the ridge piece, supported by the principal rafters and supporting the common rafters.

SALTBOX A colonial house form with two stories in front and one story behind under a pitched roof, with the rear slope longer than the front.

SHEATHING Boards encasing the frames of a building. On houses these boards are covered by clapboards, while on barns the sheathing might be left exposed.

SUMMER KITCHEN A kitchen workroom where the cookstove was temporarily moved during the hot summer months. Usually a separate structure.

THRESHOLD A board placed at the base of the doorjambs by the threshing floor to prevent the threshed grain from escaping.

TITHE BARN A large warehouse built during the Middle Ages to house the tithe, a ten percent levy on harvests charged by the church.

WATTLE AND DAUB A type of nogging made of saplings woven between studs (wattle) and covered with mud and horsehair (daub).

Bibliography

Brunskill, R.W. *Traditional Farm Buildings in Britain*. London: Victor Gollancz, Ltd., 1987.

Endersby, Elric, Alexander Greenwood, and David Larkin. *Barn: The Art of a Working Building*. New York: Houghton Mifflin, 1992.

Darley, Gillian. *Built in Britain: A View of Traditional Architecture*. London: Weidenfield and Nicolson, Ltd., 1983.

————. *The National Trust Book of the Farm*. London: The National Trust and Weidenfield and Nicolson, Ltd., 1981.

Glassie, Henry. *Passing the Time: Folklore and History of an Ulster Community*. Dublin: The O'Brien Press, 1982.

Halsted, Byron D. *Barns, Sheds and Outbuildings*. Lexington, Mass.: The Stephen Greene Press, 1881, repr. 1977.

Hartley, Dorothy. *Food in England*. London: Macmillan & Co., 1954.

————. *Lost Country Life*. New York: Pantheon, 1979.

Hawkc, David Freeman. *Everyday Life in Early America*. New York: Harper & Row, 1988.

Hubka, Thomas C. *Big House, Little House, Back House, Barn*. Hanover, N.H.: University Press of New England, 1984.

McAlester, Lee, and Virginia McAlester. *A Field Guide to American Houses*. New York: Alfred A. Knopf, 1984.

McMurry, Sally. *Families and Farmhouses in Nineteenth-Century America: Vernacular Design and Social Change*. New York: Oxford University Press, 1988.

Nicholson, Graham and Jane Fawcett. *The Village in England*. New York: Rizzoli, 1988.

Noble, Allen G. *Wood, Brick & Stone: The North American Settlement Landscape*. Vol. 2, *Barns and Farm Structures*. Amherst, Mass.: University of Massachusetts Press, 1984.

Robert, Isaac Phillips. *The Farmstead: The Making of the Rural Home and the Lay-out of the Farm*. New York: The Macmillan Company, 1902.

Roe, Keith E. *Corncribs in History, Folklife & Architecture*. Ames, Iowa: Iowa State University Press, 1988.

Upton, Dell, ed. *America's Architectural Roots: Ethnic Groups That Build America*. Washington, D.C.: The Preservation Press, 1986

Upton, Dell, and John Michael Vlach, eds. *Common Places: Readings in American Vernacular Architecture*. Athens, Ga.: University of Georgia Press, 1986.

I am most grateful to the farmers and houseowners who cooperated with me by allowing their buildings to be researched and photographed. I would also like to thank the staff of the following open air museums and living history farms and their consultants, in particular:

Mike Melson and Ron Westphal, The Homeplace
Tennessee Valley Authority–Land Between the Lakes
Golden Pond, Kentucky
pages 58–71

Rhonda Howdyshell, Public Relations Specialist
Museum of American Frontier Culture
Staunton, Virginia
pages 10–16, 18–21, 34–43, 140

Gail Hunton
Longstreet Farm in Holmdel, New Jersey
Monmouth County Park System
Lincroft, New Jersey
pages 129–33

Kerry Adams, Interpretive Specialist
Cobblestone Farm
Ann Arbor, Michigan
pages 72–75

Blake Hayes, Conservator of Historic Buildings
Henry Ford Museum and Greenfield Village
Dearborn, Michigan
pages 76–79

Tom Robbins
Mountain Farm Museum
Great Smoky Mountains National Park
Cherokee, North Carolina
pages 49–57

Burt Lock
Johnson Farm
Peaks of the Otter, Virginia
pages 44–48

John Reilly
Old World Wisconsin
Eagle, Wisconsin
pages 80–102

Steve Davis
Living History Farms
Urbandale, Iowa
pages 114–28

Oliver H. Kelley Farm
Minneapolis, Minnesota
pages 103–13, 134

Thanks also to the following individuals for their expert work and advice: Elizabeth Ackerman; Tommy Candler, *photographs pages 202, 206–13, 220–22, 224;* Elric Endersby and Alexander Greenwood of the New Jersey Barn Company, *photographs pages 144–57, 168–72, 184, 197, 200;* Allan Noble; June Sprigg; Elizabeth Whiting Agency, *photographs pages 214–19, 222–23, 225–27;* Mr. & Mrs. Wright Miers, *photographs pages 194, 196, 197*